Decorative Arts 1900

Decorative Arts 1900

. . . .

Highlights
from
Private Collections
in
Detroit

. ✤ .

Peter Barnet

MaryAnn Wilkinson

. ✤ .

with an introduction by
Martin Eidelberg

The Detroit Institute of Arts

This catalogue is published in conjunction with the exhibition
«Decorative Arts 1900: Highlights from Private Collections in Detroit»
at the Detroit Institute of Arts
November 7, 1993 - January 9, 1994.

© The Detroit Institute of Arts Founders Society 1993
Distributed by the University of Washington Press, Seattle

ISBN 0-89558-139-6

Library of Congress Cataloging-in-Publication Data

Barnet, Peter.
 Decorative arts 1900 : highlights from private collections in
Detroit / Peter Barnet, MaryAnn Wilkinson : with an introduction by
Martin Eidelberg.
 p. cm.
 Catalog of an exhibition shown at the Detroit Institute of Arts
Nov. 7, 1993-Jan. 9, 1994.
 Includes bibliographical references and index.
 ISBN 0-89558-139-6 (pbk. : acid free)
 1. Decorative arts—History—19th century—Exhibitions.
2. Decorative arts—History—20th century—Exhibitions. 3. Arts and
crafts movement—Exhibitions. 4. Decoration and ornament—Art
nouveau—Exhibitions. 5. Wiener Werkstätte—Exhibitions.
6. Decorative arts—Private collections—Michigan—Detroit—
Exhibitions. I. Wilkinson, MaryAnn. II. Detroit Institute of
Arts. III. Title.
NK775.B37 1993
745′.09′03407477434—dc20 93-35718
 CIP

. . . .

Edited by Julia P. Henshaw, Director of Publications
Photography by Dirk Bakker, Director of Photography
Designed by Judith A. Moldenhauer
Typeset by Doug Hagley, Ann Arbor
Futura (regular, bold, and extra-bold) and Sabon (regular and bold)
3000 copies were printed by Wintor-Swan, Detroit
Vintage Velvet, 80 lb. text

This exhibition was organized by
the Detroit Institute of Arts
and funded by a generous grant from
United Technologies Automotive,
the Founders Junior Council,
the City of Detroit,
the State of Michigan, and
the Founders Society.

✛

Table of Contents

Lenders to the Exhibition

Thomas W. Brunk

Gayle and Andrew Camden

D. DeCoster

David and Bobbye Goldburg

H. Gary and Melissa Lipton

Thomas and Marianne Maher

Manoogian Collection

Masco Corporation

Donald Morris Gallery, Inc.

Milford and Barbara G. Nemer

William and Patsy Porter

Randall and Patricia Reed

Donald and Marilyn Ross

James and Rose Ryan

Laurie and Joel Shapiro

Jerome and Patricia Shaw

Dr. Lawrence and Reva Stocker

Ronald S. and Nina H. Swanson

Bruce Szopo

Sheila and Jan van der Marck

Janis and William M. Wetsman

Arthur E. Woehrlen, Jr. and Sara Heikoff Woehrlen

and anonymous lenders

Samuel Sachs II
Director
The Detroit
Institute of Arts

Foreword

THE DETROIT INSTITUTE OF ARTS takes particular pleasure in presenting the exhibition «Decorative Arts 1900: Highlights from Private Collections in Detroit». As we approach the year 2000, the thought of the year 1900 has special resonance for us. The turn of the last century can be seen as a convenient date for the beginning of modern times. It was an era of great energy and variety everywhere, when many technological innovations allowed for increased communication and travel within the continents of Europe and America and transatlantic travel between the two. By exhibiting together objects from Britain, America, and Europe, the exhibition offers the fruitful opportunity to see these works in the context of an emerging global society.

There are pieces here intended for use in everyday life (and indeed many still are), from the sturdy oak furniture of Gustav Stickley to the delicate glass lamp by Louis Comfort Tiffany, from the Charles Ashbee piano with its Shakespearean inscriptions to the forward-looking geometric designs of Josef Hoffmann. Some were manufactured for the homes of the growing middle classes, others were uniquely hand-crafted for the pure aesthetic pleasure of the most sophisticated avant-garde connoisseurs on both continents. All are splendid well-preserved examples from the wide range of media used in the decorative arts.

As a great manufacturing center, Michigan has historically contributed in significant ways to the development of progressive design. Exhibitions held at the Detroit Society of Arts and Crafts stimulated interest in the first decades of this century. Objects and artists associated with the Pewabic Pottery, the Cranbrook Academy of Art, and the furniture makers of Grand Rapids are represented here. It is not surprising, therefore, that so many astute private collectors from our area have preserved and treasured these works.

In addition to providing a richly rewarding exhibition for the museum, «Decorative Arts 1900» represents a gratifying collaboration between two curatorial departments, as Peter Barnet, Associate Curator of European Sculpture and Decorative Arts, and MaryAnn Wilkinson, Associate Curator of Twentieth-Century Art, equally shared the myriad responsibilities for selecting the works, writing the catalogue, and installing the exhibition. They are to be applauded for their hard work and the great success of the show.

Sponsorship of the exhibition by United Technologies Automotive was supplemented by a special grant from the Founders Junior Council; our most sincere thanks go to both groups. Most importantly, our greatest appreciation goes to the many astute Detroit-area collectors who have shown great generosity in lending these wonderful works to the museum for a wider public to learn from and enjoy.

x

Peter Barnet
Associate Curator
European Sculpture and
Decorative Arts

MaryAnn Wilkinson
Associate Curator
Twentieth-Century Art

Preface and Acknowledgments

«DECORATIVE ARTS 1900: Highlights from Private Collections in Detroit» was organized to celebrate the broad interest among local collectors in turn-of-the-century decorative arts. The exhibition brings together one hundred thirty superb objects designed or made around 1900 by a diverse group of artists and designers from Great Britain, America, and the European continent. These works, in all media, range in style from the eclecticism of late Victorian Britain, to the austerity that characterized Arts and Crafts in America, to the curvilinear approach of Art Nouveau in France and Germany, and to the geometric solutions found in Vienna. While not all of the major designers of the period can be represented in an exhibition of this nature, fine works by lesser-known figures complement the major examples by key designers and lend vitality and depth to the exhibition. We believe that visitors will come away with greater insight into the crosscurrents of design at the turn of the century, as well as with an enhanced appreciation for the discerning eye of each collector.

An exhibition on this scale inevitably draws upon the talents of many individuals to make it a success, and we gratefully acknowledge the help and encouragement we received from colleagues here and elsewhere. Samuel Sachs II, Director of the Detroit Institute of Arts, and Joseph P. Bianco, Jr., Executive Vice President of the Founders Society, have enthusiastically supported the exhibition concept from the outset. Jan van der Marck, Chief Curator and Curator of Twentieth-Century Art, and Alan Phipps Darr, Curator of European Sculpture and Decorative Arts, encouraged us to enlarge the show we originally planned.

We were joined in our collaboration by individuals in other departments of the museum. Michael Kan, Curator of African, Oceanic, and New World Cultures; Bonita LaMarche, Associate Curator, Twentieth-Century Art; Laurie Barnes, Assistant Curator, Asian Art; Nancy Rivard Shaw, Curator, and James Tottis, Associate Curator, American Art, advised us on many stylistic issues, as did Sarah Towne Hufford, Assistant Curator, Education, who also helped us develop the public programs. Tara Robinson, Curator of Exhibitions, kept us on schedule and worked through administrative details. Louis Gauci and Robert Loew, Jr., in Exhibitions and Design developed the thoughtful presentation of the objects. Valuable help was also given to us by Phyllis Ross, Intern, European Sculpture and Decorative Arts; Suzanne Quigley, Pamela Watson, Kimberly Dziurman, Terry Birkett, and Michael Kociemba in the Registrar's office; Barbara Heller, Carol Forsythe, John Steele, and James Leacock in the Conservation Services Laboratory; John McDonagh, Patricia Berdan, and Donna Blumer in the Development Department; and Lisa Steele, Cyndi Summers, Laura Arnsbarger, and Kathryn Darby of Marketing and Public Relations.

The superb catalogue photography is thanks to Dirk Bakker, Director of Photography, and Robert Hensleigh, Associate Director, ably assisted by Eric Wheeler and Francesca Quasarano. Julia Henshaw, Director of Publications, edited the catalogue and coordinated its production; she was assisted by Mary F. Jarvis, Publications Intern, and Pamela Marcil, Executive Secretary. The sensitive design of the catalogue and collateral materials was done by Judith A. Moldenhauer. Mary Beth Kreiner, Curatorial Coordinator, tracked down a myriad of details and references, finding time to write the lively and concise biographies.

Special thanks are due to Martin Eidelberg, Professor of Art History at Rutgers University and veteran historian of the period, for his affable criticism, pertinent suggestions, and lively essay. We also thank Nicholas M. Dawes, Deborah Gann, Philippe Garner, Jonathan Hallam, Martin Levy, Linda Parry, Mark Waller, Michael Whiteway, and Inge Zerunian. James Robinson, independent furniture conservator, aided in the presentation of the objects. We are grateful to these specialists outside the museum for information and insight, while accepting, however, full responsibility for any errors.

We are fortunate in the many supporters who together have made this exhibition possible. United Technologies Automotive has provided generous and crucial funding, supplementing the contibution of the State of Michigan, the City of Detroit, and the Founders Society. The Founders Junior Council made an important early pledge to support the production of the catalogue. The Friends of Modern Art and the Visiting Committee for European Sculpture and Decorative Arts have lent their support to many of the public educational adjuncts to the exhibition.

Finally, our greatest debt is to the lenders. The collectors have demonstrated admirable generosity in their willingness to share these important works of art with the public. Knowledgeable about the period and particularly about the individual objects in their care, their energy and enthusiasm has been an inspiration.

. � .

We dedicate our work to the memory of our fathers.

. ✑ .

Introduction

Martin Eidelberg

The Course of Design
at the Turn of the Century

THE HISTORY OF LATE NINETEENTH- AND EARLY TWENTIETH-CENTURY decorative arts, like all chronicles of human achievements, is a history dependent on our interpretation. Even though we are dealing with events of only a hundred years ago, that era already constitutes a distant past. Time is a formidable barrier, and the past is not easily recuperable. There are no oral histories or videotapes from 1900, few living descendants with direct knowledge. If we turn to the written word—contemporary books, magazines, newspapers—we may find references to the craftspeople and objects in which we are interested, but all too often initial joy turns to frustration: much was not reported, much was hidden beneath an obscuring blanket of polite prose, perceptive criticism was rare. It remains for us today to interpret the material and reconstruct the history of those years.

As it is generally narrated by art historians and would-be historians, the history of decorative arts in this period is a series of successive artistic movements. We are told that the early and middle parts of the nineteenth century in both Europe and the United States were dominated by the advent of the industrial revolution and the proliferation of imitative styles such as Neo-Classicism, the Neo-Gothic, and Orientalism. There then was a reform movement, primarily in England, which advocated a return to handicraft and a simple, unostentatious style. The next stage, Art Nouveau, centered primarily in Belgium and France, was based on dynamic, curvilinear forms and ornament. Lastly, there was a return to a sober, more rectilinear style, primarily in Germany and Austria as well as the United States. The cycle came to a close with World War I.

This version of history is the one normally followed, though there may be minor variations based upon the national or personal prejudices of the narrator. As it is said, history is the myth we agree upon. The schema is attractive because it imposes an order and logic that are reassuring. Each stylistic movement is neatly compartmentalized. One section leads to the next—generally through reaction rather than evolution, thus leaving few gray transitional areas. In actuality, though, there were many stylistic currents and subcurrents, frequently

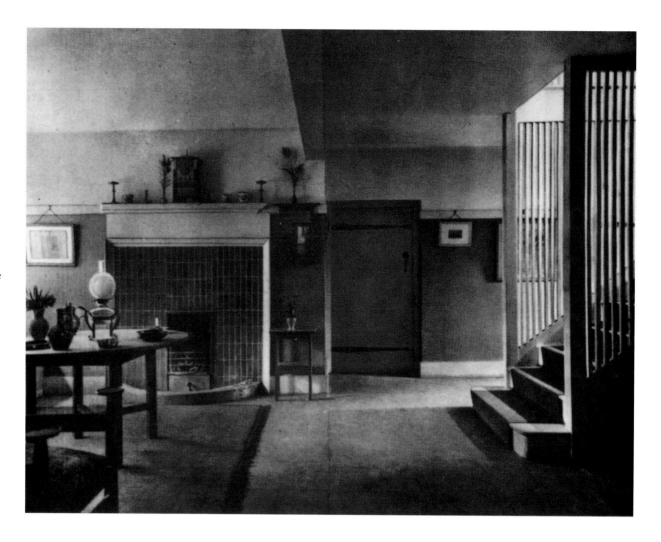

Figure 1.
Charles F. A. Voysey
Hall in the architect's home
«The Orchard»
Chorleywood, 1899.

overlapping and interacting. Rather than the image of a river with a purposeful flow, or even a river with several branches, the analog should be a delta with crisscrossing streams, tidal pools, and backwaters.

As a starting point, we might consider the issue of historicism. While nineteenth-century authorities stressed the validity and necessity of borrowing from the past, by the 1870s critics were already lamenting the deleterious effects of this practice. Ever since, it has become customary to assign to historicism the role of a villain, a stultifying factor which inhibited the creative powers of designers. But, in fact, historicism played a positive role. For example, the inspiration of medieval crafts and craftsmen, as well as early Renaissance printing, English vernacular furniture, and Near Eastern textiles,

cat. nos. 19-21 was crucial to the development of both the theory and work of William Morris. Historicism expanded the repertoire of forms and decorative motifs in an ultimately positive way, and these borrowings were

cat. no. 9 often used in free and inventive new combinations. Christopher Dresser's ceramics show that he was

cat. nos. 73-74 inspired by both Peruvian and Japanese pottery. Similarly, Carlo Bugatti inventively combined Arabic

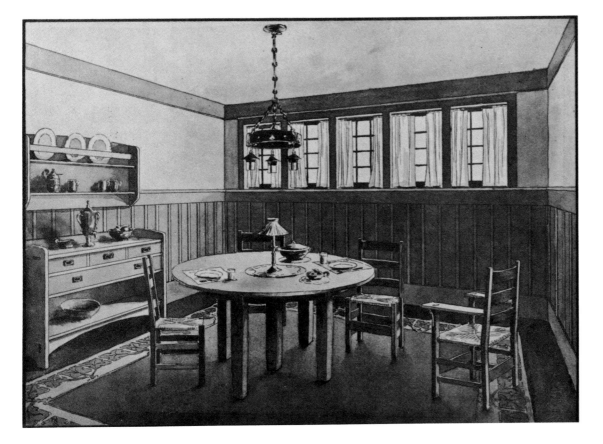

Figure 2.
Gustav Stickley and Associates
Design for the dining room
in a country house
(from *The Craftsman*, 1904).

and Japanese styles to create strikingly idiosyncratic furniture, as did Antonio Gaudí in the early part

of his career.

Historicism also introduced important principles to Western design. Owen Jones, whose

Grammar of Ornament (London, 1856) was one of the most frequently consulted compilations of

historic styles, stressed that designers should not merely copy motifs but, rather, grasp underlying

principles such as the importance of flat, colored planes. Edward Godwin discovered in Japanese art the *cat. no. 11*

beauty of simplicity and the balance of solid and void. As can be seen in Félix Bracquemond's ceramics

or the Joseph-Théodore Deck charger, Japanese woodblock prints were emulated not only for their motifs *cat. no. 78*

of flora and fauna, but also for principles of asymmetry and the reestablishment of the relationship

of subject and ground.

Moreover, Western craftsmen were stimulated by the technical achievements of older

and non-Western cultures, and here too historicism played a beneficial, even crucial role. The direction

of modern silverware and jewelry was transformed through the contributions made by historicism: Tiffany

and Company's inlays of different metals and René Lalique's extraordinary jewelry of semi-precious stones

and horn would not have been created without the study of Islamic and Japanese examples. Islamic

enameled glass and Roman and Chinese cameo glass provided technical inspiration for the leading

Figure 3.
Victor Horta
Stairwell in the Hôtel Tassel
Brussels, ca. 1893.

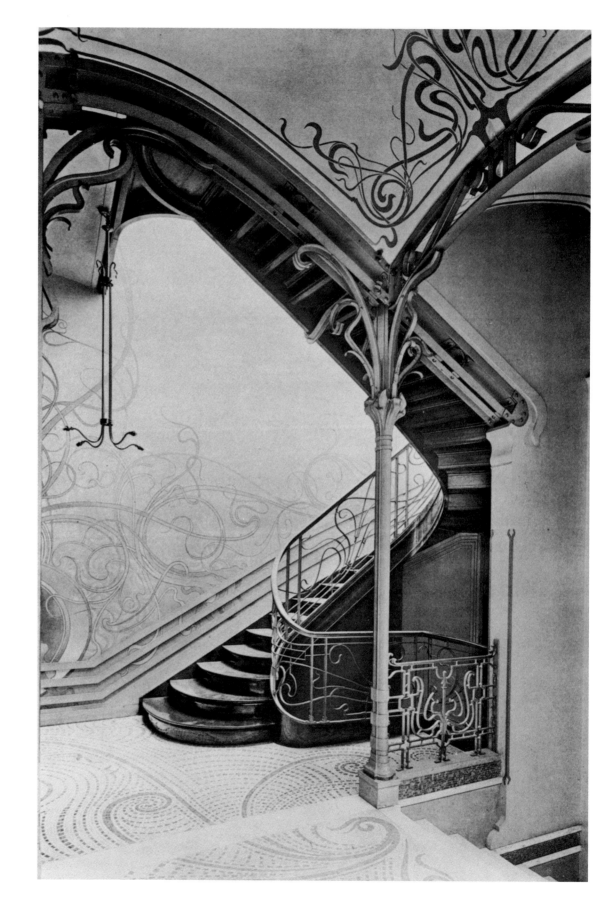

lights of French glassmaking—Joseph Brocard, Eugène Rousseau, and Emile Gallé; their works, in turn, *cat. nos. 85-86*

served as the foundation for almost all glass that was made at the turn of the century.

Isnik pottery and

the bright, polychromatic wares of Japan inspired Deck and his followers. The flambé and matte glazes

of Far Eastern ceramics became a preoccupation of French ceramists such as Ernest Chaplet and Auguste

Delaherche, and these became the mainstay of later Western ceramics. Hispano-Moresque lusterware was

inspirational to nineteenth-century potters such as Ulisse and Giuseppe Cantagalli, William De Morgan, *cat. no. 5*

and Clément Massier. While their first attempts may have been relatively direct imitations of non-Western

wares, later works were so far removed and transmogrified that we might overlook their historical sources.

If the De Morgan vases are still redolent of the past, the Zsolnay vase and the extravagantly organic Keller *cat. no. 130*

et Guérin ewer are so far removed from Hispano-Moresque wares that we might not stop to reflect on the

source of their iridescent glazes. Likewise, while the vase by Pierre-Adrien Dalpayrat is still relatively close *cat. no. 77*

to the Japoniste tradition, the Eastern origin of the flambé glazes on Gottlieb Elstor's vase and the matte *cat. no. 97*

glazes used by William Grueby and Artus Van Briggle are less apparent because they are used within a *cat. nos. 27, 67*

Western context of form and subject.

Early in his career, Louis C. Tiffany was enthralled by the glowing

color in the stained glass windows at Chartres, the richness of Early Christian and Byzantine mosaics,

and the vitality of early medieval and Mogul metalwork. His love of those arts is revealed in an exotic

bench covered in glittering mosaic with a Romanesque meander pattern, and hung with a Byzantine or *cat. no. 62*

Merovingian fringe of glass jewels. By contrast, his beautiful Lotus Lamp seems so inventive and sensuous, *cat. no. 65*

so unfettered by the past, that we might almost overlook that the combination of leaded glass and mosaic

is the direct outcome of his prior emulation of early forms of ecclesiastical art. Indeed, all too often we

forget the positive contributions made by nineteenth-century historicism.

We also need to consider the

chronological position of historicism as a movement. While it may be convenient to think of historicism

as an early, preliminary phase, in fact, it is a thread that runs continuously throughout the period under

consideration. Gallé frequently used historic references at the beginning of his career in the 1870s and

1880s, and he still had occasion to call upon explicitly Japanese forms even at the end of his career. The

grace of French Art Nouveau furniture is the result of a conscious attempt to gallicize the movement

by employing Rococo formulas. After 1910, young French designers such as Jacques-Emile Ruhlmann

and Paul Iribe turned to the Louis XVI style for inspiration. Mary Chase Perry Stratton worked in an *cat. nos. 96, 32-33*

adventurously modern Art Nouveau style in the years just after 1900, but by 1910 she, like many ceramists,

retreated to a safer, conservative Far Eastern mode. Clearly, historicism is an integral and complicating

factor in any history of modern decorative arts.

One of the terms most frequently used in discussing late nineteenth- and early twentieth-century design is Arts and Crafts. These nouns were first joined in a meaningful way in 1888 when various British artists and designers joined forces to establish the Arts and Crafts Exhibition Society. Whereas the term was used in a relatively nonspecific way at first, it gradually came to represent an advocacy of handicraft as opposed to industrial manufacture. The meaning of the term was affirmed by the various arts and crafts societies which were founded in the United States, beginning with those established in Boston and Chicago (1897), then those in New York (1900), Minneapolis and Grand Rapids (1902), Providence (1904), and not least of all, Detroit (1906). All these organizations had as their primary purpose the fostering of handicraft.

Ironically, there were varying degrees of hand labor among the objects that we deem today as Arts and Crafts. Much was designed by one person and executed by others, thus continuing the division of labor created by the industrial revolution, and much was not even made by hand. Charles Rohlfs designed and with shop assistants made furniture in a small, relatively personal business. Frank Lloyd Wright designed different furniture for each architectural commission but it was made by outside workshops. Peter Behrens and Richard Riemerschmid supplied designs for furniture that was produced by various companies. Firms like those of Gustav Stickley and Charles Limbert were essentially medium-size industries, where design and execution were separate operations, heavy machinery was used, and handicraft was mainly a matter of outward appearance.

cat. nos. 36-37

cat. nos. 69-71

cat. nos. 72, 119

cat. nos. 30, 44-58

Likewise, while the silver of Charles R. Ashbee and the Guild of Handicraft was raised by hand, Liberty and Company's line of pewter objects was of cast, standardized models. Van Briggle designed and executed the first model of each vase, but then cast it in serial production and had to defend his practice. Although all Grueby vases were made entirely by hand and were greatly admired for expressing a handicraft ethic, in fact, they were fixed models designed by one person and executed by staff workers who signed each vase as though it were their own artistic creation. Handicraft, per se, is a misleading criterion for determining what is Arts and Crafts.

cat. no. 3

cat. nos. 13-14, 67

cat. no. 27

The term Arts and Crafts has also come to signify a style of the sort that we see in the work of the British architect Charles F. A. Voysey and Americans such as Stickley. It is a style marked by simplicity and honesty in all areas of concern: materials, structure, and ornament. There is a predominance of architectonic, often rectilinear structures; the use of oak and copper rather than more costly mahogany and bronze; and emphasized elements such as exposed mortise and tenons and large hinges. When there is decoration, it tends to be compartmentalized

Figs. 1-2

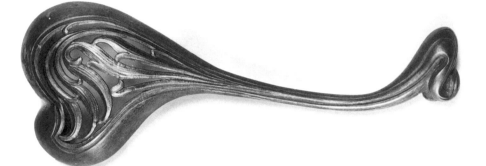

Figure 4.
Edward Colonna
Sugar Spoon, ca. 1898
Paris, Musée des Arts Décoratifs
(photo: Hélène Adant).

or set off in bands, with blocky, geometric conventionalization of motifs, as in the flat, squared leaves on the Liberty candlesticks designed by Archibald Knox, the Roseville Pottery vase designed by Frederick Hurten Rhead, and the anonymous English carpet.

cat. no. 14

cat. nos. 34, 24

The other term which must be invoked in discussing the decorative arts of 1900 is Art Nouveau. Its origins can be traced to Belgium in about 1892-93 when Henry van de Velde and Victor Horta began to explore the possibilities of using dynamic, rhythmically charged lines to transform structure and ornament. The stairwell of the Hôtel Tassel is an early and stunning example of the Art Nouveau style in its purest form. The etymological derivation of the term can be traced to the art gallery L'Art Nouveau which Siegfried Bing opened in Paris on December 26, 1895. Whereas his gallery had previously been devoted to the sale of Oriental art, Bing decided to throw his hat in the ring and handle modern painting and decorative arts. He first favored both English Arts and Crafts as well as the work of Van de Velde, but gradually the term Art Nouveau became identified with the motif of the abstract, whiplash curve. Bing assembled a team of designers, including Edward Colonna and Eugène Gaillard, who worked in this exuberant but nonetheless graceful mode. Van de Velde's vase and graphic designs and Paul Follot's coffee and tea service represent the way in which objects could be transformed through the use of linear energy. By the late 1890s the Art Nouveau style was established throughout all of Europe, often with local names and distinctive regional accents, and it also crossed the Atlantic.

Fig. 3

Fig. 4

cat. nos. 127-128, 84

The terms Arts and Crafts and Art Nouveau are generally conceived of as describing separate, sequential stages in the evolution of design. Certainly the contrast between the architectural sobriety of the one and the lush richness of the other are apparent. Yet we must be cautious, because there was a great deal of overlap, both in terms of chronology and style. While the important foundation stones of the Arts and Crafts movement were laid in England in the third quarter of the century

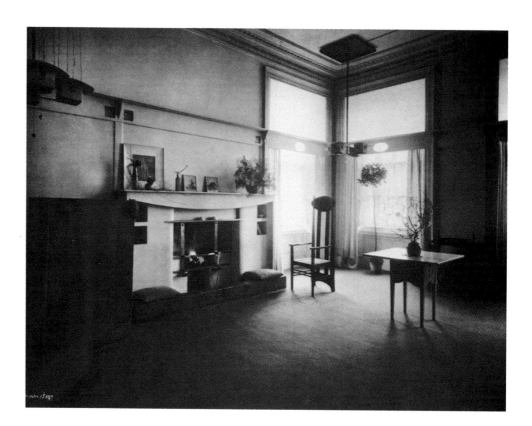

Figure 5.
Charles Rennie Mackintosh
Drawing room in the architect's apartment at
120 Mains Street, Glasgow,
ca. 1899–1900.

and the Art Nouveau style arose only after 1892-93, we must not think that the Arts and Crafts movement came to an end when Art Nouveau began. Quite the contrary. If anything, there was only a brief, though universal, fascination with Art Nouveau. On the other hand, Voysey and Ashbee were at the heights of their careers in 1900, and it was at this time that the English mode swept the international field. Arts and Crafts geometricizing designs could be found in Brussels, Amsterdam, Helsinki, as well as in cities across the United States. This proved a serious challenge to the Art Nouveau style and marked the ultimate triumph of the British mode of design.

Figs. 5-7

cat. nos. 15-16

Moreover, after 1900 interiors from Glasgow and Vienna to Syracuse and Chicago, though still within the architectonic, rectilinear Arts and Crafts tradition, showed a crispness and new elegance of form. The refinements introduced by Charles Rennie Mackintosh and the Glasgow school helped guarantee the success of this vision. The founders of the Wiener Werkstätte, Josef Hoffmann, Koloman Moser, and Fritz Wärndorfer, were won over by Voysey and Mackintosh both in terms of style and the idealism of a handicraft workshop. In turn, Americans were stimulated by this *cat. nos. 41, 30* Anglo-Viennese alliance, as is shown by the works of Karl Kipp and Charles Limbert.

Though we might prefer to think of Arts and Crafts and Art Nouveau as two quite distinct styles, the distinction between them proves to be a tricky business. While we may automatically classify artists such as Peter Behrens and

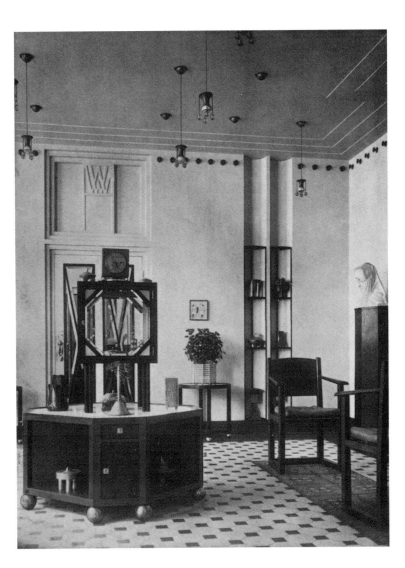

Figure 6.
Josef Hoffmann
Wiener Werkstätte showroom
Vienna, ca. 1903.

Joseph Maria Olbrich as Art Nouveau, their works are often more closely aligned with the English Arts and Crafts style. The Behrens chair and the Olbrich clock and coffee and tea service are so architectonic *cat. nos. 72, 112, 114* in form and decoration that they could fit comfortably in an interior by Voysey; they are at a far remove from the truly Art Nouveau creations of Guimard or Follot.

The screen by Van de Velde should also make *cat. no. 126* us reconsider the system of nomenclature. Van de Velde was one of the originators of the Art Nouveau style, yet he admired and lectured on the English Arts and Crafts movement. This oak screen, like much of his early furniture and architecture, maintains that English allegiance in its robust material, its forthright carpentry, and the plainness of its overall form. Van de Velde gives vent to dynamic, linear forces only in the upper and lower borders of the outer panels. Likewise, Bruno Paul skillfully merged *cat. no. 115* these two idioms in a chair where the sturdy nature of the structure is relieved by the channeled lines of torsion in the arms. The desk and table by Charles Rohlfs show medievalizing Arts and Crafts forms *cat. nos. 36-37*

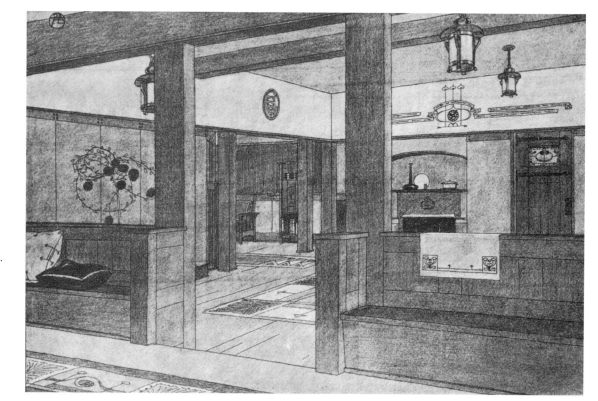

Figure 7.
Harvey Ellis
Design for the living room
in an urban home
(from *The Craftsman*, 1903).

decorated with vibrant linear patterns worthy of Edward Colonna, though in this case the success of the grafting of the two styles is less certain.

Were the terms Arts and Crafts and Art Nouveau the only stylistic categories with which we had to contend, our task might not be that difficult. But many of the most outstanding objects created around the turn of the century do not fall within either classification;

cat. no. 65 they are unabashed paeans to nature. The Lotus Lamp by Tiffany Studios may have an indebtedness to the medieval past in its use of mosaic and leaded glass, but it certainly cannot be considered to be historicizing in style. Much of the lamp was assembled by hand and its sensual, three-dimensional naturalism sets it apart from the Protestant-like ethic of objects designed by Voysey or Stickley. Nor does it exhibit any of the abstract, rhythmic lines of Art Nouveau. This lamp is but one example of a large

cat. no. 86 group whose inspiration is drawn wholly from nature. The Gallé lamp in the form of an umbelliferous

cat. nos. 35, 106 plant, the Arequipa Pottery vase with wisteria blossoms and leaves, and the Keller et Guérin ewer sculpted in the form of gourd and vine—all constitute examples of this major stylistic group.

This flora- and fauna-based vocabulary can be traced to the early nineteenth century's interest in nature, but it was also reinforced by the fascination with Japanese art that began in the 1860s and 1870s. Gradually, artists were urged to study nature directly but, nevertheless, it remained a study influenced by the principles

of Japanese art. The representation of the gentle swaying of foliage in the wind and the inclusion of a charming butterfly or grasshopper reflect this new, intimate view of nature. The beautiful marquetry of iris and dragonfly on the table by Gallé demonstrates how Japonisme and the cult of nature could be integrated. By 1900 this emphasis on nature was not a minor branch or subcategory of design but, in fact, one of the most pervasive styles: from the Rookwood Pottery in Cincinnati to Louis Majorelle's cabinetry shop in Nancy, from Georg Jensen's silver workshop in Copenhagen to the school for decorative arts in Prague.

cat. no. 85

cat. nos. 38-39, 103-105

This cult of nature and Art Nouveau could be combined or even hybridized. In 1895 Horta and Guimard agreed to eliminate the leaf and blossom and keep only the plant stem — the stem being symbolic of the sap or life force within. Some designers, as we have seen, chose to keep the blossom and leaf, while others compromised and combined these naturalistic elements within a rhythmically complex Art Nouveau design. Galileo Chini's vase is an animated combination of realistically rendered fauna contorted into whiplash curves. Colonna's lamp, while rhythmically Art Nouveau at the top, has relatively naturalistic leaves at the base. The marquetry inlay on the Majorelle cabinet devoted to a marine theme represents the sea creatures in a relatively naturalistic way but the iron mounts formed as seaweed are set in a mildly Art Nouveau pattern. These systems of juxtaposition and hybridization reveal the wealth and complexity of design at the turn of the century.

cat. no. 75

cat. no. 76

cat. no. 105

Yet one more stylistic category needs to be considered, namely Symbolism. Perhaps the most typical image associated with the years around 1900 is that of a woman's head, detached from the body, pensively lost in a dreamlike state. A splendid example is Victor Prouvé's bronze coupe, «The Night», which conveys the essence of nocturnal sleep (1894, Musée de l'Ecole de Nancy). A woman's head floats serenely and mysteriously forward, a poppy behind her ear suggesting opiated dreams. Her hair flows behind in the wind, sheltering tormented, Rodinesque figures. Such evocative imagery is also the essence of the «Despondency» vase by Van Briggle. The recumbent man, bound in a contorted pose of deep thought, blends into the vessel. Though constrained within a severe, rectilinear framework, Emilie Schleiss-Simandl's sculpted ceramic figure conveys the same mysterious Symbolist mood.

cat. no. 67

cat. no. 122

Symbolism, however, also overlapped other stylistic categories. The jewelry of René Lalique, for example, skillfully joined Symbolist imagery with the cult of nature; women's heads frequently emerged from bouquets of poppies or lilies or metamorphosed into dragonflies or other insects. Such a combination is repeated in the vase by Gottlieb Elstor, with its evocative image of the heads of two lovers surrounded by lush foliage. We might also consider how Gallé was both Naturalist and Symbolist; he saw nature as emblematic of a larger, enigmatic cosmos, and described his art as

Fig. 8

cat. no. 97

the «herborisation of ideas».

The turn of the century was a remarkable period of creativity in the decorative arts as well as in painting. Indeed, an analogy between these two areas is insightful since both register a multiplicity of styles and a complexity of interactions. It would not be amiss to compare Van de *Fig. 9* Velde's vibrant line with the dynamic, movement-filled works of Vincent van Gogh. Similarly, the marquetry inlays in Gallé's and Majorelle's furniture can well be compared to the works of Pierre Bonnard and other Japanese-inspired Nabis and Post-Impressionists. Elstor's vase and Lalique's jewelry might be compared to Odilon Redon's haunting Symbolist images. The complex geometry of Wiener Werkstätte objects can be compared to the richly patterned paintings of Koloman Moser and other Secession artists. These are not coincidental analogies; rather, they stem from an important historic reality. There was a close union between painting, architecture, and design.

Ever since the Renaissance, the so-called fine arts have sought to assert their intellectual and humanistic aspirations, and to separate themselves from the manual crafts. The distinction between the two became an established tradition in Western thought until the late nineteenth century when the dichotomy was seriously challenged, both in word and deed. By the 1890s, decorative arts had entered the exhibition salons of France and Belgium, and the traditional barriers began to dissolve. Gauguin's decision to make ceramics and Bing's commissioning of the Nabi painters to design windows to be executed by Tiffany were emblematic of this attempt to bring the arts together. Often there were career crossovers and many of those who became designers, such as Tiffany, Van de Velde, and Behrens, began as painters. This inevitably had a significant impact on their art. Van de Velde, for example, greatly admired and imitated the paintings of Van Gogh, and thus the affinity between the dynamic, linear structure of his objects and Van Gogh's paintings and drawings should not come as a surprise.

The close relationship between the fine arts and the decorative arts should make us reconsider how we view their history. We should have anticipated the multiplicity and complexity of trends in the decorative arts since, after all, they are related to the great variety of styles in painting at the turn of the century. Perhaps part of the problem is that we need to find a descriptive language that is more communal. As we have seen, the stylistic names used for the decorative arts are confusing and, moreover, bear little or no relationship to the terms used for painting and sculpture. The beauty and inventive genius of the arts at the turn of the century demands an appropriate nomenclature and a more sensitive history.

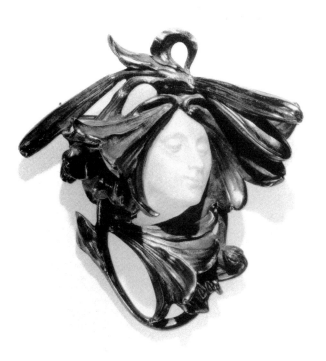

Figure 8.
René Lalique
Brooch, ca. 1900
whereabouts unknown.

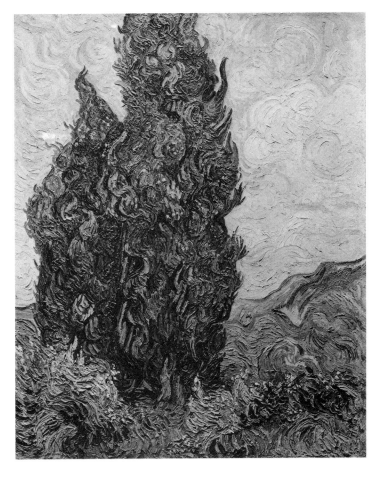

Figure 9.
Vincent van Gogh
Cypresses, 1889
New York, The Metropolitan Museum of Art
Rogers Fund, 1949 (49.30).

Catalogue
of the
Exhibition

British

Charles Robert Ashbee
English, 1863–1942

John Broadwood and Sons, manufacturer

Upright Piano • 1900

. . . .

Oak and various materials, interior veneered in holly, with painted decoration
124.5 x 138.4 x 66 cm (49 x 54½ x 26 in.) closed
170.2 x 273.1 x 66 cm (67 x 107½ x 26 in.) open

In the five panels above the keyboard are painted inscriptions from
The Merchant of Venice (V, i)

| THE MAN THAT HATH NO MUSIC IN HIMSELF | NOR IS NOT MO VED WITH CONCORD OF SWEET SOUNDS | IS FIT FOR TREA SONS STRATEGEMS AND SPOILS | THE MOTIONS OF HIS SPIRIT ARE DULL AS NIGHT | AND HIS AFFEC TIONS DARK AS EREBUS |

Inscribed on the right below the keyboard «DESIGNED AND ORNAMENTED BY
C R ASHBEE AND MADE BY JOHN/BROADWOOD & SONS...AD 1900»
Broadwood serial number 93572

Anonymous loan

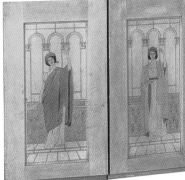

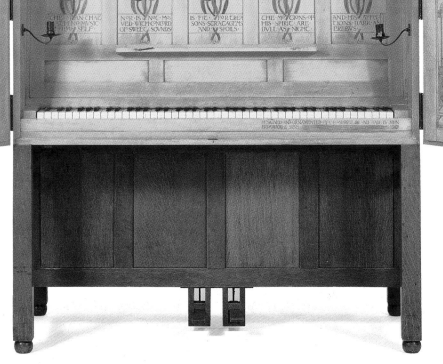

Detail

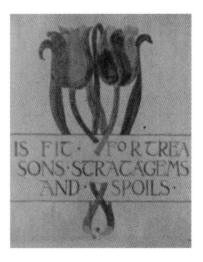

Detail

THE piano was made for E.P. Jones's «House in the Hill» in Tettenhall, Wolverhampton. Jones was a friend and patron of Ashbee and the interior of the house was one of his most significant commissions. This is one of only four pianos known to have been designed by Ashbee and it was undoubtedly influenced by the Manxman piano designed by Baillie Scott and made by Broadwood in 1896. The boxy forms of the so-called «artistic» pianos produced by Broadwood around 1900 stand in strong contrast to the Victorian tradition of curvaceous grand pianos. Four female figures with musical instruments are painted inside the doors. They hold, from left to right: cymbals, triangle, lute, and recorder.

4

2

Charles Robert Ashbee
The Essex House Press

The Flower and The Leaf · 1902

LIKE William Morris's work for the Kelmscott Press, the book designs for the Essex House Press are Gothic Revival in style. The use of vellum with decoration done by hand, features which recall medieval manuscripts and the earliest printed books, emphasized their handcrafted nature, despite being printed in relatively large editions. This anonymous poem, thought then to be by Geoffrey Chaucer, was published as number six of Ashbee's «Great Poems of the Language» series.

THE FLOWER AND THE LEAF.

WHEN that Phebus his chaire of gold so hie Hadde whirled up the sterrie sky a-lofte, And in the Boole was entred certainely : When shoures sweet of raine discended softe, Causing the ground, fele times & ofte, Up for to give many an wholesome aire, And every plaine was eke yclothed faire

WITH NEWE green, and maketh smalle floures To springen here and there in field & mede ; So very good & wholsome be the shoures, That it renueth that was old and dede In winter time; and out of every sede Springeth the hearbe, so that every wight Of this season wexeth ful glad and light.

b I

Three full-page illustrations and 85 initial letters drawn and hand colored by Edith Harwood
Set in Caslon type and printed on vellum
18.4 x 12.1 cm (7¼ x 4¾ in.)
Publisher's binding, parchment over boards with blind-stamp logo of flower and text «SOUL IS FORM»
Copy no. 66 from an edition of 165

Collection of Sheila and Jan van der Marck

3

Charles Robert Ashbee

Guild of Handicraft, Ltd., manufacturer
English, 1888–1907

Biscuit, Butter, and Cheese Stand · 1904

· · · ·

Silver, chalcedony, and glass
23.5 x 31.1 cm diam. (9¼ x 12¼ in.)
Impressed inside dish: maker's mark of the Guild of Handicraft, Ltd.,
leopard's head, lion passant, and date letter «i»

Anonymous loan

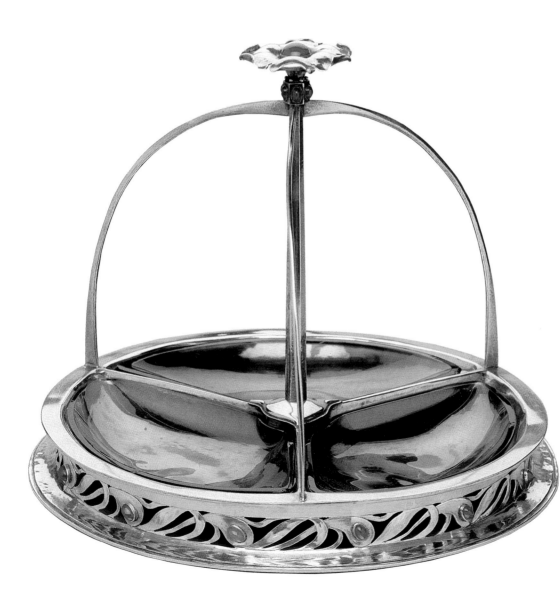

Tʜɪs refined design dates to the Chipping Campden (Gloucestershire) period (1902–07) of Ashbee's Guild of Handicraft. Ashbee founded the Guild in 1888 in response to the excessive historicism of much Victorian design. During the 1890s the Guild produced attractive silver in a simple Arts and Crafts style. By about 1900, however, Liberty's and other competing manufacturers were producing silver in generally similar styles and in 1907 the Guild was liquidated.

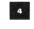

Thomas James Cobden-Sanderson
English, 1840–1922
The Doves Press and Bindery

Johann Wolfgang von Goethe, *Die Leiden des jungen Werther* · 1911

Set in type adapted from Jenson's *Pliny* (1476) by Cobden-Sanderson and Emery Walker and printed on vellum
23.5 x 16.5 cm (9¼ x 6½ in.)
Bound in 1912 at the Doves Bindery from a design by Cobden-Sanderson, executed by Charles McLeish Senior
and Junior; morocco leather binding with gilt; «The Doves Bindery 19 C-S 12» on lower left turn-in of back cover
Edition of 225 copies, of which this is one of 25 printed on vellum
Collecton of Sheila and Jan van der Marck

THE Doves Bindery, founded with the encouragement of William Morris, made Cobden-Sanderson the most famous English binder within a decade. Emery Walker, who nine years earlier had advised Morris in setting up the Kelmscott Press, became Cobden-Sanderson's partner in the bindery. Despite Walker as their common link, the Doves books look very different from the Kelmscott Press books (cat. no. 21) in their ascetic typography and rejection of excess ornament.

5

William Frend De Morgan
English, 1839–1917

Pair of Vases · ca. 1888–97

. . . .

Glazed earthenware with luster
46.4 x 17.2 cm diam. each (18¼ x 6¾ in.)
Inscribed on bottom in underglaze blue «DM/2289/18
FULHAM» and «DM/JH/2288/18/FULHAM»

Anonymous loan

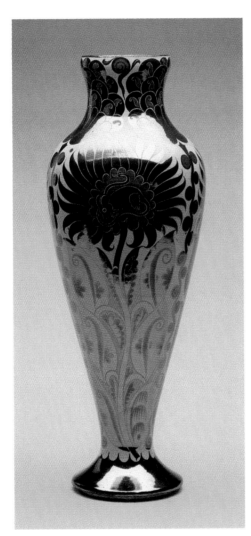

Christopher Dresser
English, 1834–1904

Minton and Company, manufacturer

Pair of Vases · 1868

. . . .

Glazed and gilded porcelain
19.1 x 12.7 cm diam. each (7½ x 5 in.)
Impressed on bottom «MINTON» and date code «G»

Anonymous loan

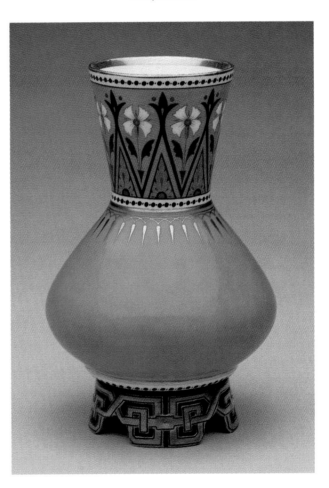

D E MORGAN'S «Persian-style» pottery has come to be recognized as a counterpart in ceramics to William Morris's textiles and wallpapers. After 1888, De Morgan produced some of his most ambitious experiments in luster decoration. The floral decoration of these vases is consistent with Morris's ideas about two-dimensional ornament and is adapted from De Morgan's study of Isnik pottery. Although the copper luster seen here was inspired by Hispano-Moresque ware, his distinctive palette was developed from Isnik examples. The initials «JH» stand for John Hersey or James Hersey, both decorators for De Morgan.

A S a free-lance designer for Minton and Company, Dresser matched his personal taste for Oriental pottery with the popular taste for the exotic. He decorated simple, elegant shapes with stylized floral and scroll decoration that was Far Eastern in inspiration. Known as «cloisonné ware», this decorative technique was developed by French ceramicist Eugène Collinot and mimics the intricate designs of enamelled cloisonné metalwork.

8

Christopher Dresser

Hukin and Heath, manufacturer

Soup Tureen, Cover, and Ladle · 1880

. . . .

Electroplated silver and wood
Tureen with cover 21 x 31.8 cm (8¼ x 12½ in.)
Ladle 31.8 x 7 x 8.3 cm (12½ x 2¾ x 3¼ in.)
Impressed on underside of tureen «2123», «Designed by
Dr. C. Dresser», and maker's mark for Hukin and Heath

Anonymous loan

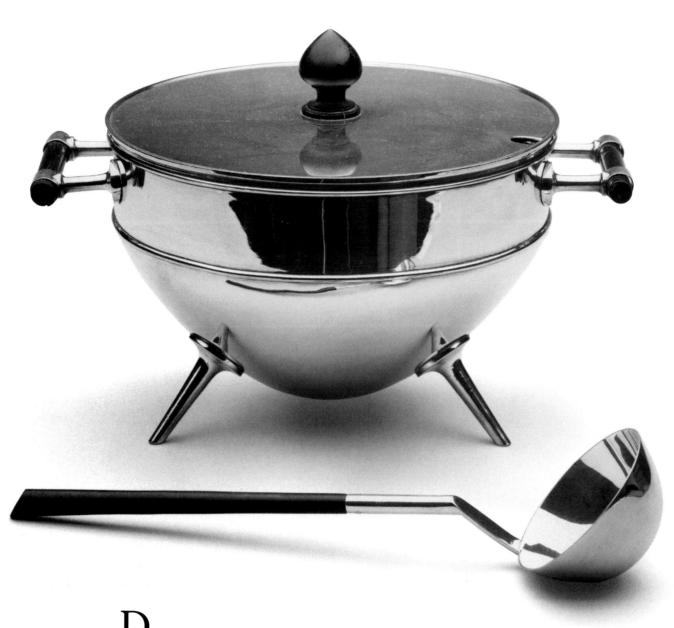

Dresser's designs for metalwork are his sparest. As seen in this tureen, Dresser's emphasis was on simple, usually geometric shapes and honest construction, well suited to industrial manufacture. Hukin and Heath also produced the tureen in a smaller size and it was available with wood or ivory handles.

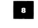

Christopher Dresser

James Couper and Sons, manufacturer

«*Clutha*» *Vase* · ca. 1883

· · · ·

Glass
22.9 x 10.8 cm diam. (9 x 4¼ in.)
Collection of Jerome and Patricia Shaw

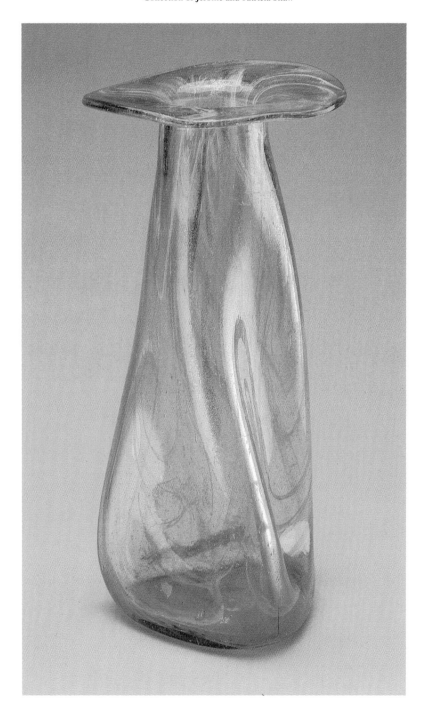

Dresser's designs for Clutha glass, produced by James Couper and Sons of Glasgow and retailed by Liberty's after 1883, revitalized British art glass by combining hand-blown but mass-production manufacturing techniques with the aesthetic sensibility of Roman and especially Venetian prototypes. Characterized by idiosyncratic shapes often related to Dresser's botanical studies, subtle yet daring color combinations that included the application of glass threads or luster patches, and novel textures that incorporated deliberate bubbles and streaks, no two vases are alike. Flakes of gold are included in this example. «Clutha», like «Tudric» and «Cymric», was a name probably invented by Liberty's; by their Gaelic sound they were meant to suggest Britain's national heritage.

10

**Vase with
Four Goat Masks**
26 x 21.6 cm diam. (10¼ x 8½ in.)
Impressed on bottom
«Chr Dresser» and «318»

Ewer
24.1 x 12.7 cm diam. (9½ x 5 in.)
Impressed on bottom «176»
and raised Ault mark

Large Handled Vase
50.8 x 33 cm diam. (20 x 13 in.)
Impressed on bottom «Chr Dresser»
and «247» and raised Ault mark

**Vase with
Four Grotesque Masks**
22.9 x 17.2 cm diam. (9 x 6¾ in.)
Impressed on bottom
«Chr Dresser» and «254»

**Vase with
Grotesque Masks**
30.5 x 22.9 cm diam. (12 x 9 in.)
Impressed on bottom
«Chr Dresser» and «248»

Christopher Dresser

Ault Pottery, manufacturer
English, 1886–present

Five Vases · 1892–96

. . . .

Glazed earthenware
Anonymous loan

Dresser's work for Ault Pottery followed the liquidation of the Linthorpe Art Pottery in 1899 but some Linthorpe shapes continued to be used. The bold designs and sometimes humorous imagery are a departure from Dresser's earlier designs for Minton and Company which were largely influenced by Japanese, Chinese, and other exotic models.

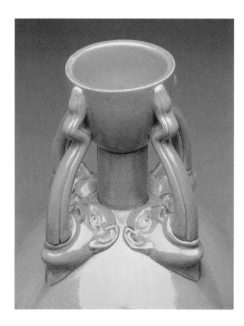

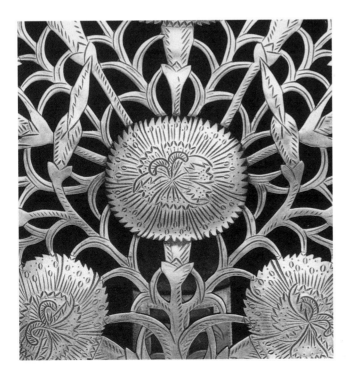

10

Ernest William Gimson
English, 1864–1919

Alfred Bucknell, maker

Pair of Firedogs • ca. 1904

. . . .

Steel
70.5 x 36.2 x 45.7 cm each (27¾ x 14¼ x 18 in.)
Anonymous loan

I
N 1894 Gimson moved to a
sixteenth-century cottage in Sapperton
in the Cotswolds. His interest in
local craft traditions led him to an
acquaintance with the Sapperton
blacksmith Alfred Bucknell who
produced firedogs and other metal
objects from Gimson's designs. These
finely cut and engraved pieces are
evidence of the success of this
collaboration.

11

Edward William Godwin
English, 1833–1886

**William Watt (Art Furniture Warehouse),
manufacturer**

Sideboard · designed ca. 1867,
this example made ca. 1876

· · · ·

Ebonized wood with glass, brass pulls and hinges
184.2 x 255.3 x 50.2 cm with leaves extended
(72½ x 100½ x 19¾ in.)
each leaf 47 x 50.2 cm (18½ x 19¾ in.)

Anonymous loan

GODWIN'S ebonized sideboard is one of the major monuments in the history of modern furniture. His approach, influenced by Japanese design, was a radical alternative to earlier Victorian design which often depended on surface embellishment. Writing in *The Architect* in 1876 (July 1, p. 5), Godwin stated: «I...set to work and designed a lot of furniture and with a desire for economy directed that it be made of deal, and to be ebonised. There were to be no mouldings, no ornamental metal work, no carving. Such effect as I wanted I endeavoured to gain, as in economical building, by the mere grouping of solid and void and by more or less broken outline.»

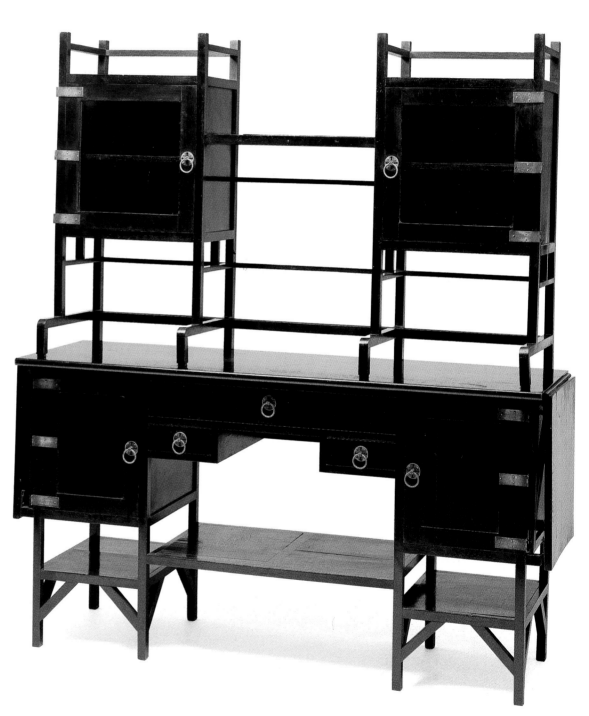

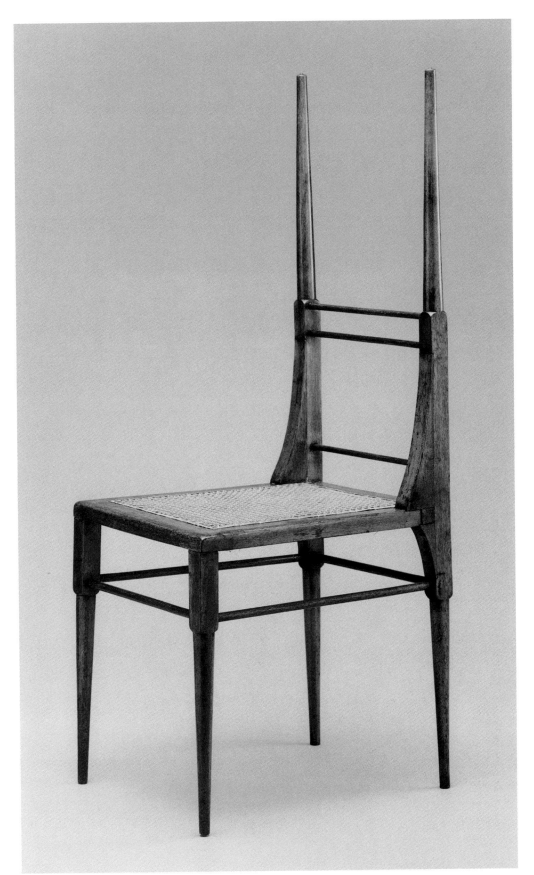

12

Edward William Godwin

Side Chair · ca. 1885

. . . .

Ash with caning
101 x 35.6 x 42.6 cm (39¾ x 14 x 16¾ in.)
Anonymous loan

THIS is a version of Godwin's so-called «Greek» chair, inspired by the designer's study of antiquities in the British Museum. It was also available in an upholstered version with turned decoration. On a small scale, the chair demonstrates Godwin's desire to articulate design through the use of line rather than surface decoration.

14

13

Liberty and Company
English, 1875–present

Archibald Knox, designer
English, 1864–1933

Clock · ca. 1901

. . . .

Pewter with abalone insets, copper hands and numerals
36.8 x 19.1 x 15.9 cm (14½ x 7½ x 6¼ in.)
Impressed on bottom «TUDRIC/097»

Anonymous loan

14

Liberty and Company

Archibald Knox, designer

Pair of Candelabra · 1905

. . . .

Pewter
28.6 x 23.5 x 13.3 cm each (11¼ x 9¼ x 5¼ in.)
Both impressed «ENGLISH PEWTER/MADE BY/LIBERTY & CO./0530»
one marked «Rd459548»

Collecton of Milford and Barbara G. Nemer

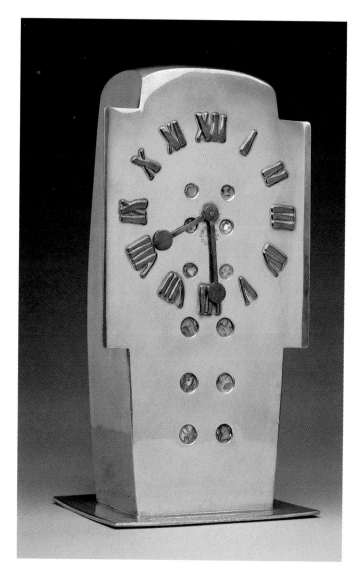

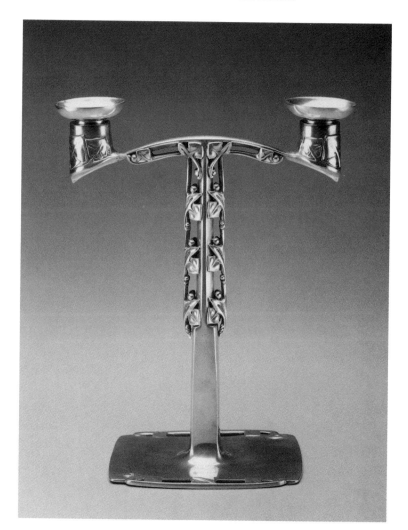

Iɴ contrast to many other British proponents of the Arts and Crafts movement, Liberty and Company subsumed the contribution of the individual craftsman or designer in its effort to create and market a house or «Liberty» style. One of many popular Liberty clock designs, this example is usually attributed to the metalworker Archibald Knox.

Iɴ 1899 Liberty's began marketing a line of silver known as «Cymric». In 1902 the pewter line «Tudric», containing a high proportion of silver, was introduced. The broad areas of undecorated metal and the use of colorful enamel in many of these products were undoubtedly influenced by Ashbee's earlier work with the Guild of Handicraft. While inspired by a continental revival of pewter, Liberty was careful to point out that the «Tudric» line was indebted to the Celtic tradition rather than the florid Art Nouveau, which was viewed with distaste by many in Britain.

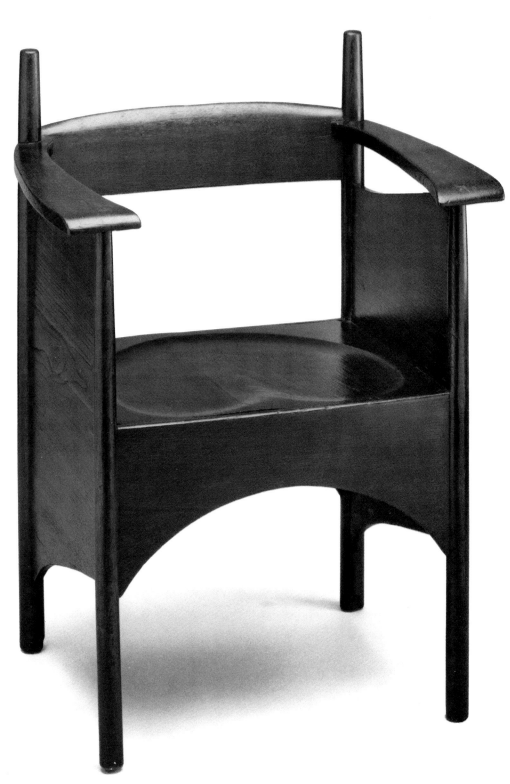

15

Charles Rennie Mackintosh
Scottish, 1868–1928

Pair of Armchairs · 1897

. . . .

Oak
83.2 x 62.2 x 45.7 cm each (32¾ x 24½ x 18 in.)
Anonymous loan

THIS chair was designed for the Smoking and Billiards Rooms of the Argyle Street Tea Rooms in Glasgow, in the same year as the Glasgow School of Art, Mackintosh's most important early commission. The simple, boxlike design is distinguished by subtle curves which shape the oak panels. A unique variant of the design (Hunterian Art Gallery, University of Glasgow) has knoblike finials on the rear posts. Mackintosh also designed a ladder-back version of the chair and one of his most famous designs, the highbacked chair with an oval crest rail, was also created for the Argyle Street Tea Rooms.

16

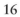

16

Charles Rennie Mackintosh

Armchair · 1902

· · · ·

Painted oak and upholstery
113.7 x 69.2 x 54.3 cm (44¾ x 27¼ x 21⅜ in.)
Anonymous loan

Iɴ 1902 Mackintosh was asked to decorate several rooms at 14 (now 34) Kingsborough Gardens in Glasgow. The delicate white furniture, such as this armchair, and stenciled walls produced for this commission mark a significant change in his work. A nearly identical chair was produced in the same year for Mackintosh's display at the Esposizione delle Arti Decorative in Turin in 1902.

17

Martin Brothers
English, active 1873–1914

Pitcher · 1890
· · · ·

Glazed earthenware
22.5 x 17.8 cm diam. (8⅞ x 7 in.)
Incised on bottom «R W Martin & Brothers/London & Southhall/9-1890»

Anonymous Loan

18

Bernard Moore
English, 1850–1935

Vase · ca. 1904
· · · ·

Glazed earthenware with luster
19.1 x 19.1 cm diam. (7½ x 7½ in.)
Inscribed on bottom in underglaze black «BERNARD/
MOORE» incised «1085»

Collection of Jerome and Patricia Shaw

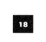

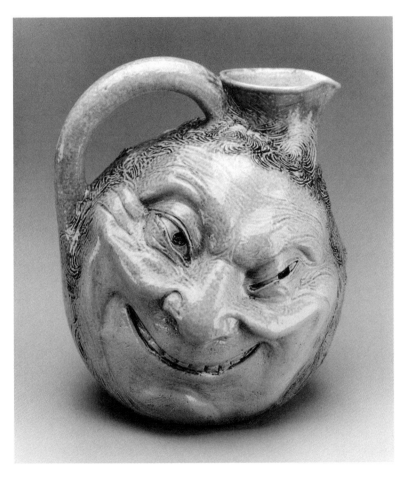

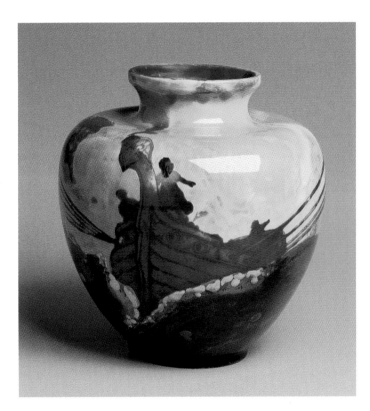

THIS grotesque yet amusing face jug was a popular early design of R. W. Martin, the eldest of the four Martin brothers and the primary designer of their distinctive line. A loose interpretation of the eighteenth-century «Toby» jug, the satyrlike features on the jugs from the early 1890s probably reflected Martin's interest in pagan imagery from Roman antiquity.

MOORE'S interest was in experimenting with glazes and decoration; by 1902 he had successfully produced *sang-de-boeuf* and flambé glazes of the kind seen on Chinese porcelain. On this vase, the decorative motif of a ship on a stormy sea with rolling waves is thought to have been derived from the work of William De Morgan; its multiple glazes with enamels and gilding demonstrate his mastery of complex glaze effects.

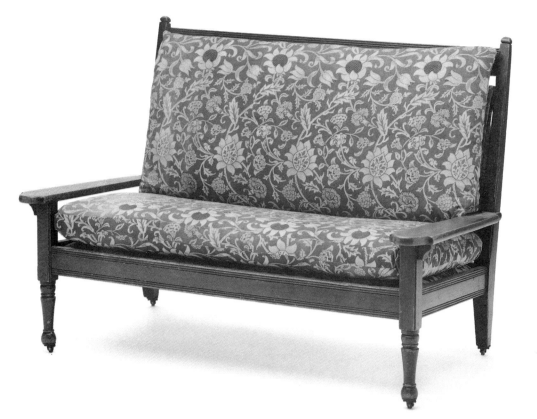

19

William Morris and Company
English, 1875–1940

W. A. S. Benson, designer (attributed)
English, 1854–1924

Settee · ca. 1880

· · · ·

Stained beech with metal casters and
cotton upholstery
85.1 x 119.4 x 74.9 diam. cm
(33½ h x 47 x 29½ in.)

Anonymous loan

Tʜᴇꜱᴇ pieces descended in the
family of T. M. Rooke, studio assistant
to Morris's collaborator, the painter
Edward Burne-Jones. The child's
chair (cat. no. 20) was given on the
occasion of the birth of Rooke's son
Noel in 1882. Morris distinguished
between «workaday furniture» and
«state-furniture...as elegant and
elaborate as we can [sic] with carving
or inlaying or painting». The settee
and the child's chair clearly belong in
the first category, appropriate to their
artisinal origin. A photograph of a
sitting room in Benson's home shows
a settee of the same design. The details
of these pieces are consistent with
furniture attributed to Benson in Morris
and Company's undated furniture
catalogue, *Specimens of Furniture,
Upholstery and Interior Decoration*,
probably published between about
1900 and 1910. The designs look
to practical, rural furniture of the
eighteenth century in a rejection of
contemporary late Victorian furniture,
which Morris saw as degraded in part
by overly mechanized production.

20

William Morris and Company

W. A. S. Benson, designer (attributed)

Child's Chair · ca. 1882

· · · ·

Painted beech with cotton upholstery
and wood casters
95.9 x 51.4 x 46.4 cm (37¾ x 20¼ x 18¼ in.)

Anonymous loan

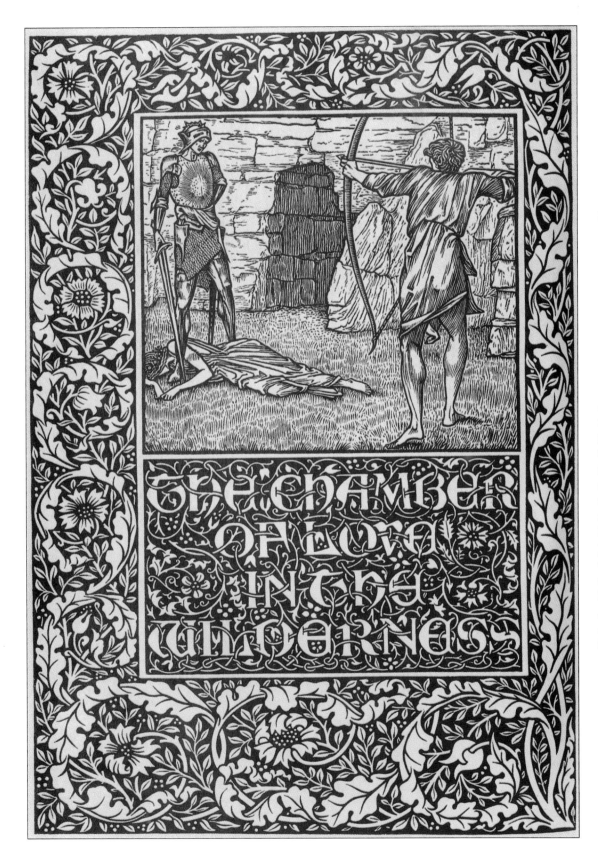

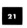

William Morris
English, 1834–1896
The Kelmscott Press

**William Morris,
The Well at the World's End ·** 1896

. . . .

Four illustrations designed by Edward Burne-Jones
and engraved on wood by William Harcourt
Hooper; eight borders and six ornaments
designed by William Morris
Set in Chaucer type and printed on «Flower»
unbleached handmade Batchelor paper
28 x 20.3 cm (11 x 8 in.)
Decorated binding, dated 1993, signed
«J. Franklin Mowery»
One of an edition of 350

Collection of Sheila and Jan van der Marck

Morris's facility for designing
two-dimensional ornament is
particularly evident in his work at
the Kelmscott Press. His designs for
foliate borders and letters are complex
and detailed, deliberately evoking the
conventions of medieval illuminated
manuscripts. The illustrations designed
by his friend and collaborator Burne-
Jones are chivalric scenes presented
within a shallow perspective that
does not contradict the flatness of the
borders. *The Well at the World's
End*, a romance set in the Middle
Ages, is considered to be Morris's
finest work of prose.

20

Lucien Pissarro

English (born in France), 1863–1944

The Eragny Press

Pierre de Ronsard, *Choix de Sonnets* · 1902

Pictorial title, border, 77 initial letters, and printer's device drawn by Lucien Pissarro
and engraved on wood by Lucien and Esther Pissarro
Set in Vale type and printed on Arches handmade paper
21.4 x 14.6 cm (8⅜ x 5¾ in.)
Publisher's binding, Hawthorn flower pattern paper over boards, signed «LP»; gilt lettering
One of 200 regular copies from an edition of 226 copies, including 26 *hors commerce*

Collection of Sheila and Jan van der Marck

Pissarro's interest in wood engraving was awakened by Auguste Lepère, a French virtuoso of that medium. Sent to England by his father, the painter Camille Pissarro, Lucien became friends with engravers Charles Ricketts, Charles Shannon, and T. Sturge Moore. In marked contrast to Ricketts's aesthetic (cat. no. 23), Pissarro's unrestrained, tapestrylike design approach is a continuation of the Gothic Revival books of William Morris's Kelmscott Press (cat. no. 21). This copy bears the signature of its former owner, French poet René Char.

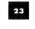

Charles Ricketts

English, 1866–1931

The Ballantyne Press

(Longus Sophistes), *Daphnis and Chloe. A most sweet and pleasant pastoral romance for young ladies, done into English by Geo. Thornley Gent* · 1893

Thirty-six illustrations and 102 initial letters engraved in wood by Charles Ricketts
and Charles Haslewood Shannon
Set in Caslon type and printed on Arnold's unbleached handmade paper
28.3 x 21 cm (11⅛ x 8¼ in.)
Decorated binding, dated 1993, signed «J. Franklin Mowery»
One of 200 regular copies from an edition of 210, including 10 *hors commerce*

Collection of Sheila and Jan van der Marck

This pastoral tale of young lovers was popular in both England and France at the turn of the century. Ricketts's volume is often considered the first British book of modern times in which type, illustrations, decoration, and paper are conceived as integral to the entire work and mutually supportive. This book deliberately followed the example, in Ricketts's own view, of the Venetian printers of the Renaissance, rather than the Gothic style of William Morris's Kelmscott Press. Its elegant, stylized design approach would shape the aesthetic of the Vale Press, founded by Ricketts three years later.

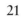

Detail

24

Moses Whittall and Company (attributed)
English, active late nineteenth century

Carpet · ca. 1900

. . . .

Wool
Woven into backing «Whittall's Anglo-Indian»,
stamped in black ink «189/264»
226.1 x 135.9 cm (89 x 53½ in.)

Collection of Bruce Szopo

THE design of the carpet with its stylized foliage is generally similar to the work of C. F. A. Voysey and other British designers of the late nineteenth and early twentieth centuries. The words «Whittall's Anglo-Indian» woven into the backing of the carpet suggest that it was produced in India for Moses Whittall and Company, listed as a carpet and rug manufacturer at the Stour Vale Mills, Exchange Street, Kidderminster in Worcester in 1885. Although not common, it is known that some British manufacturers had items made in Asia.

American

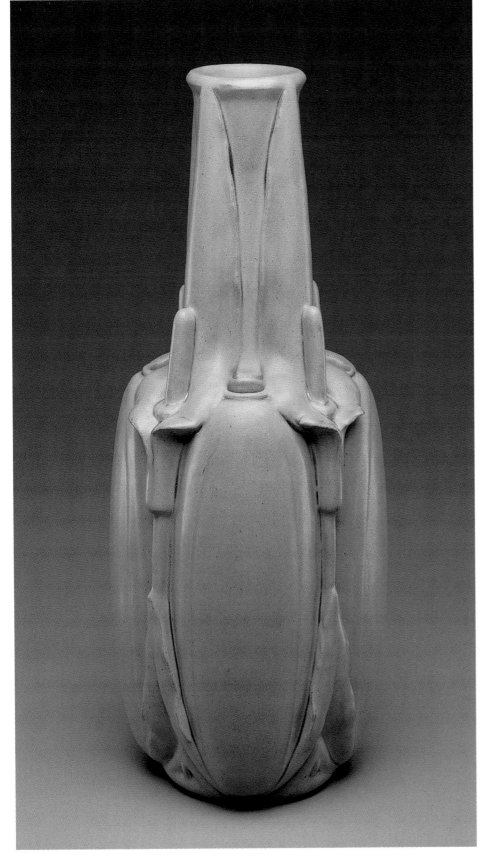

25

Gates Potteries
American, active 1890–1920

Fritz Albert, designer
American (born in Germany), 1865–1940

*«Teco»**Vase*** · ca. 1905

· · · ·

Glazed earthenware
43.2 x 17.8 cm (17 x 7 in.)
Inscribed on bottom «141», «Gates»; impressed twice «TECO»

Collection of Jerome and Patricia Shaw

THE art pottery line «Teco» was an outgrowth of the architectural terracotta business of Gates Potteries. William D. Gates himself took a particular interest in the line, designing many vessel forms and experimenting with glazes. The Teco line made its debut in the Chicago Architectural Club's 1900 exhibition. Club members, including architect Frank Lloyd Wright, subsequently designed some Teco ware which owed as much to abstract architectural concerns about space as to traditional ceramics. In this vase, Albert, a sculptor, created a highly plastic, bold relief design based on the calla lily.

Gorham Manufacturing Company
American, 1818–present

«Martelé» Presentation Ewer and Plateau · 1904

. . . .

Silver
Ewer 69.2 cm h. (27 ¼ in.);
plateau 6.4 x 50.2 cm diam. (2½ x 19¾ in.)
Ewer impressed marks on bottom «Martelé»/
spread-winged eagle/lion passant, anchor, «G»/
«950-1000 FINE»/«EZH»/«S» joined with «L»
Plateau marks the same, but without «EZH»

Collection of Masco Corporation

Tʜᴇsᴇ pieces are recorded in Gorham's records as EZH and EZI, completed on March 3, 1904. The ewer weighs 128.8 troy ounces and the plateau 116.16 ounces, both unusually heavy. The silversmith spent 89 hours on the ewer before the chasing specialist spent 548 hours on the surface. Beginning in 1900 Gorham referred to their handmade line with the word «martelé» (the French word for hammered) to convey the idea of individually crafted pieces. The impressive size and amount of time spent on the pieces, as well as the conjoined letters «S» and «L» indicate that the ewer and plateau represented Gorham at the Louisiana Purchase Exposition of 1904 in Saint Louis.

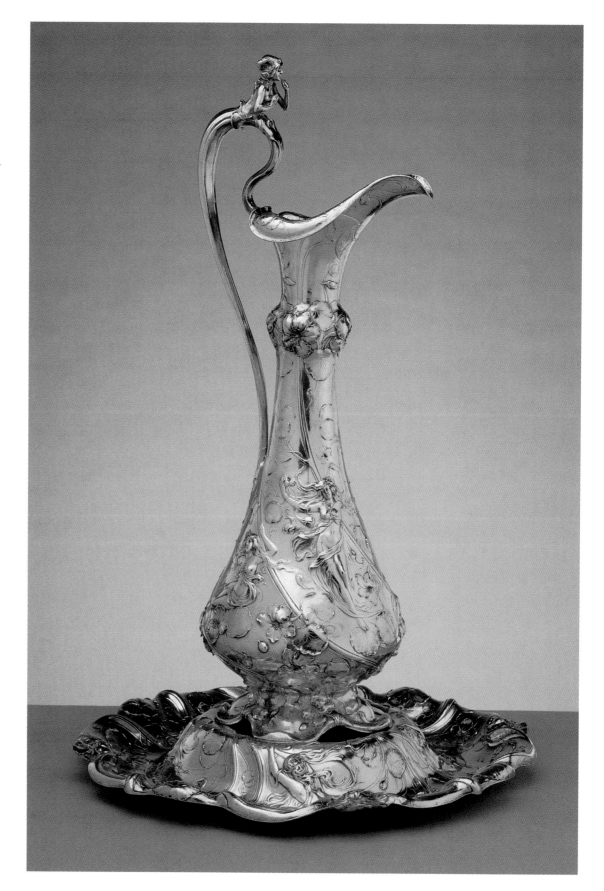

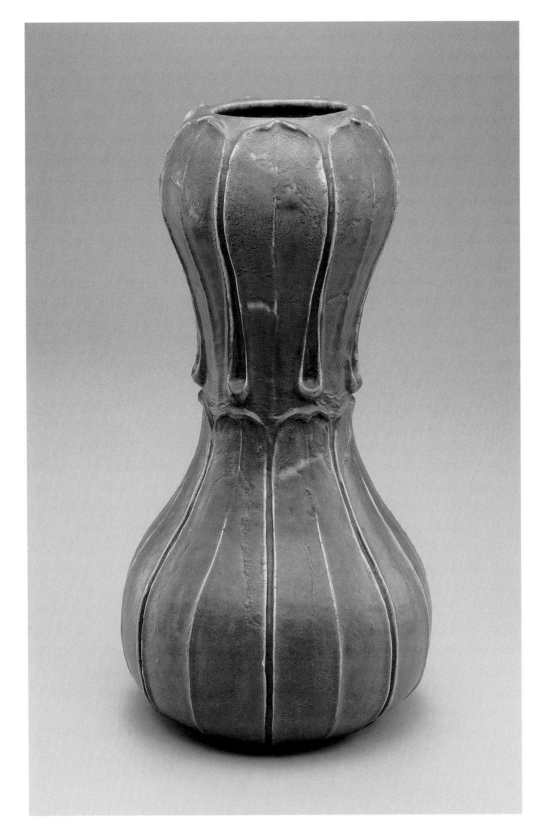

27

Grueby Faience Company
American, 1894–ca. 1920

George Prentiss Kendrick, designer
American, 1850–1919

Vase · ca. 1900

. . . .

Glazed earthenware
36.8 x 19.7 cm diam. (14½ x 7¾ in.)
Impressed on bottom «GRUEBY/BOSTON, MASS»

Collection of Jerome and Patricia Shaw

THIS vase epitomizes the successful
combination of the organic motifs
characteristic of the designs of Kendrick,
Grueby's first designer, and the matte glaze
(«Grueby green») for which William Henry
Grueby became famous. The flat leaf forms
modeled into the body emphasize the
verticality of the bold double gourd shape.
Grueby's restrained decorative schemes
were a welcome contrast to the ornamented
pottery common to the market.

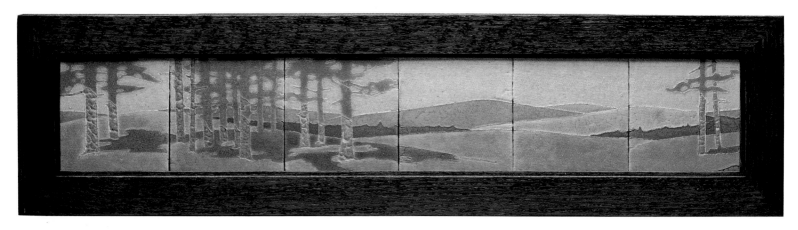

28

Grueby Faience Company

Addison Le Boutillier, designer
American (born in France), 1872–1951

Frieze «The Pines» · 1906

· · · ·

Glazed earthenware
26 x 103.5 cm (10¼ x 40⅝ in.);
tiles each 15.6 cm sq. (6⅛ in. sq.)

Collection of H. Gary and Melissa Lipton

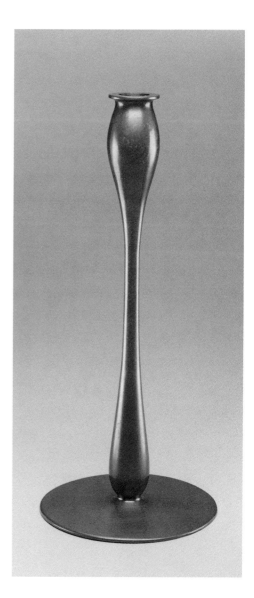

29

Robert Riddle Jarvie

American, 1865–1941

Pair of Candlesticks · 1905–17

· · · ·

Copper or copper alloy
34 x 14.9 cm each (13⅜ x 5⅞ in.)
Incised on bottom «Jarvie» signature, letter «I»
within an oval, and «18»

Collection of William and Patsy Porter

Wᴵᴸᴸᴵᴀᴹ Grueby's success was founded on the production of decorative ceramic architectural tiles. Originally produced with designs in historical styles, such as «Moorish», «Chinese», and «Italian Della Robbia», later tile designs drew motifs from the New England landscape. «The Pines», designed by Le Boutillier, an architect who succeeded Kendrick as chief designer in 1901, was a popular addition to the decor of Arts and Crafts homes. These examples were part of a fireplace frieze of fourteen separate tiles, a set of eight tiles flanked by two groups of three tiles each, which were sold for $75 on June 14, 1906, to George D. Mason, architect for the Fink house in Detroit. After their removal from the house, the two smaller groups were framed together to make this frieze.

Bᴇɢɪɴɴɪɴɢ in 1905 Jarvie designed and made more than sixteen candlestick models, each designated with a Greek letter; this model is the «iota». Like Stickley and other American Arts and Crafts designers, Jarvie's work is austere, with little or no decoration. The success of his pieces relies on strong, elegant proportions and carefully patinated surfaces.

Charles P. Limbert Company
American, active 1902–1944

Charles P. Limbert, designer
American, 1854–1923

Table with Oval Top (model no. 158) · ca. 1910

· · · ·

Oak
74.3 x 91.4 x 120.7 cm (29¼ x 36 x 47½ in.)
Under shelf Limbert brand and stencilled «158»

Collection of Arthur E. Woehrlen, Jr., and Sara Heikoff Woehrlen

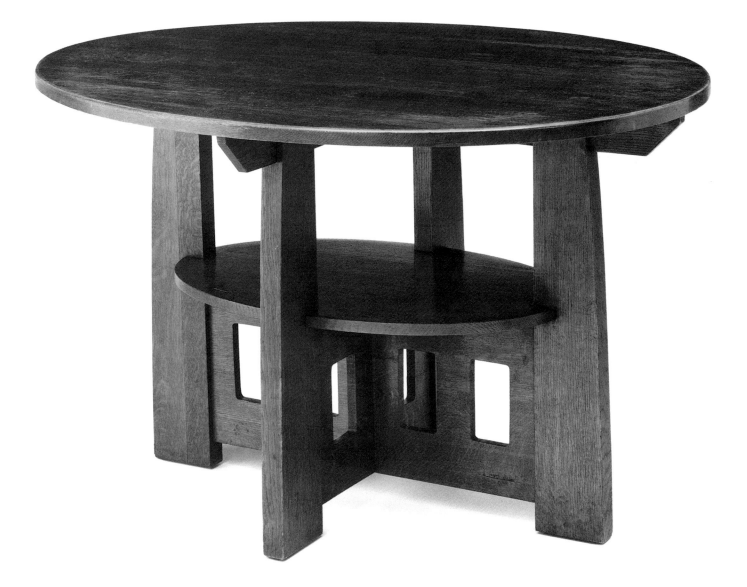

THE rectangles cut out of the stretcher of this table are characteristic of Limbert's work and are clearly derived from Charles Rennie Mackintosh's designs. His frequent use of parallel planes, oval and trapezoidal shapes, and pierced members sets Limbert's work apart from that of Stickley and most other American designers of the period.

28

Newcomb Pottery
American, active 1895–1940

Joseph Meyer, potter
American, 1848–1931

Harriet Joor, decorator
American, d. 1965

Vase · 1901

. . . .

Glazed earthenware
42.6 x 16.5 cm diam. (16¾ x 6½ in.)
Impressed on bottom «NC» monogram in blue, «Q»;
incised on bottom «HJ» monogram; inscribed in underglaze
blue «HJ» monogram, «D52»

Collection of Jerome and Patricia Shaw

«SIMPLE, big designs and firm drawing» were
the standards imposed on underglaze painting
by the head decorator, Mary Sheerer, at
Newcomb Pottery. This large vase, painted in
the characteristic cobalt blue of the pottery,
depicts lilies, one of the wild flowers of
the Southern landscape. The design is
conventionalized by the use of strong outline
and flat color, and the naturalistic rendering
of the flowers—by Joor, the daughter of a
botanist—forms a continuous, subtly varying
pattern which emphasizes the shape of the vase.

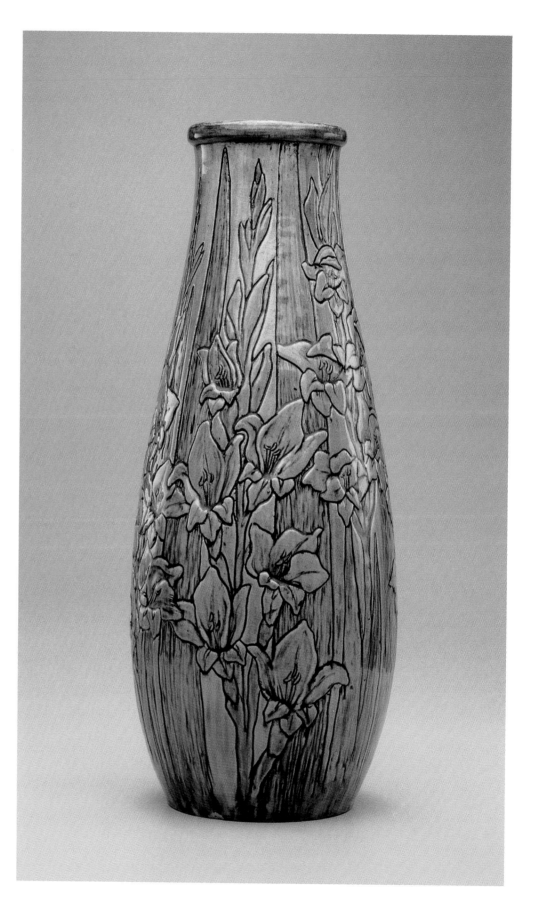

Pewabic Pottery

American, active 1900–present

Mary Chase Perry (Stratton)
American, 1868–1961

Vase · 1916–17

. . . .

Glazed earthenware
31.8 x 16.5 cm diam. (12½ x 6½ in.)
Two circular paper labels (2 cm, ⅞ in. diam.) on base, both printed in black
ink: «PEWABIC DETROIT»; on one handwritten in ink «MARY/CHASE/
STRATTON» and on the other «#1»

Collection of Thomas W. Brunk

Pewabic Pottery

Mary Chase Perry (Stratton)

Vase · 1917

. . . .

Glazed earthenware
22.9 x 13.3 cm diam. (9 x 5¼ in.)
Impressed circular mark on base «PEWABIC DETROIT» and
circular paper label (2 cm, ⅞ in. diam.) «PEWABIC DETROIT»
printed in brown ink

Collection of Thomas W. Brunk

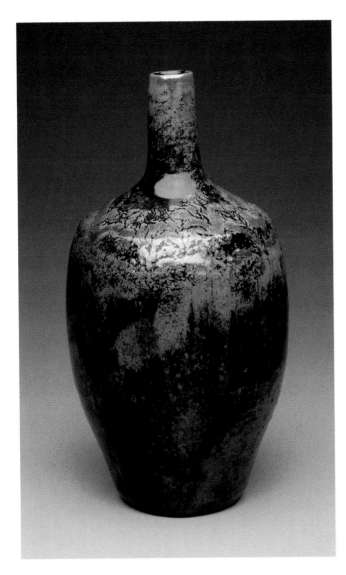

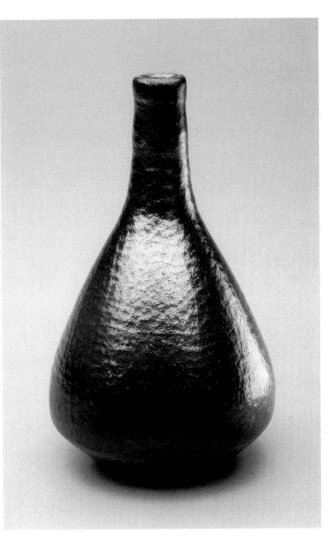

Mary Chase Perry and Horace J. Caulkins (1850–1923) together founded a pottery atelier in an old stable in Detroit around 1900. Encouraged by her friend Charles Lang Freer, one of this country's most noted collectors of Oriental art, Perry began to experiment with surface color and texture, eventually developing six iridescent glazes (blue-gold, rose, green, purple, yellow, and copper-red) for which the pottery would justly become famous.

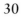

34

Frederick Hurten Rhead
American (born in England),
1880–1942

Roseville Pottery Company
American, active 1892–1954

«Della Robbia»
Vase • 1906–08
. . . .

Glazed earthenware
28.6 x 26.7 cm diam.
(11¼ x 10½ in.)
Incised outside above foot «GB»
and «H. Smith»

**Collection of Jerome and
Patricia Shaw**

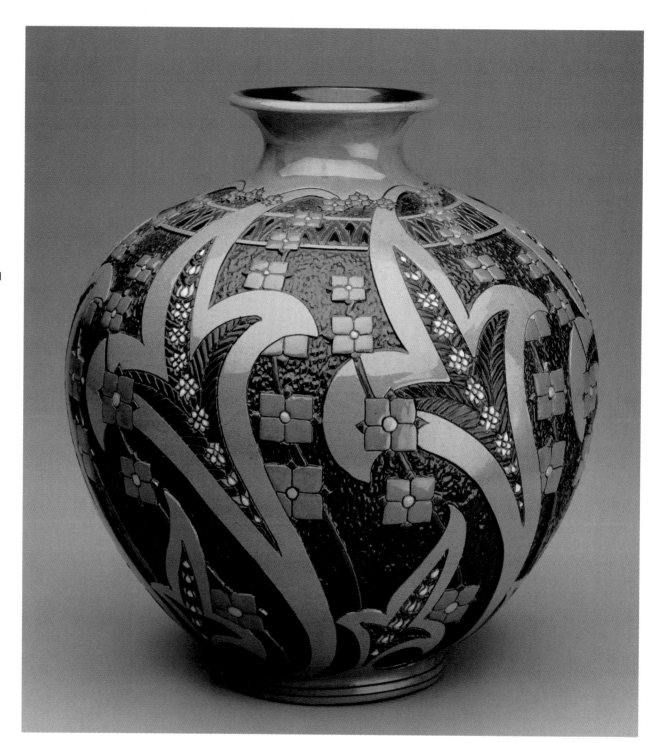

RHEAD developed the «Della Robbia» line for Roseville in 1905 and production began in 1906; this large, successful line encompassed as many as one hundred designs. Its name did not refer to the Italian Renaissance family of sculptors, famous for glazed earthenware reliefs, but rather to the Della Robbia pottery in Birkenhead, Staffordshire, known for its fine sgraffito designs. Simple vessel forms enlivened by organically inspired relief ornament that is complex and rhythmic are the hallmarks of this line.

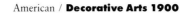
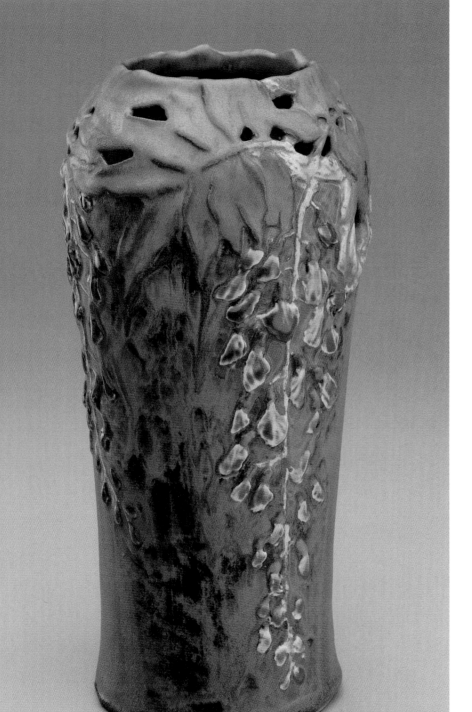

35

Frederick Hurten Rhead
Arequipa Pottery
American, active 1911–18

Vase · 1911–13

. . . .

Glazed earthenware
29.2 x 14 cm diam. (11½ x 5½ in.)
Indistinctly incised on bottom «AREQUIPA»

Collection of Jerome and Patricia Shaw

T HE naturalistic design of this vase, unusual
for Rhead, may stem from his association with
Adelaide Alsop Robineau, a designer with
whom he worked at the University City Pottery
prior to Arequipa. The wisteria stands out in
relief, balanced by broad undecorated areas.

Charles Rohlfs
American, 1853–1936

Desk on a Swiveling Base · ca. 1900

. . . .

Oak
142.6 x 65.4 x 62.9 cm (56⅛ x 25¾ x 24¾ in.)
Branded inside desk «R» within a bow saw

Collection of H. Gary and Melissa Lipton

THE furniture of Charles Rohlfs offers a lively alternative to the Arts and Crafts aesthetic promoted in America by Gustav Stickley and his followers. Using the same quarter-sawn oak preferred by these furniture designers, Rohlfs created complex pieces skillfully embellished with carving, open work, and shaped elements. The desk, one of only a few examples of this design known, swivels on the bracket-footed base. The four drawers on one end are balanced by a hinged cabinet door on the other. The table features some of Rohlfs's most muscular and accomplished carving, closer to Hector Guimard's metalwork designs than to most more delicate European Art Nouveau furniture.

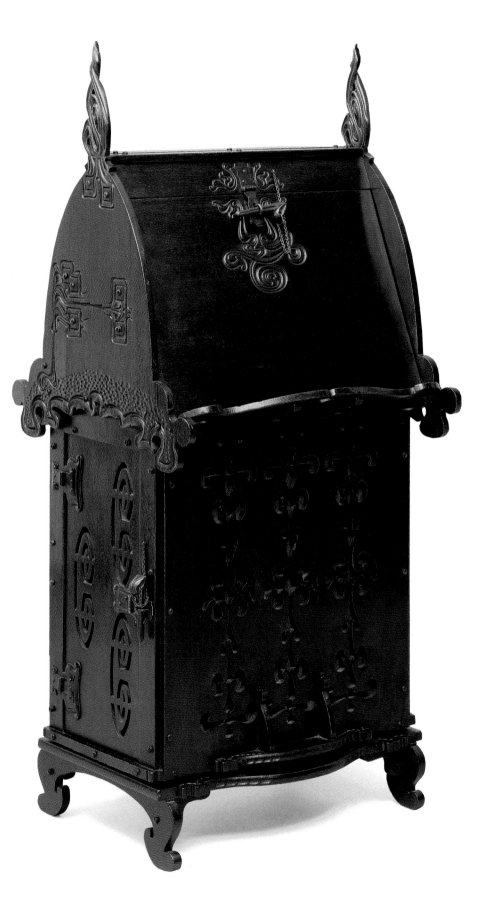

37

Charles Rohlfs

Library Table · 1907

· · · ·

Oak
76.8 x 152.4 x 91.4 cm (30¼ x 60 x 36 in.)
Branded outside apron «R» within a bow saw and «1907»

Collection of William and Patsy Porter

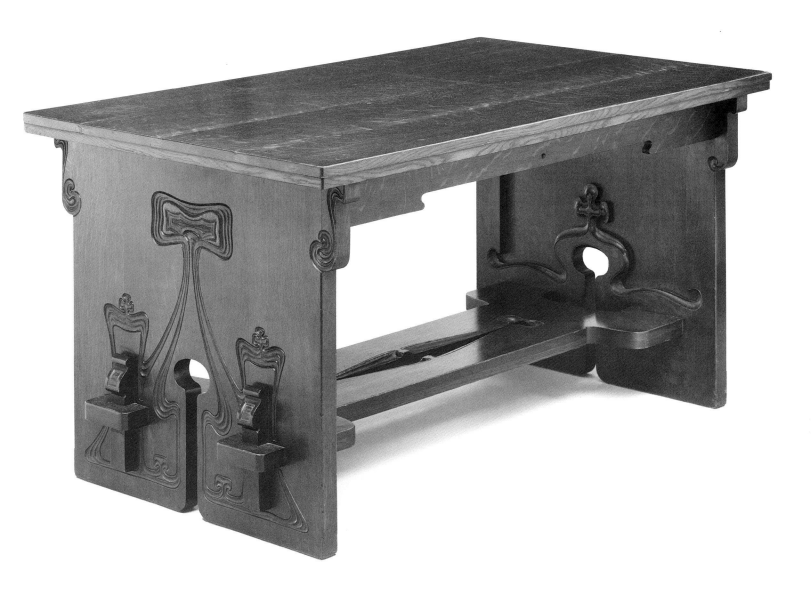

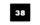

Rookwood Pottery
American, active 1880–1960

Kataro Shirayamadani, designer and decorator
American (born in Japan), 1865–1948

Vase with Copper Fish · 1900
. . . .

Glazed earthenware and copper
46.4 x 14.6 cm diam. (18¼ x 5¾ in.)
Impressed on base Rookwood mark for 1900, «804A», and Shirayamadani
in Japanese characters

Collection of Jerome and Patricia Shaw

T HE use of Japanese motifs, especially aquatic fauna, demonstrates an awareness of the international avant-garde at the generally conservative Rookwood operation. Shirayamadani, one of Rookwood's most talented designers, developed a complex method for electro-depositing copper or silver designs onto the vessel body; this method allowed the applied ornament to subtly merge with the surface patterning. The extraordinarily detailed modeling in metal of the carp and sea grasses is echoed by carved sea grasses on the upper third of the vase. The continuing swirl of bronze around the body of the vase contrasts with the softly tinted «Sea Green» glaze and makes for a particularly elegant and unified design (cat no. 38). In the dragon vase (cat. no. 39), the motif and the bold patterning of contrasting glaze colors are both drawn from Japanese sources. The sweep of the dragon's tail emphasizes the shape of the vase. Costly and labor-intensive, only a few works that incorporated electrodeposited elements were produced over a six-year period (1897–1903).

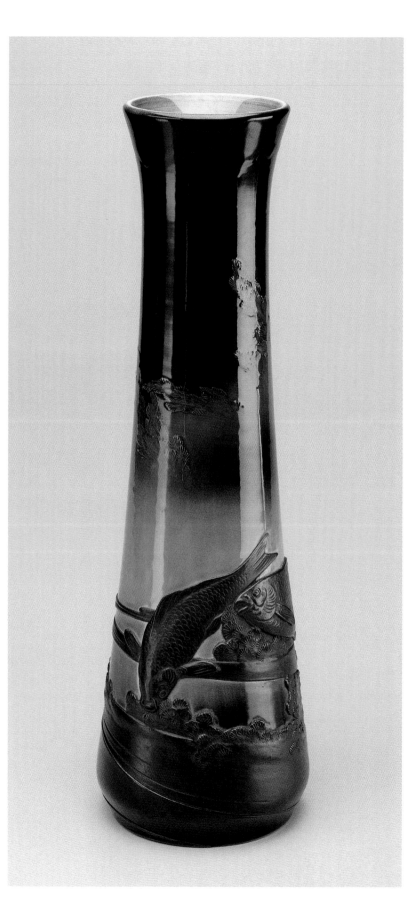

39

Rookwood Pottery

Kataro Shirayamadani, designer and decorator

Vase with Applied Dragon · 1900

· · · ·

Glazed earthenware and copper
29.2 x 19.7 cm diam. (11½ x 7¾ in.)
Impressed on base
Rookwood mark for 1900, «787C»,
and Shirayamadani in Japanese characters

Collection of Jerome and Patricia Shaw

36

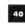

Rookwood Pottery

William Purcell McDonald, designer
American, 1865–1931

John Dee Wareham, designer
American, 1871–1954

***Plaque with Witches' Scene
from* Macbeth** · 1901

· · · ·

Glazed earthenware
95.9 x 65.4 cm unframed (37¾ x 25¾ in.)
Signed on front at lower left in raised letters
«William Purcell McDonald» and «John Dee
Wareham», incised in plaster on back «Nov. 1901»

Collection of Jerome and Patricia Shaw

Tʜɪꜱ large plaque was commissioned
for the Queen City Club, Cincinnati.
Its dramatic subject can be compared
to Rookwood ware of the previous
decade decorated with scenes of ghosts
and witches, but the granular surface,
glowing, subtly modulated color, and
large size are without clear precedent.

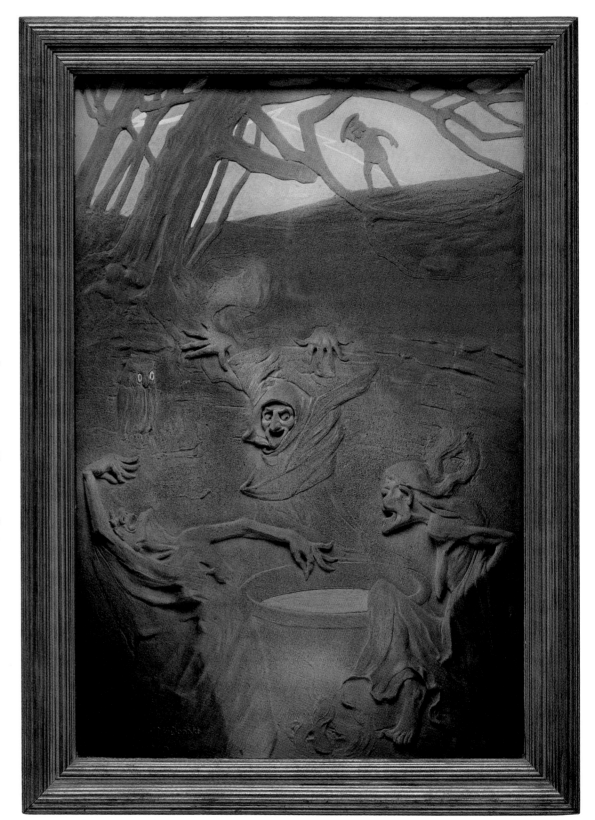

41

Roycroft Workshops
American, 1895–1938

Karl Kipp, designer
American, active ca. 1908–31

Pair of Candlesticks (model no. C-42) · ca. 1910

. . . .

Copper and silver
19.1 x 11.4 cm diam. each (7½ x 4½ in.)
Each impressed on rim of base with
Roycroft Workshops mark

Collection of David and Bobbye Goldburg

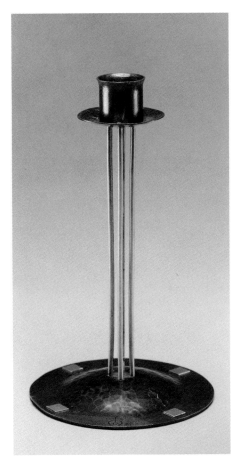

42

Roycroft Workshops

Side Chair («Special Chair» model no. 024) · ca. 1910–12

. . . .

Oak and leather
99.7 45.7 x 43.2 cm (39¼ x 18 x 17 in.)
Carved Roycroft Workshops mark on front seat rail

Collection of William and Patsy Porter

THIS chair was owned by Elbert Hubbard, founder of the Roycrofters, and it descended in his family. Although not unique, the «Special Chair» was an exceptionally expensive item at $75 while other side chairs in the 1912 Roycroft catalogue are priced at $10 or $11. The hand-embossed leather upholstery accounts for the high price and the rarity of this piece.

THE Roycrofters offered a variety of candlesticks and other objects in copper, of which this is one of the most sophisticated. The candle is held aloft by four silver rods rising from a hammered copper base decorated with four applied squares of silver. The appearance of the silver squares on the base suggests the influence of Wiener Werkstätte design, not surprising since the Roycroft designer Dard Hunter (1883–1966) was in Vienna in 1908 and 1910.

38

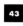

43

Gustav Stickley
American, 1857–1942

Craftsman Workshops
American, 1901–1915

China Cabinet · ca. 1901–02

. . . .

Oak with copper hardware
174.6 x 113.7 x 43.8 cm (68¾ x 44¾ x 17¼ in.)
On upper back large red decal
(Stickley in rectangle)

Collection of William and Patsy Porter

T HIS china cabinet with three
shelves visible behind glass doors
above hidden storage is an early,
uncatalogued design, apparently
never a production item. The large
strap hinges and the structural elements
are consistent with some of Stickley's
earliest work from about 1901.

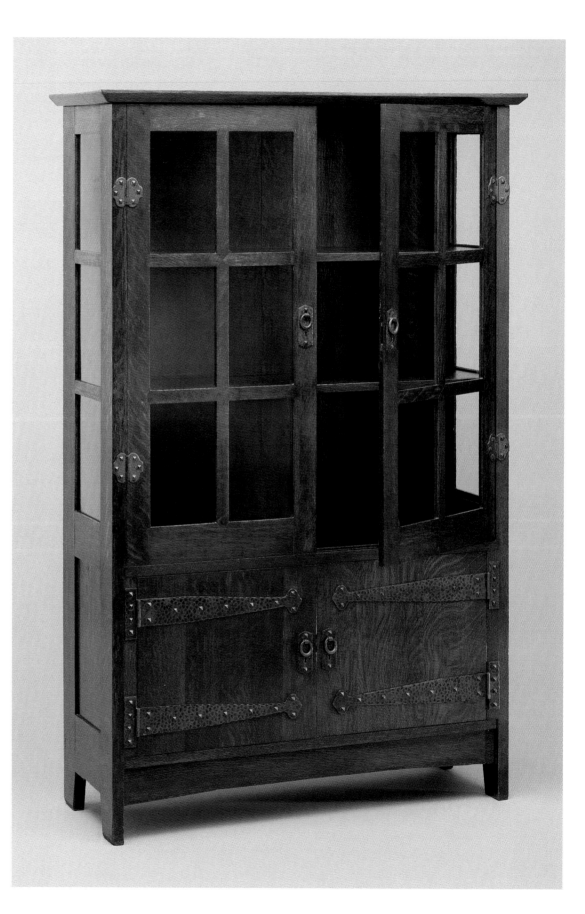

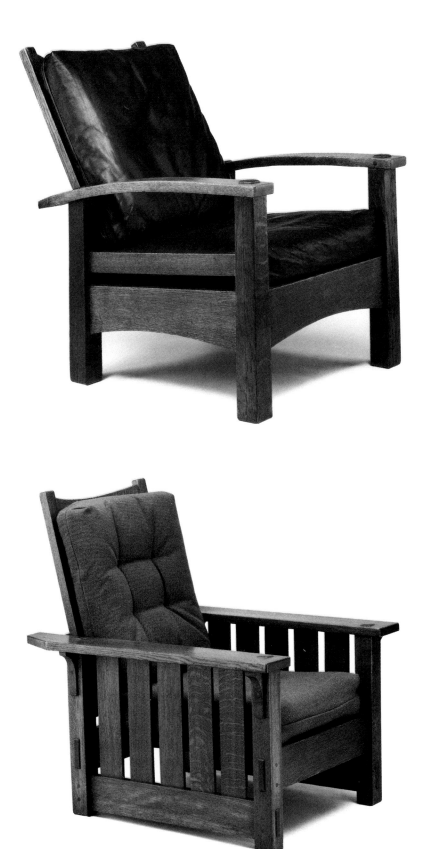

Gustav Stickley

Craftsman Workshops

***Bow Arm Reclining Chair
(model no. 2340)*** • ca. 1901

. . . .

Oak with leather upholstery
99.1 x 72.4 x 82.6 cm (39 x 28½ x 32½ in.)

**Collection of Arthur E. Woehrlen, Jr.,
and Sara Heikoff Woehrlen**

STICKLEY was granted a patent for this straight arm reclining chair in 1901, and it is likely the first so-called «Morris chair» that he designed. The paper label, preserved from 1905 on cat. no. 45, provides detailed information not usually available. The price of $33 indicates that the cushions were originally covered in leather. Stickley's 1904 catalogue gives the cost of the same chair with canvas cushions as $26.50. The version of the Morris chair with bowed arms, arched stretchers, and reverse tapered legs is one of Stickley's most successful early designs. The legs, broader at the floor than at the arms, anchor the piece to the ground while the arched elements provide a visual spring to the design.

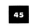

Gustav Stickley

Craftsman Workshops

***Reclining Chair
(model no. 332)*** • designed 1901,
this example produced 1905

. . . .

Oak
101.6 x 80 x 96.5 cm (40 x 31½ x 38 in.)
Outside rear stretcher «Gustav Stickley» red decal, inside
rear stretcher paper label printed «Craftsman Workshops/
Eastwood NY/Gustav Stickley/Serial no. 23063»; and
inscribed in ink «April 16, 1905 $33»

Collection of Bruce Szopo

46

Gustav Stickley
Craftsman Workshops

Sideboard with Open Shelf (model no. 955) · ca. 1901–02

· · · ·

Oak
112.1 x 153 x 62.9 cm (44¼ x 60¼ x 24¾ in.)
Collection of William and Patsy Porter

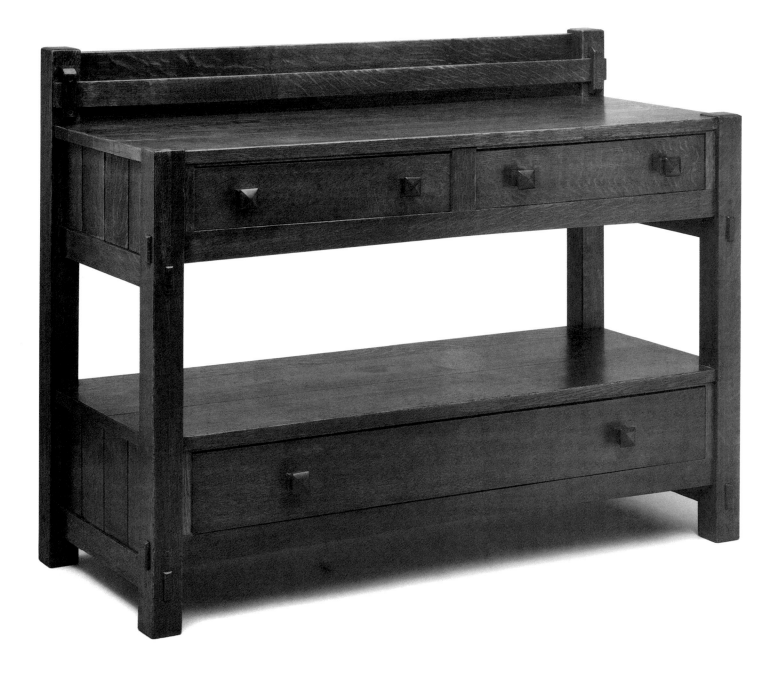

47

Gustav Stickley

Craftsman Workshops

Sideboard (model no. 967) · ca. 1901–02

. . . .

Oak with iron hardware
111.1 x 152.4 x 60.3 cm (43¾ x 60 x 23¾ in.)

Collection of William and Patsy Porter

THESE are two of Stickley's earliest sideboard designs. The example with two drawers above an open shelf and a single long drawer is illustrated in *The Craftsman* magazine of July 1902 (p. 204) and it appears again in the 1902 retail plates with the piece with hinged doors below. In addition to the characteristically massive proportions, the large square knobs are found in wood and metal on pieces dating from 1901 to 1903.

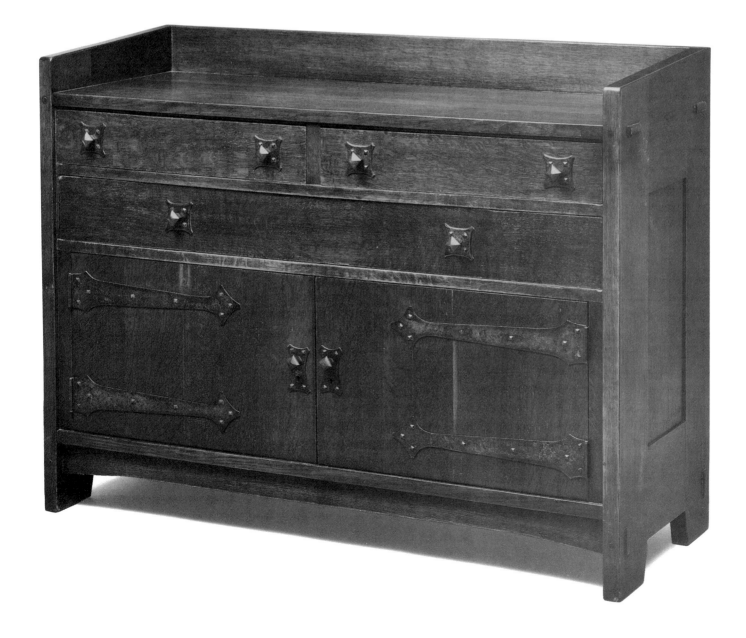

42

48

Gustav Stickley

Craftsman Workshops

Dining Table · ca. 1901–02

. . . .

Oak
76.2 x 150.5 cm diam. of top (30 x 59¼ in.)

Collection of Thomas and Marianne Maher

THIS fixed-top dining table does not appear in any of Stickley's literature, but it can be compared to the smaller table (model no. 441) illustrated in the 1902 retail plates. The flaring stretchers and the pyramidal finial clearly date this piece to the early Craftsman period. Stickley made a variety of dining tables throughout his career, mostly extension tables. The size of this example and the overhang of the top indicate that it was intended for the dining room rather than the library.

49

Gustav Stickley

Craftsman Workshops

**Pair of Side Chairs
(model no. 1299)** · ca. 1901–02

. . . .

Oak with rush seats
89.9 x 45.7 x 47.6 cm each
(35⅜ x 18 x 18¾ in.)
Inside rear leg red decal
(joiners compass outlined)

Collection of Bruce Szopo

FIRST published in *Chips from the Workshops...* in 1901, this design is known as the «Thornden Chair». The broad stretchers and the proportions of this chair are characteristic of the early period, but the same basic design continues throughout Stickley's entire production.

Gustav Stickley
Craftsman Workshops

Library Table with Arched Stretchers (model no. 407) • ca. 1901–02
. . . .

Oak, leather, and brass
76.8 x 121.9 cm diam. of top (30¼ x 48 in.)
Under top large red decal (Stickley in rectangle)

Collection of William and Patsy Porter

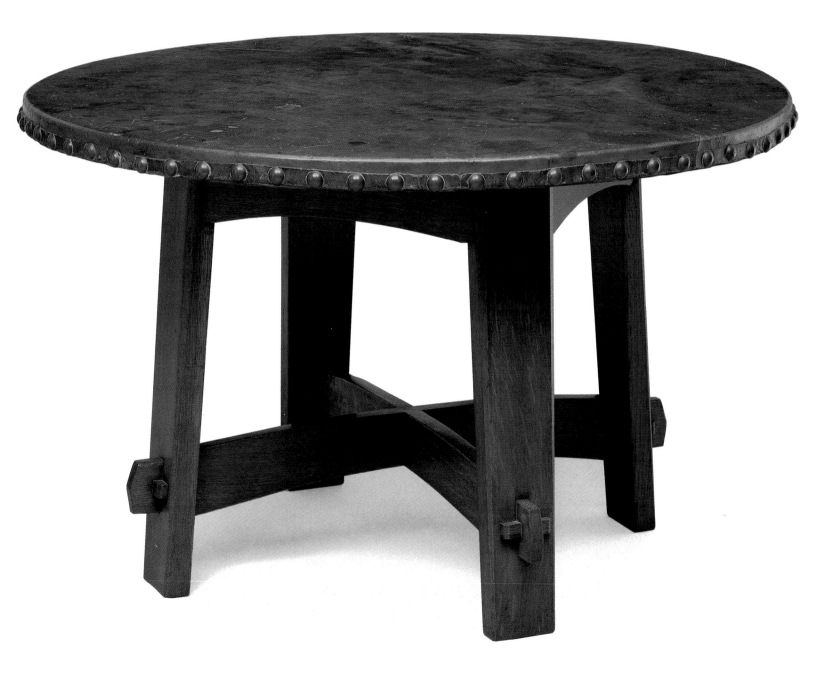

44

Tʜᴇꜱᴇ two early examples (cat. nos. 50 and 51) appear in line drawings on the same page of *Chips from the Workshops...*, published by Stickley in 1901. The success of these pieces lies in the shaped stretchers, the proportions, and such visible structural details as the tenon-and-key fastenings of model no. 407 (cat. no. 50) and the faceted dowel which fixes the stretchers of model no. 420 (cat. no. 51). Perhaps more than any other form, the leather-covered oak library table with brass nails epitomizes Gustav Stickley's Craftsman furniture.

51

Gustav Stickley
Craftsman Workshops

Library Table (model no. 420) · ca. 1901

· · · ·

Oak, leather, and brass
74.3 x 108.6 cm diam. of top (29¼ x 42¾ in.)
Collection of Thomas and Marianne Maher

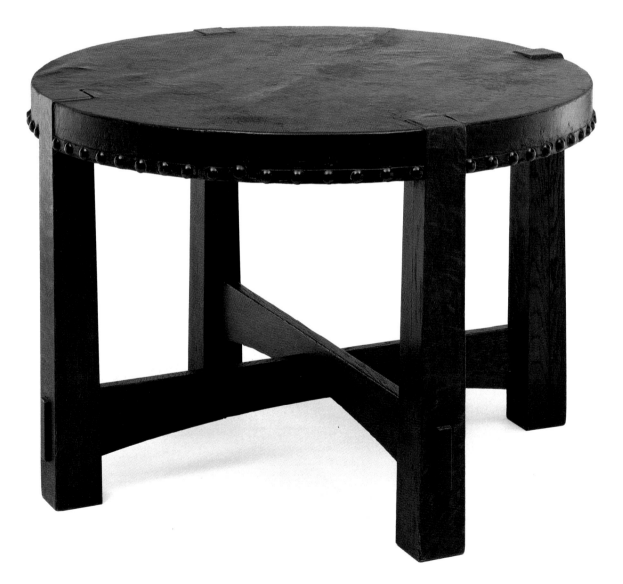

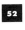

52

Gustav Stickley

Craftsman Workshops

Window Seat (model no. 177) · ca. 1901–02

· · · ·

Oak and leather
66 x 68.6 x 48.9 cm (26 x 27 x 19¼ in.)
Inside leg red decal (Stickley in rectangle)

Collection of Randall and Patricia Reed

THE prominent inverted V-shaped arch of this small window seat is one of the hallmarks of Stickley's early period (1901-04). First illustrated in a line drawing in Stickley's 1901 catalogue *Chips from the Workshops...*, the window seat demonstrates that not all products of this period are of massive proportions. The exposed tenons are a characteristic detail used throughout Stickley's career.

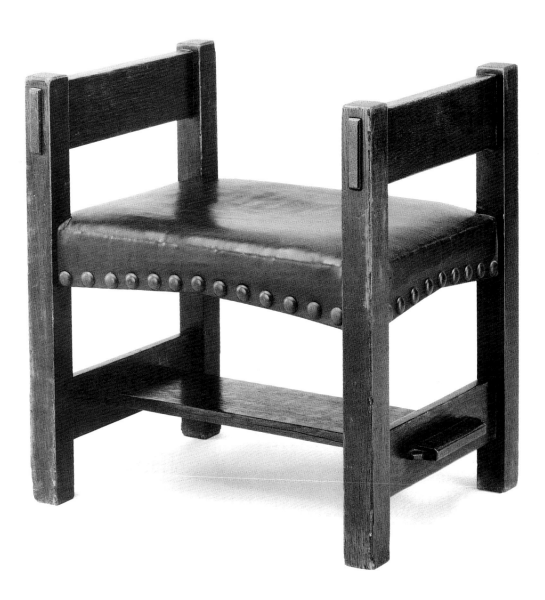

THIS unusually small settle bears fine inlaid decoration. On the interior and exterior of the side slats the design consists of four trees and a yellow road while the back slats show a similar design with a single tree. Ellis presumably adopted the concept of decorating a wide panel of oak with figurative inlay from furniture of the British Arts and Crafts movement.

53

Gustav Stickley
Craftsman Workshops
Harvey Ellis, designer
American, 1852–1904

Settle · 1903
. . . .

Oak with inlay of wood and pewter
77.5 x 127 x 68.6 cm (30½ x 50 x 27 in.)
On lower back red decal (Stickley in rectangle)
Collection of William and Patsy Porter

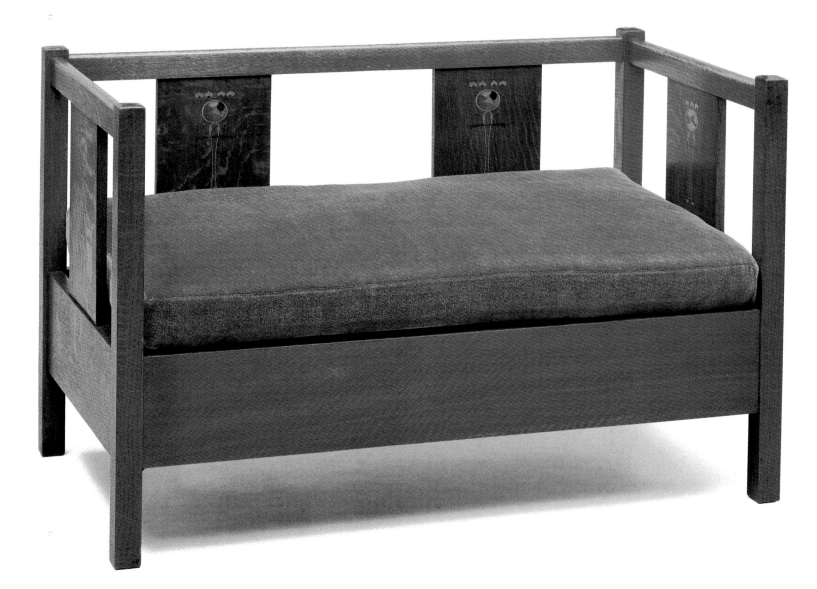

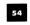

Gustav Stickley

Craftsman Workshops

Harvey Ellis, designer

Fall-Front Desk • 1904

. . . .

Oak with inlay of wood, copper, and pewter
111.8 x 76.8 x 32.7 cm (44 x 30¼ x 12⅞ in.)
On rear red decal «Gustav Stickley»

Collection of H. Gary and Melissa Lipton

Fall-front desks were produced from the beginning of Craftsman Workshops. The elegant proportions, the use of stylized floral inlay, and the absence of such structural elements as the exposed tenon are all indicative of Harvey Ellis's role as the designer of this piece.

55

Gustav Stickley

Craftsman Workshops

Harvey Ellis, designer

***Double-Door Bookcase
(model no. 702)*** · ca. 1904–06

· · · ·

Oak

147 x 115.9 x 36.2 cm (57⅞ x 45⅝ x 14¼ in.)

Inside left red decal «Gustav Stickley»

Collection of H. Gary and Melissa Lipton

Tʜɪs double-door bookcase is characteristic of Harvey Ellis's work for Stickley. The broadly arched apron, the overhanging top, the applied columns and capitals, the leaded glass and the absence of hardware all represent a departure for Craftsman furniture which had previously been primarily concerned with expressing structural elements.

56

Gustav Stickley
Craftsman Workshops

Electric Table Lamp with Wicker Shade (model no. 502) · ca. 1905

. . . .

Oak, wicker, silk, and copper
45.7 x 33 cm diam. (18 x 13 in.)
Stamped in copper disc under base: joiner's compass with «Als ik kan»

Collection of D. DeCoster

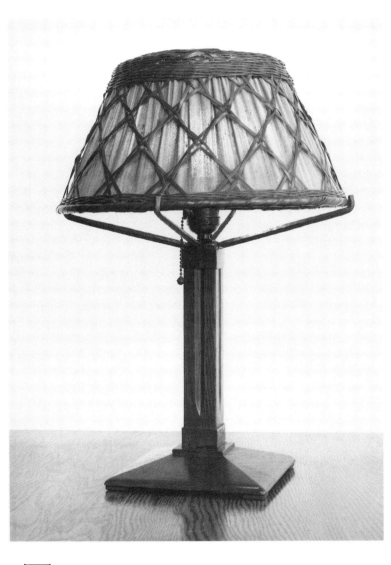

57

Gustav Stickley
Craftsman Workshops

***Two Light Electric Bracket Fixture (model no. 224) and
Lantern (model no. 205 1/2)*** · ca. 1905
(Lantern not illustrated)

. . . .

Copper, glass, and iron
Bracket Fixture 47 x 41.9 x 20.3 cm (18½ x 16½ x 8 in.)
Lantern 43.2 x 24.1 cm diam. (17 x 9½ in.)

Collection of D. DeCoster

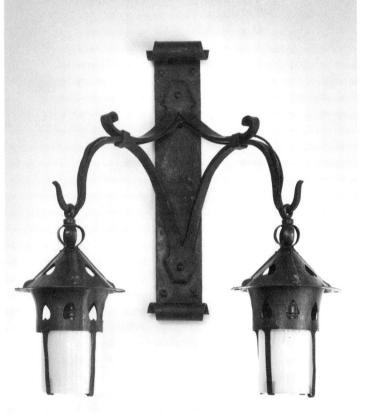

Tʜᴇ most common form of American Arts and Crafts lamp has a squared vertical post of oak on a square base. The shade is often a square oak frame inset with glass panels. Stickley's version is somewhat more refined than the ordinary lamp, with a channel carved in each face of the post and hammered copper bands. The wicker shade is original, but the silk lining, originally available in green, red, yellow and orange, is a replacement.

Tʜᴇsᴇ lanterns with heart-shaped cut-outs are among Stickley's most common designs for lighting. The customer had a choice of opalescent, crystal, or amber glass. The evidence of hand working, seen in the hammer marks on the copper surface, was central to the Arts and Crafts concept of the well-made object.

50

58

Gustav Stickley

Craftsman Workshops

Rug • ca. 1910

· · · ·

Hemp with cotton warp
3.7 x 3.1 m (12 x 10 ft.) including fringe
Collection of William and Patsy Porter

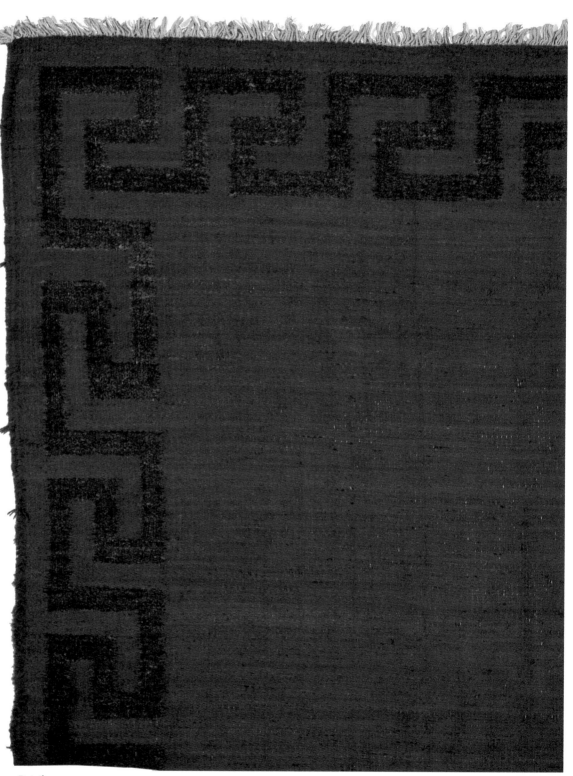

STICKLEY advertised that his rugs were woven in India of heavy bullocks' wool. This example, however, is woven in hemp, likely also an Indian product, perhaps intended for semioutdoor use such as on a porch. The Greek key pattern of this example is typical of Stickley's so-called «Drugget» rugs, but the combination of dark green and red is unusually vibrant.

Detail

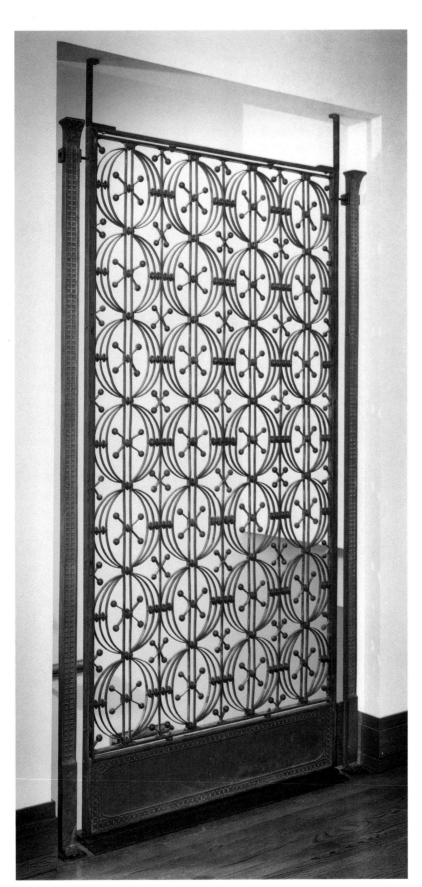

59

Louis Sullivan
American, 1856–1924

The Winslow Brothers Company, manufacturer

Elevator Grille with Side Bars from the Chicago Stock Exchange Building · 1893–94

· · · ·

Iron
213.4 x 121.9 cm (84 x 48 in.)
Collection of David and Bobbye Goldburg

THE Chicago Stock Exchange Building, designed by the firm of Adler and Sullivan, is one of the most significant buildings in the history of American architecture. Demolished in 1972, the thirteen-story Stock Exchange was a key example of the firm's pioneering tall metal-framed buildings. Lively ornamental ironwork, such as this geometric grille, was integral to Sullivan's vision of what he called «organic architecture».

Louis Sullivan

*Window from
Henry Babson House* · 1907

. . . .

Leaded glass in painted wood frame
128.9 x 84.1 x 5.7 cm (50¾ x 33⅛ x 2¼ in.)
Collection of Janis and William M. Wetsman

THE large house built for Henry Babson in Riverside, Illinois, was the first residence designed by Sullivan in nearly twenty years. It has been remarked that the spatial organization of the interior of the Babson house (now destroyed) did not betray the influence of Sullivan's former assistant, Frank Lloyd Wright. In the window design, however, Wright's influence is strong. Sullivan's earlier tendency to use organic forms has been abandoned here in favor of an entirely geometric approach that recalls Wright's designs for windows.

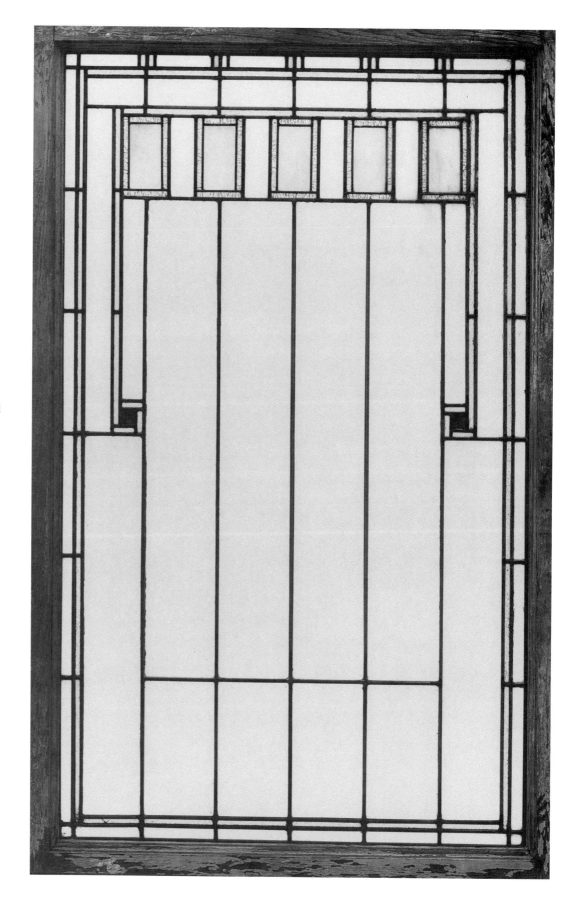

Tiffany and Company
American, 1837–present

Punch Bowl · ca. 1880

. . . .

Silver and silver-gilt
30.5 x 44.5 cm diam. (12 x 17½ in.)
«TIFFANY & Co/6175 MAKERS 7457/STERLING-SILVER/925-1000/M/29 ᴘᴛꜱ»

Collection of Masco Corporation

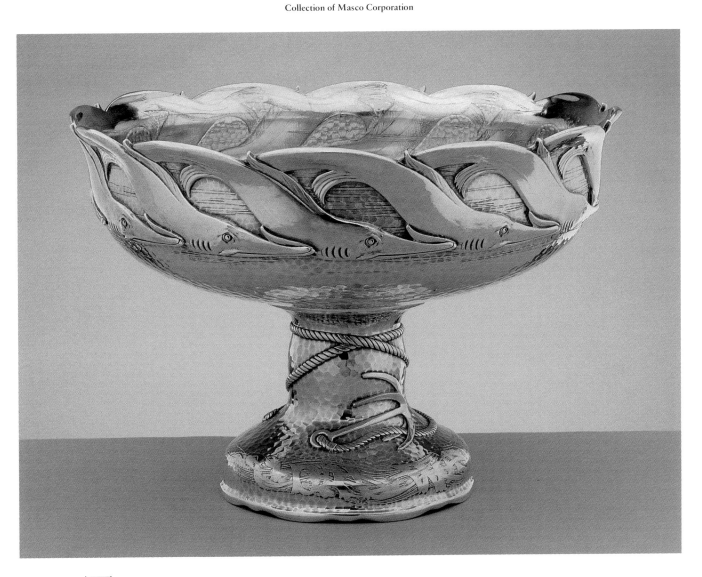

The words «Tidal Wave» which appear in the wave pattern on this punch bowl likely refer to the racing yacht of that name. A frieze of dolphins is chased around the rim on a hammered surface. A rope coils around the stem of the bowl, terminating in an anchor resting on the base. Documents in the Tiffany and Company archives reveal that number 7457 was the first order of pattern no. 6175. The next order was the well-known Buck Cup, dated 1881, in the collection of the New York Yacht Club, which differs slightly as a water bug and crab appear on the base in place of the rope and anchor. The mark «M» stands for Edward C. Moore, President of Tiffany and Company from 1875 to 1891. Usually credited with the success of the company, Moore was a collector of Japanese art and promoted the strong influence of Japanese design which can be seen here and in other Tiffany products of the period.

54

UNFORTUNATELY, the original location of this elaborate bench is not known. It conforms generally, however, with the New York interiors created by Tiffany before about 1900, the best known of these being the home of Henry O. Havemeyer (created between 1890 and 1892). In keeping with Tiffany's fondness for medieval sources, the pattern of the top of the bench is derived from twelfth-century Italian «Cosmatesque» pavements.

Detail

62

Louis Comfort Tiffany
American, 1848–1933

L. C. Tiffany and Associated Artists or
Tiffany Glass and Decorating Company

Bench · ca. 1880–1900
. . . .

Glass, stone, and bronze
48.3 x 205.7 x 38.1 cm (19 x 81½ x 15 in.)
Collection of Jerome and Patricia Shaw

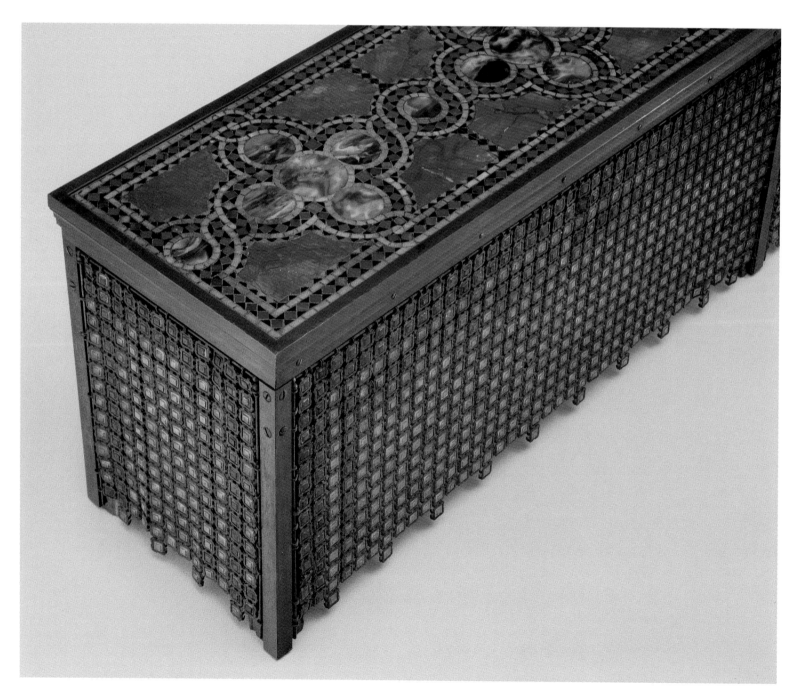

Louis Comfort Tiffany

Tiffany Glass and Decorating Company

Vase · ca. 1896

· · · ·

Glass
42.6 x 18.4 cm diam. (16¾ x 7¼ in.)
Engraved on bottom «X-1209» and circular paper label with monogram
of the Tiffany Glass and Decorating Company surrounded by the words
«TIFFANY FAVRILE GLASS REGISTERED TRADE MARK»

Collection of William and Patsy Porter

Louis Comfort Tiffany

Tiffany Glass and Decorating Company

Bowl · 1892–93

· · · ·

Glass
17.2 x 27.6 cm diam. (6¾ x 10⅞ in.)
Engraved on bottom «5558 LCT»

Collection of William and Patsy Porter

TIFFANY'S first blown-glass vessels of the 1890s are among his greatest contributions. Probably inspired by Emile Gallé, Tiffany began to explore the coloristic and sculptural possibilities of the material he called Favrile glass. The engraved number «5558» on the bowl allows us to date the piece to the very first years of Tiffany's work in blown glass. He did not publicize his achievements until 1894; the extraordinary fluidity of the bowl conveys the excitement of this experimental period. Probably dating to about 1896, the large vase (bearing the number «X–1209») has a symmetrical pattern and a firmly defined shape. A vase acquired by the Cincinnati Art Museum in 1897 (acc. no. 1897.111) bears the preceding engraved number «X–1208».

56

65

Louis Comfort Tiffany

Tiffany Studios

Table Lamp • 1900–05
· · · ·

Leaded glass, bronze, and glass mosaic
85.1 x 63.5 cm diam. (shade) (33½ x 25 in.),
45.7 cm (18 in.) diam. at base

Anonymous loan

Tiffany began making lamps with leaded-glass shades shortly before 1900, but this now-famous aspect of the business did not proliferate until the first decade of the twentieth century. Many of the lamp designs are based on floral motifs. This large and richly decorated example, known as the Lotus Lamp, at $750 was the highest-priced model offered in Tiffany's 1906 list. It has been said that it was too costly for the company to keep more than one in inventory, so another lamp was not made until the one in stock was sold. As a consequence it is one of the rarest of Tiffany's lamps.

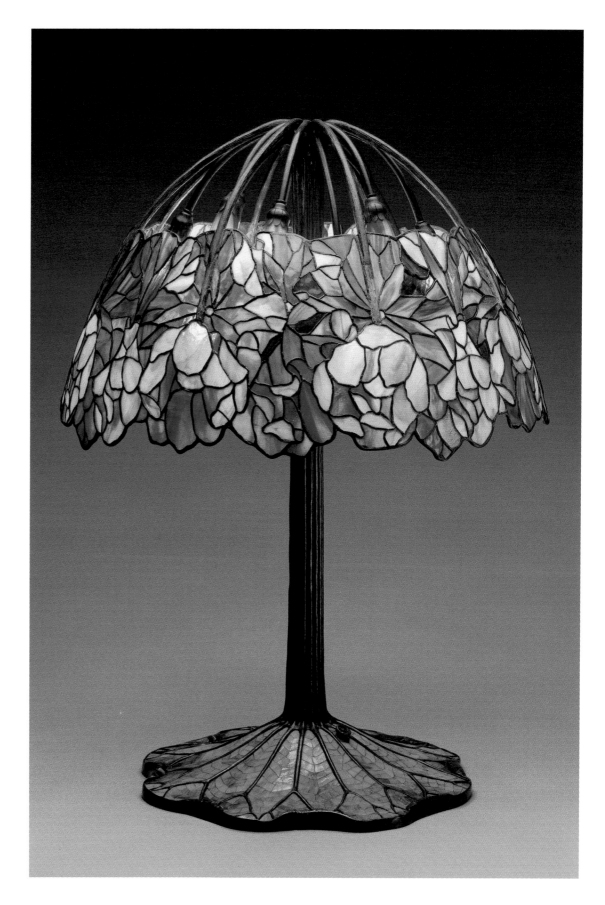

Van Briggle Pottery Company
American, 1901–Present

Artus Van Briggle, designer
American, 1869–1904

«**Despondency**» **Vase** · designed 1903,
this example produced 1909

· · · ·

Glazed earthenware
31.1 x 17.8 cm diam. (12¼ x 7 in.)
Incised on bottom «9», «15», Van Briggle monogram inside square,
«Van Briggle/Colo Springs/1909»

Collection of Jerome and Patricia Shaw

66

Louis Comfort Tiffany

Tiffany Studios

Compote · 1912

· · · ·

Glass
23.2 x 16.8 cm diam. (9⅛ x 6⅝ in.)
Engraved under base «5199G L.C. Tiffany-Favrile»

Collection of William and Patsy Porter

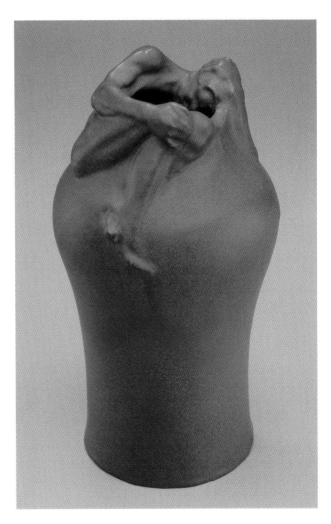

Tʜɪѕ compote belongs to the type known as «aquamarine» for the blue-green color of the glass and its depiction of underwater themes. Technically remarkable, these creations of about 1912–16 are far from the first seemingly relaxed experiments in blown-glass of the 1890s. Here, water lilies seem to grow from the base of the vase as the flowers open in the bowl. The decoration is entirely encased in greenish glass to reinforce the watery nature of the piece.

Fᴏʟʟᴏᴡɪɴɢ a trip to Paris where he studied Chinese ceramics, Van Briggle produced a «dead» or matte glaze with a finely textured surface, applied with an atomizer. An integral part of the design is the subtly sculptured male nude, a reflection of Van Briggle's interest in continental Art Nouveau; its emotional theme owes more to French than American sensibilities. «Despondency» was first exhibited in Paris in 1903. Van Briggle's designs continued to be produced under the direction of his wife after his death.

58

68

Dirk van Erp
American (born in the Netherlands), 1860–1933

Table Lamp · 1908–09

. . . .

Copper and mica
47 x 45.7 cm diam. (shade) (18½ x 18 in.)
Collection of William and Patsy Porter

Dirk van Erp produced a variety of objects, including lamps, candlesticks, vases, and other accessories, mostly in copper. The beauty of these objects lies in their simple forms and hammered surfaces. In his successful line of lamps, Van Erp usually combined translucent mica with patinated copper to create subtle textures. This bulbous lamp with an elevated cap above the shade is an early design, pre-dating the use of Van Erp's Copper Shop mark.

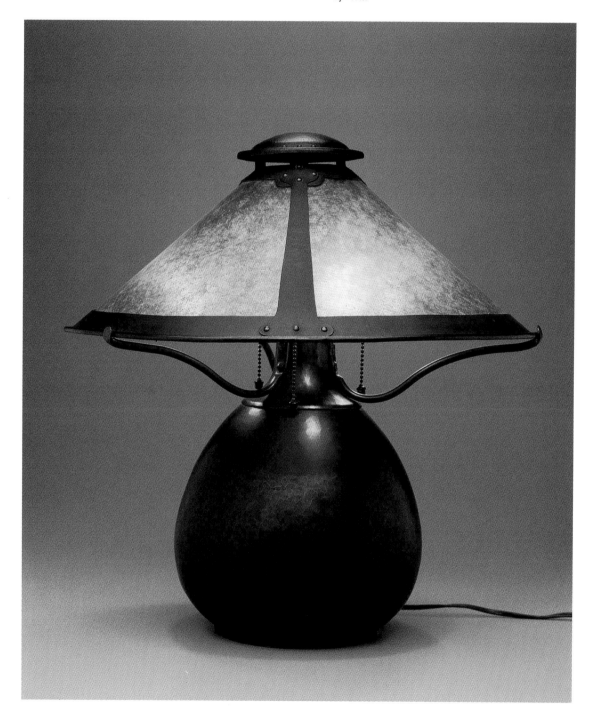

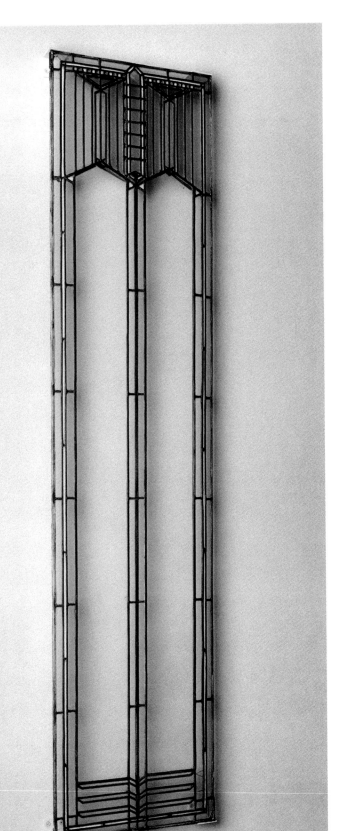

69

Frank Lloyd Wright
American, 1867–1959

**Window from the
B. Harley Bradley House** · 1900

· · · ·

Glass and lead
162.6 x 38.1 cm (64 x 15 in.)

Collection of David and Bobbye Goldburg

The Bradley house in Kankakee, Illinois, was one of the most significant early residences designed by Wright. The dramatic, overhanging peaked roofs of the house are echoed in the window design seen here. This is characteristic of Wright's insistence that a building must be approached as an organic whole, with individual interior and exterior elements related to the overall design.

70

Frank Lloyd Wright

Chest of Drawers with Mirror from the William Martin House • 1902

. . . .

Oak with glass and brass hardware
142.9 x 115.6 x 52.1 cm (56¼ [28¼ without casters to
top of dresser] x 45½ x 20½ in.)

Collection of Thomas and Marianne Maher

Frank Lloyd Wright designed nearly all of the furniture and fixtures in his Prairie-style houses. The chest from the William Martin house in Oak Park, Illinois, and the pieces from the Robert Evans house in Chicago are characteristic of the simple, usually oak, furniture he provided for these early houses. The horizontal mouldings on these pieces echo the strong horizontal lines of the buildings which help to define the Prairie style.

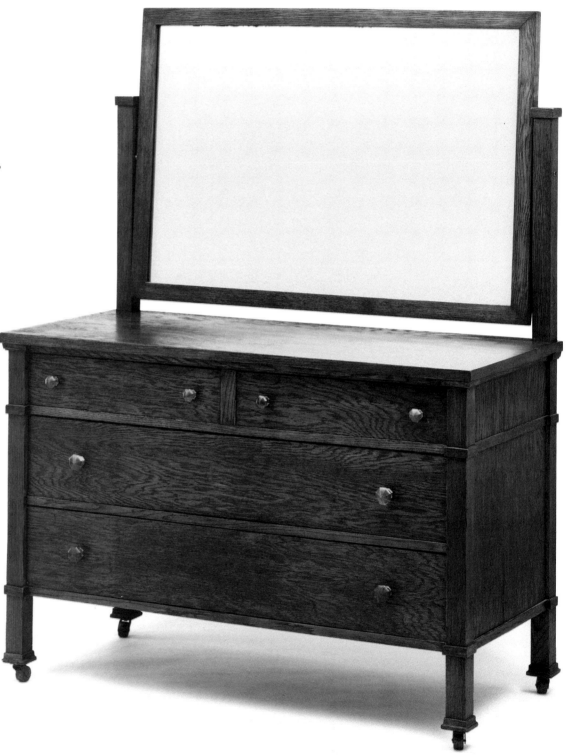

71

Frank Lloyd Wright

*Table and Rocker from
the Robert Evans House* · 1908

. . . .

Oak
Table 72.4 x 117.2 x 56.5 cm (28½ x 46⅛ x 22¼ in.)
Rocker 90.2 x 40 x 78.4 cm (35½ x 15¾ x 30⅞ in.)

Collection of William and Patsy Porter

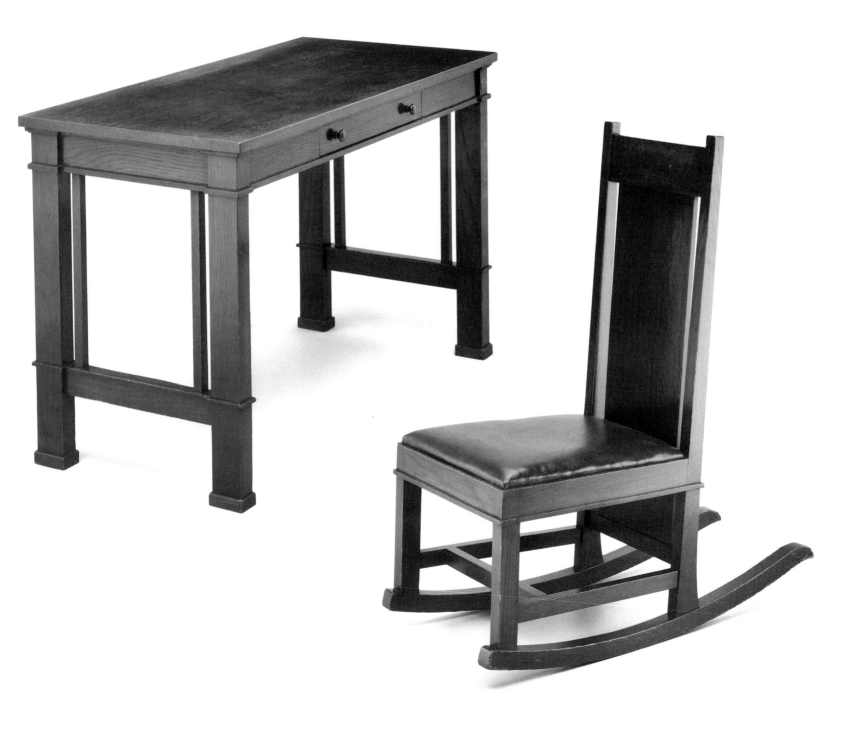

Continental

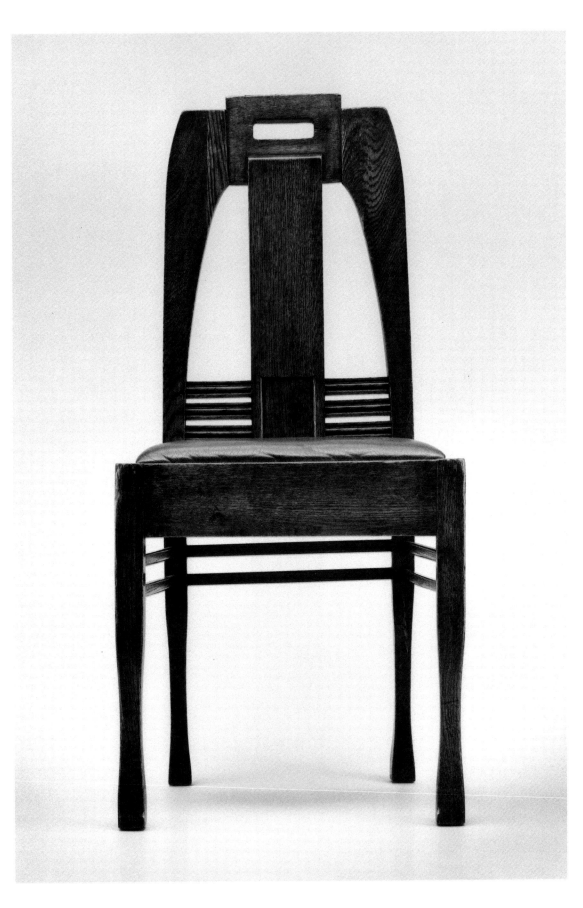

Peter Behrens
German, 1868–1940

Side Chair · 1902
. . . .
Oak with upholstery
98.4 x 45.1 x 46.4 cm (38¾ x 17¾ x 18¼ in.)
Collection of David and Bobbye Goldburg

THE architect Peter Behrens first showed this chair as part of a set of dining room furniture at the Wertheim Department Store in Berlin in 1902. Riemerschmid and others also designed affordable furniture in the modern style for the store. This chair is among Behrens's early designs, created while he was a member of the artists' colony in Darmstadt. Already, however, there is evidence of the simplicity and restraint that characterize most of Behrens's best-known work, the architecture and product designs he created while chief designer for the electric company AEG from 1907 until 1922.

64

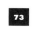

73

Carlo Bugatti
Italian, 1856–1940

Day Bed · ca. 1900
. . . .

Wood, copper, brass,
pewter, vellum,
and upholstery
74.3 x 207.7 x 75.6 cm
(29¼ x 81¾ x 29¾ in.)

Anonymous loan

By about 1895 Bugatti began to incorporate vellum in most of his furniture designs. Its warm color and smooth texture disguise much of the joinery, creating the appearance of furniture that is molded rather than made of separate pieces. The mirror and the day bed demonstrate Bugatti's use of vellum as well as his increasing use of circular design elements during the period around 1900. The day bed is an excellent example of the fine, insectlike geometric metal inlay that characterizes much of Bugatti's best work. In the furniture designed for the Esposizione delle Arti Decorative in Turin in 1902, Bugatti's work achieved an extraordinary fluidity consistent with the organic quality sought by French and Belgian Art Nouveau designers. After his move to Paris in 1904, Bugatti devoted less time to furniture design and focused instead on silver and other small, precious objects.

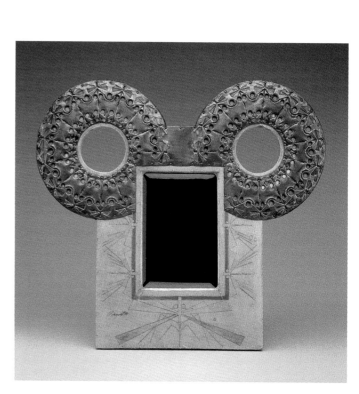

74

Carlo Bugatti

Mirror · ca. 1900
. . . .

Painted and gilded vellum,
copper, and glass on wood
43.8 x 47 x 2 cm
(17¼ x 18½ x ⅞ in.)
Signed at lower left «Bugatti»

Anonymous loan

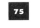

Galileo Chini
Italian, 1873–1956

L'Arte della Ceramica, manufacturer

Vase • ca. 1895

· · · ·

Tin-glazed earthenware
26.7 x 24.1 cm diam. (10½ x 9½ in.)
Printed paper label on bottom «Manifattura/L'Arte della Ceramica/No. 39», in pen
«Firenze», «Firenze» in underglaze blue, L'Arte della Ceramica monogram in
underglaze blue and also impressed

Collection of Jerome and Patricia Shaw

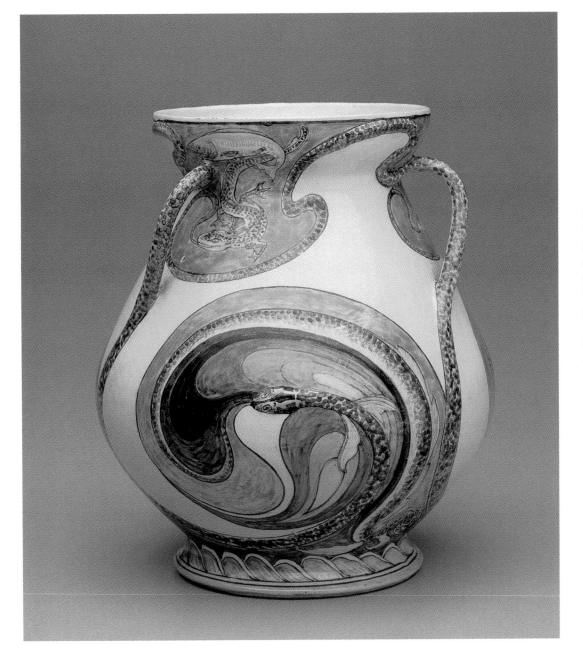

THE decoration of Chini's vases shows his familiarity with Art Nouveau ornament in France and Britain, boldly and idiosyncratically interpreted. Serpents, a favorite motif, emphasize the swelling shape of the vase and curl into dramatic but nonfunctional handles. The shell pattern at the base is a reminder of his Italian predecessors in ceramic design, as is his use of tin glazes based on seventeenth- and eighteenth-century maiolica.

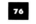

76

Edward Colonna
French/American (born in Germany), 1862–1948

Table Lamp · 1900–01

· · · ·

Gilt bronze and silk
45.1 x 26.7 x 14.6 cm diam. (17¾ x 10½ w x 5¾ in.)
Signed on top of base «COLONNA»

Collection of James and Rose Ryan

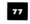

77

Pierre-Adrien Dalpayrat
French, 1844–1910

Vase · ca. 1900

· · · ·

Glazed stoneware
71.1 x 21.6 cm diam. (28 x 8½ in.)
Incised on bottom «Dalpayrat»

Collection of Jerome and Patricia Shaw

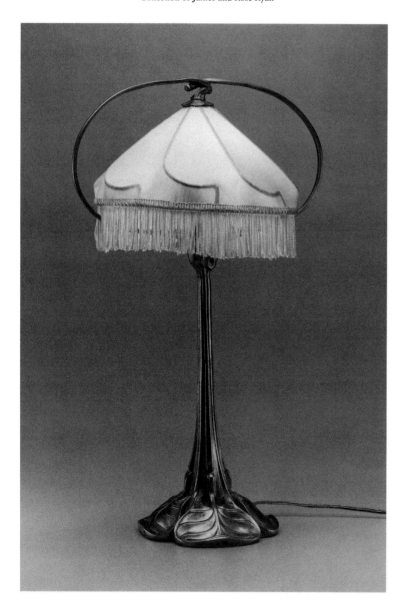

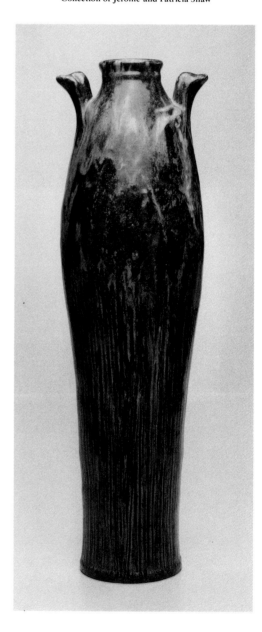

Cᴏʟᴏɴɴᴀ designed in Paris for Siegfried Bing's gallery L' Art Nouveau from 1898–1903, between extended periods of work in North America. Although trained as an architect, he was often at his best during this period, when he created jewelry and other metalwork with lively and elegant curving lines, such as the wire frame of the lampshade seen here.

Tʜᴇ monumental size of this vase provides an unbroken field for Dalpayrat's experiments with glazes. He became known for his *rouge Dalpayrat* and flambé glazes, in a combination of colors for marbled effects. The elongated shape of the vase with handles of stylized foliate leaves is likely derived from Japanese export ware.

78

Joseph-Théodore Deck
French, 1823–1891

Charger · ca. 1875

· · · ·

Glazed earthenware
7 x 50.8 cm diam. (2¾ x 20 in.)
Impressed on bottom «TH DECK»

Collection of Donald and Marilyn Ross

Known to his contemporaries as a master glaze chemist, Deck developed a distinctive palette of a few glazes, which he used consistently in his work of the 1870s. The turquoise areas here are colored in his characteristic *bleu de Deck*. Chinese and Japanese export ware, which Deck studied in Paris, are the sources for the tree peony design and the spiral background motif.

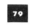

Maurice Denis
French, 1870–1943

Librairie de l'Art Indépendant, Paris

André Gide, *Le Voyage d'Urien* · 1893

30 lithographs by Maurice Denis
Printed on wove paper
20.3 x 19.1 cm (8 x 7½ in.)
Decorated binding, ca. 1956 signed «Pierre-Lucien Martin»
Copy no. 218 from an edition of 300
Collection of Sheila and Jan van der Marck

THIS example of Art Nouveau book illustration heralds the twentieth-century genre of the *livre de peintre*. In contrast to the English ideas of the illustrated book (cat. nos. 2 and 21), the vignettes created for these books advance the narrative rather than decorate the page. The illustrations were not reproduced from drawings but executed by the artist's own hand in an original print medium, in this case lithography. Denis's lithographs, done in a soft grey outline style with only one color added, echo the mysterious atmosphere of his Symbolist paintings.

Deutsche Silberwerkstätte

Fruit Bowl · ca. 1904

· · · ·

Silver and enamel
18.1 x 23.5 cm diam. (7⅛ x 9¼ in.)
Impressed «KRALL 800» and German royal mark (crown and crescent)
Collection of Milford and Barbara G. Nemer

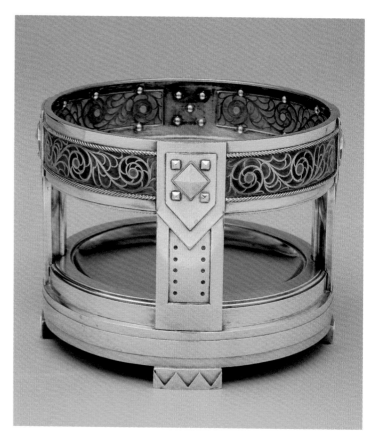

THIS two-tiered bowl incorporates some of the favorite geometric themes of the period around 1900. The silver feet and the four vertical supporting elements feature a bold sawtooth and chevron ornament which contrasts with the graceful enameled floral *rinceaux* of the rim.

81

Taxile Doat
French, 1851–ca. 1938

Bottle with Stopper · 1899–1905
. . . .

Glazed stoneware and *pâte-sur-pâte*
26 x 19.7 cm diam. (10¼ x 7¾ in.)
Inscribed on base monogram
«TD (intertwined) OAT/Sevres»

Collection of Jerome and Patricia Shaw

AFTER 1877, Doat specialized in *pâte-sur-pâte* decoration at Sèvres. He experimented with stoneware and porcelain pastes, creating finely textured vessels which he then finished with matte and crystalline glazes in a variety of colors. He favored the gourd shape. This example is finely detailed to suggest a wine flask, down to the trompe l'oeil raffia handles. Two rectangular and two circular *pâte-sur-pâte* medallions of putti harvesting fruit decorate the shoulder of the vessel.

70

Otto Eckmann
German, 1865–1902

Königliche Porzellan-Manufaktur, manufacturer

Vase · 1900

· · · ·

Glazed porcelain with bronze mounts
51.4 x 27.9 cm (20¼ x 11 in.)
Impressed in bronze at base «OE»

Collection of Jerome and Patricia Shaw

THE foliate bronze mounts, fabricated by Otto Schulz, support the vase as both stand and handles, in a manner consistent with eighteenth-century European examples of gilt metal stands created for Oriental porcelain. The vase shape is drawn from Oriental models and covered with a rich mottled glaze. Glazes of this type were developed by Hermann August Seger, a master chemist who was technical director of the Königliche Porzellan-Manufaktur in Berlin after 1878.

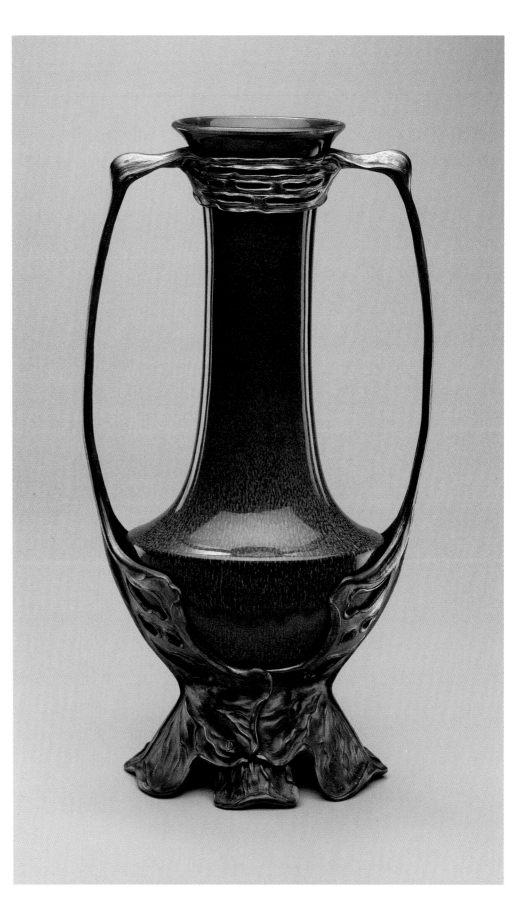

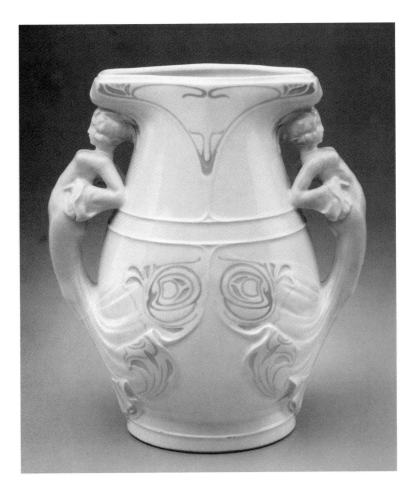

83

Georges de Feure
French (born in the Netherlands),
1868–1943

**G.D.A. (Gérard-Dufraissex-Abbot),
manufacturer**

Vase · 1903

· · · ·

Glazed porcelain
23.5 x 21.6 cm diam. (9¼ x 8½ in.)
Impressed on bottom «530», stamped
underglaze green «1» and G.D.A. mark
(incorporating monograms for de Feure
and Art Nouveau Bing with
«LEUCONOË» below)

Collection of Jerome and Patricia Shaw

Between 1900 and 1903, de Feure produced more than two hundred designs for Siegfried Bing, the Parisian promoter of the Art Nouveau style. Bing in turn organized a complete retrospective exhibition of de Feure's works in 1903, which showed the breadth of the artist's designs for furniture, posters, books, paintings, and ceramics. A recurring motif is the sinuous and seductive woman; two such females form the handles of this vase, surrounded by delicate linear decoration.

84

Paul Follot
French, 1877–1941

Coffee and Tea Service · 1903

· · · ·

Silver plate
Large pot 19.1 x 29.9 x 12.7 cm (7½ x 11¾ x 5 in.)
Small pot 16.5 x 27.3 x 12.7 cm (6½ 10¾ x 5 in.)
Sugar 12.7 x 15.2 x 9.5 cm (5 x 6 x 3¾ in.)
Creamer 9.8 x 15.2 x 8.9 cm (3⅞ x 6 x 3½ in.)
Each piece impressed above foot «P Follot»;
impressed on bottom «MORLOT 03»; engraved
on side initial «K»

Collection of Milford and Barbara G. Nemer

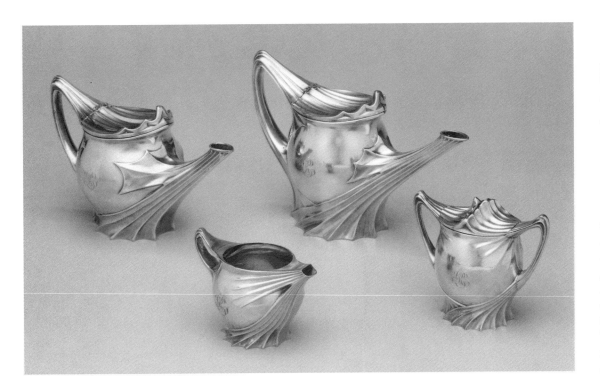

Follot is best known for his role in the creation of the Art Deco style, but as early as 1901 he designed metalwork and textiles for La Maison Moderne, Julius Meier-Graefe's shop in Paris. As seen in the bulbous vegetal forms of this silver-plated service, his work is entirely in keeping with Art Nouveau. This service was displayed in the first salon of the Société des Artistes décorateurs in 1904.

Emile Gallé
French, 1846–1904
Les Etablissements d'Emile Gallé, manufacturer

Table · 1890–1900
. . . .

Walnut and maple with veneer of various exotic woods
64.1 x 38.7 x 71.1 cm (25¼ x 15¼ x 28 in.)
Signed in marquetry on top «E GALLÉ»

Collection of James and Rose Ryan

GALLÉ's reputation is based
primarily on his designs in glass
and ceramic. He also produced Art
Nouveau furniture with elaborate
designs in marquetry. This table,
with its shaped corners, curving feet,
and floral marquetry in exotic woods,
is characteristic of his work.

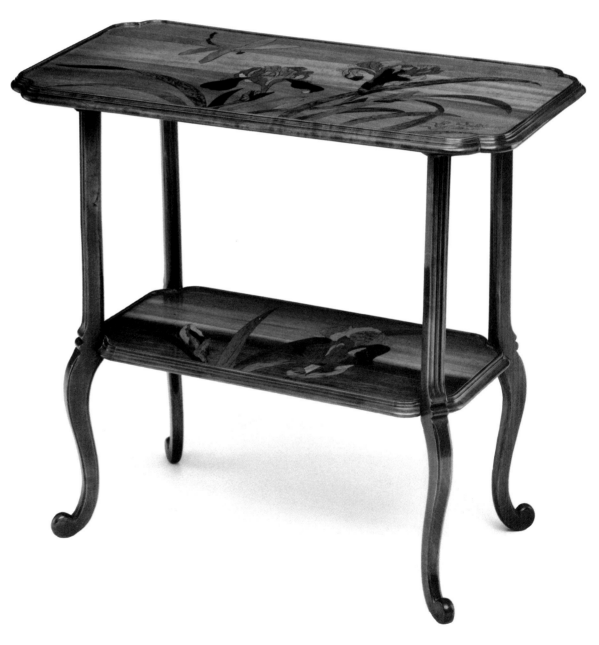

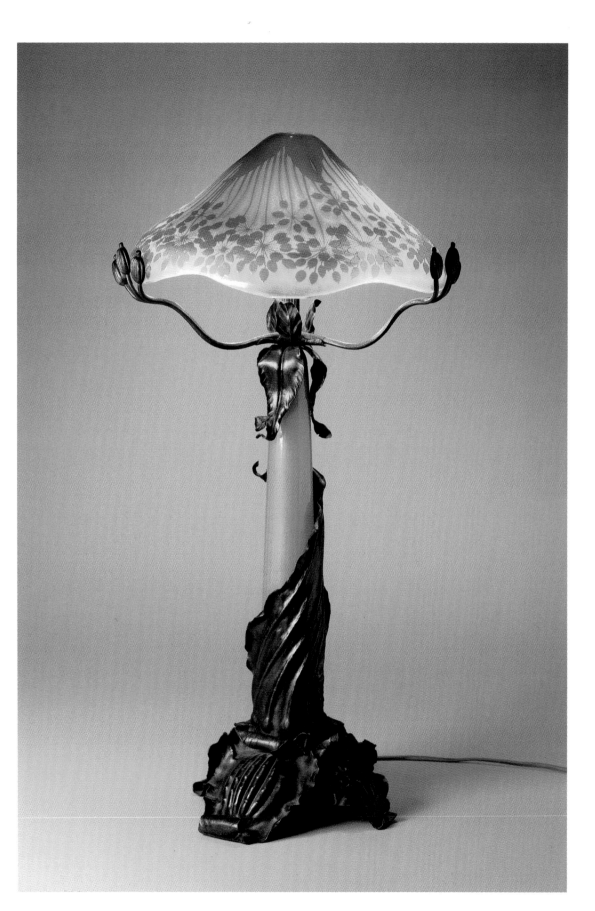

Emile Gallé

Table Lamp · ca. 1900

· · · ·

Glass and iron
76.8 x 38.1 cm diam. (30¼ x 15 in.)
Signed on shade in cameo «Gallé»

Collection of Jerome and Patricia Shaw

THE lamps designed by Gallé
demonstrate his desire to integrate a
single design concept into every aspect
of an object. From the base to the
top of the shade, every detail of this
lamp corresponds to the forms of the
living plant. Alternately identified as
dill or hemlock, this family of plant
was particularly attractive to Gallé,
who frequently depicted its multiple,
bulbous seed pods, lacy flowers, and
thick, ribbed stem.

87

Léon Gruel
French, 1841–1923

Pour les Cent Bibliophiles, Paris

Joris Karel Huysmans, *A Rebours* · 1903

· · · ·

200 wood engravings in color by Auguste Lepère
Set in a typeface designed by George Auriol and printed by Emile Fequet on Blanchet
et Kléber wove paper with «Les Cent Bibliophiles» watermark
Signed decorated binding of the period commissioned by Albert Dubosc from
the Gruel Bindery
25.4 x 17 cm (10⅜ x 6¾ in.)
Morocco leather with leather inlays and gilt; moiré silk endpapers
Copy no. 76 from an edition of 130, with the imprint M. Paul Moreau

Collection of Sheila and Jan van der Marck

No revolutionary, Gruel worked in a style steeped in a long tradition of decorated bindings. Yet, by adopting the floral mosaic decorations favored by younger designers, he identified with the Art Nouveau fashion that swept his work into the twentieth century. For this Symbolist masterpiece by Huysmans, he created a binding appropriate to the spirit of the book.

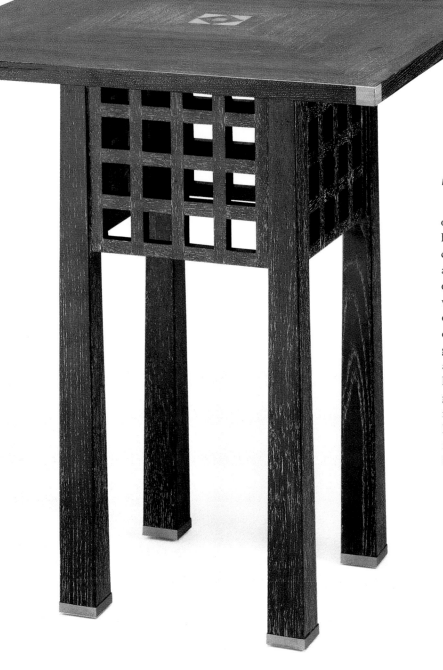

88

Josef Hoffmann
Austrian, 1870–1956

Table · 1903–04

. . . .

Oak, white paint, inlaid maple, and white metal
78.1 x 69.2 cm square (30¾ x 27¼ in.)
Anonymous loan

THIS small table is an important example of the influence of Japanese design on Hoffmann. He designed it for the writing cabinet of Dr. Koller in Vienna and it features a favorite surface treatment of Hoffmann's early period. After staining the oak black, white pigment has been rubbed into the open grain to enliven the surface. The wide overhang of the top and the openwork grid of the aprons is evocative of Japanese architecture and furniture. One need not look outside Europe, however, for the geometric maple inlay on the top and the metal feet. The distinctive reverse-tapered legs of the table are a feature that can be found in some of the early work of Gustav Stickley at about the same time.

76

Josef Hoffmann

Jacob & Josef Kohn, manufacturer

Side Chair • ca. 1904

· · · ·

Beech and other woods with upholstery
99.4 x 43.8 x 45.7 cm (39⅛ x 17¼ x 18 in.)

Anonymous loan

THE bentwood pieces designed by
Hoffmann and manufactured by J. & J. Kohn
are among the best-known products of the
Wiener Werkstätte. Kohn can be credited
with recognizing the potential for excellence
in design to elevate a mass-produced product
above its competition. By working with
Hoffmann and Koloman Moser, Kohn was
able to offer a broad range of manufactured
furniture in the new Viennese style. The so-
called Purkersdorf chair (cat. no. 89) was
designed in 1904 for the dining room of the
sanatorium of the same name and it then
appeared in Kohn's 1906 catalogue. The
settee and two barrel-shaped armchairs
are variations on a Hoffmann design first
produced by Kohn about 1902.

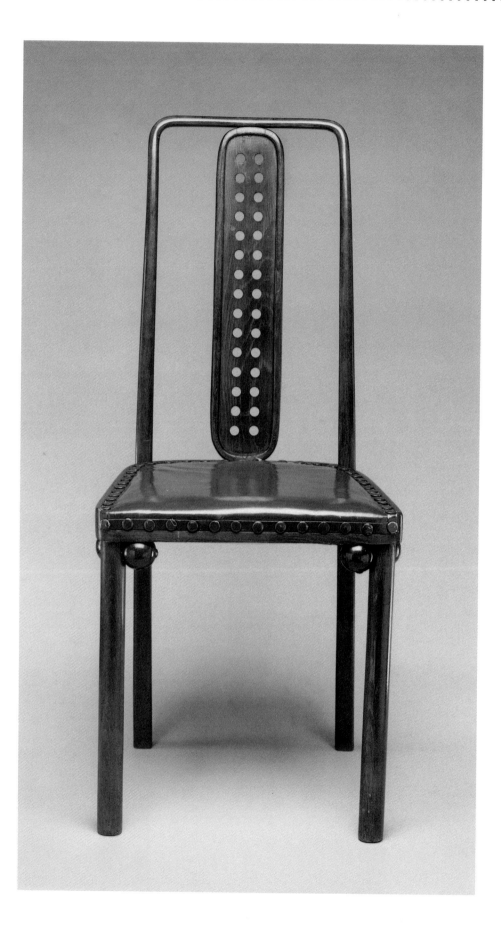

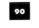

Josef Hoffmann

Jacob & Josef Kohn, manufacturer

Pair of Armchairs and Settee · 1905

(Settee not illustrated)

. . . .

Beech with mahogany stain, brass, and upholstery
Armchairs 71.1 x 58.1 x 59.7 cm each (28 x 23 x 23½ in.)
Settee 71.1 x 125.7 x 59.7 cm (28 x 49½ x 23½ in.)
Each piece with paper label of Jacob & Josef Kohn under the seat

Collection of Dr. Lawrence and Reva Stocker

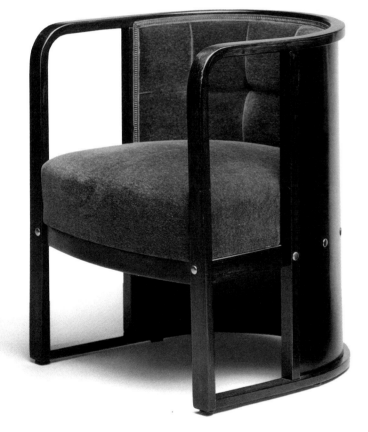
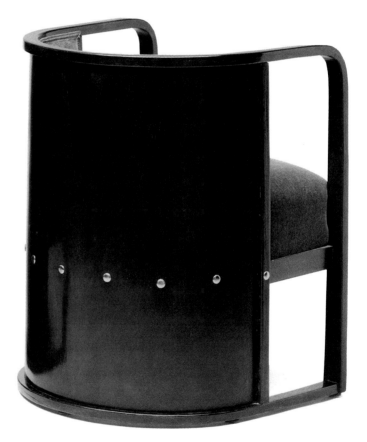

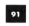

Josef Hoffmann

Jacob & Josef Kohn, manufacturer

Side Chair • ca. 1906

. . . .

Beech and other woods
108.3 x 41.9 x 45.7 cm (42⅝ x 16½ x 18 in.)
Jacob & Josef Kohn paper label under seat

Anonymous loan

THE so-called Seven Ball chair (cat. no. 91), with its paired bentwood hoops and seven turned wooden balls is one of the most distinctive of Hoffmann's designs for Kohn. The famous *Sitzmachine*, or machine for sitting (cat. no. 92), is Hoffmann's bold geometric interpretation of William Morris's reclining chair.

92

Josef Hoffmann

Jacob & Josef Kohn, manufacturer

Armchair **(Sitzmachine)** · 1908

. . . .

Beech, other woods, and metal
110.5 x 81.6 x 64.1 cm (43½ x 32⅛ x 25¼ in.)

Anonymous loan

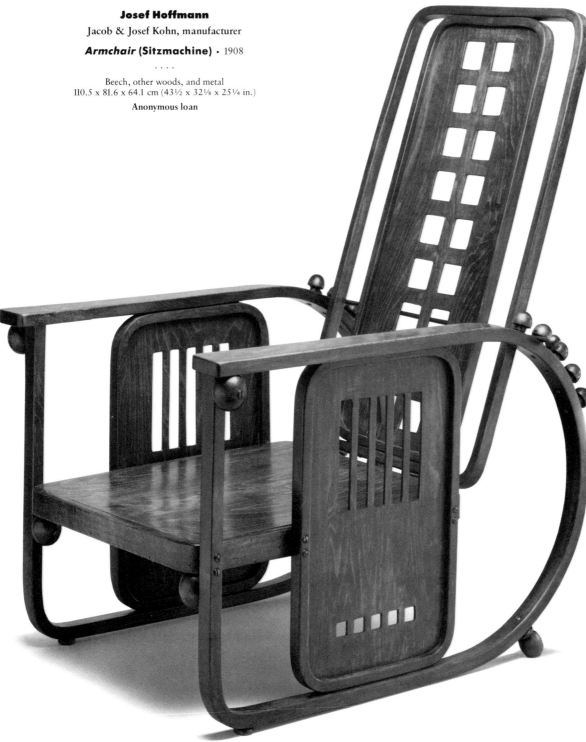

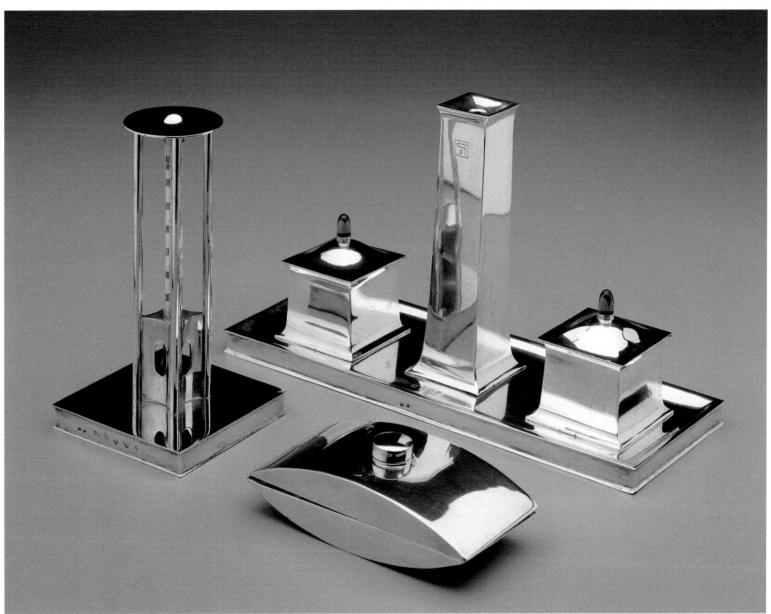

Josef Hoffmann

Wiener Werkstätte, manufacturer

Desk Set: Tray with Inkwell and Candlestick, Blotter, and Thermometer · ca. 1904

. . . .

Silver with amethyst finials and glass
Tray with Inkwell and Candlestick 19.4 x 33 x 21.1 cm diam.
(7⅝ x 13 x 4¾ in.)
Blotter 5.1 x 15.9 x 7.6 cm diam. (2 x 6¼ x 3 in.)
Thermometer 20 x 10.8 x 10.8 cm (7⅞ x 4¼ x 4¼ in.)
Impressed marks: Vienna silver mark, «WW» monogram, rose
trademark of Wiener Werkstätte, «JH» monogram (on thermometer also
«MA» monogram), and «JS» monogram on candlestick and blotter

Anonymous loan

Hoffmann explored a variety of surface treatments on his silver and other metalwork designs. Many of his pieces have lively hammered and punched surfaces, but the smooth, unembellished surface of this desk set is not unusual. The spare surfaces allow the strong architectonic forms of these pieces to register clearly. Bearing the monogram «JS» on the blotter and the candlestick, this desk set was ordered by Karl Wittgenstein for his son-in-law Jerome Stonborough.

**Josef Hoffmann and/or
Koloman Moser**

Austrian, 1868–1918

*Sugar Bowl, Salt Cellar, Oil and
Vinegar Set, and Toothpick
Stand* · ca. 1904

. . . .

Painted iron and glass
Sugar bowl 3.8 x 17.2 cm diam. (1½ x 6¾ in.)
Salt cellar 3.2 x 5.7 cm diam. (1¼ x 2¼ in.)
Oil and vinegar set 18.4 x 15.9 x 7.6 cm
(7¼ x 6¼ x 3 in.)
Toothpick stand 5.4 x 4.5 cm square (2⅛ x 1¾ in.)

Anonymous loan

FROM about 1904, Hoffmann and
Moser both designed geometric objects
in painted perforated sheet metal
(such as the group seen here) as well
as similar objects in silver. Hoffmann's
brass tray, with its set of hammered
bowls, demonstrates a marked stylistic
change which occurred about ten
years later. They are indicative of an
interest in fluted, curving, and twisted
shapes which has been called a
«Baroque» phase of Viennese modern
design.

Josef Hoffmann

Wiener Werkstätte, manufacturer

Tray and Four Bowls · ca. 1922

. . . .

Brass
Tray 3.5 x 31.8 cm diam. (1⅜ x 12½ in.)
Large bowl 12.1 x 12.1 cm diam. (4¾ x 4¾ in.)
Bowl 6.7 x 10.2 cm diam. (2⅝ x 4 in.)
Two small bowls 5.1 x 10.2 cm diam. each
(2 x 4 in.)
Stamped under tray «Wiener/Werk/Stätte», «JH»,
and «Made/in/Austria»

Collection of Dr. Lawrence and Reva Stocker

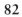

82

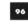

Paul Iribe
French, 1883–1935

Cabinet-on-Stand · 1913
· · · ·

Mahogany, leather, bronze with gilding,
and plywood
176.5 x 128.3 x 37.5 cm (69½ x 50½ x 14¾ in.)
Signed and dated on proper left

Anonymous loan

IRIBE'S remarkable cabinet reveals powerful stylistic changes leading to the development of Art Deco. Instead of searching for ideas in organic forms or geometry, Iribe has returned to the great traditions of eighteenth-century furniture, as seen in the use of gilded wood, the fluted legs, and especially in the prominent floral swags. In 1912, Iribe was commissioned to design furniture for the couturier Jacques Doucet, who was an influential patron of the Parisian avant-garde. In 1914 Iribe left France for the United States. This cabinet was made, therefore, at a crucial transitional stage of his career and of early twentieth-century design.

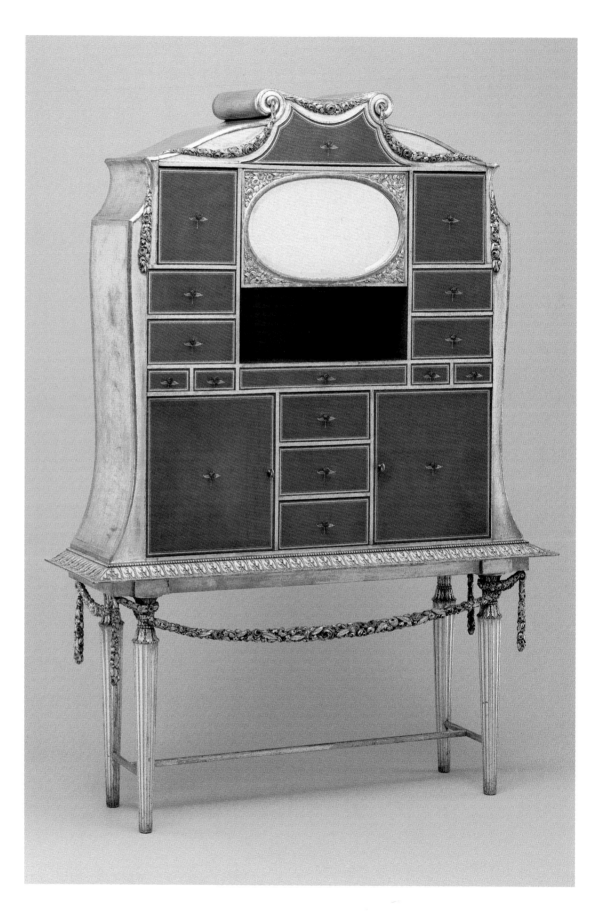

97

Königliche Porzellan-Manufaktur

Gottlieb Elstor, designer
German, 1867–1917

Vase · 1899

· · · ·

Glazed porcelain
27.9 x 26.7 cm diam. (11 x 10½ in.)
Inscribed on bottom blue scepter and TH monogram,
«D.273», impressed «6200», incised «G XIII»

Collection of Jerome and Patricia Shaw

98

René Lalique
French, 1860–1945

René Lalique et Cie., manufacturer

Medusa · ca. 1900

· · · ·

Bronze
17.5 x 12 x 8.2 cm (7 x 4⅞ x 3¼ in.)
Engraved on side base «R. LALIQUE»

Collection of Laurie and Joel Shapiro

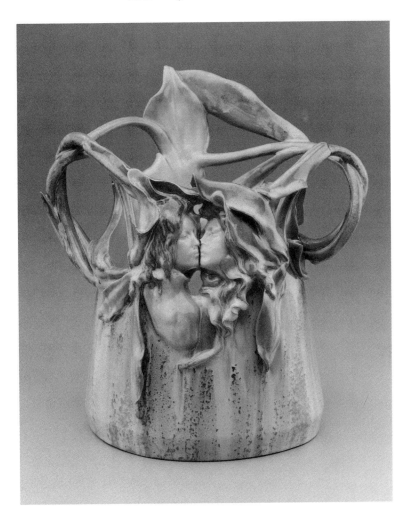

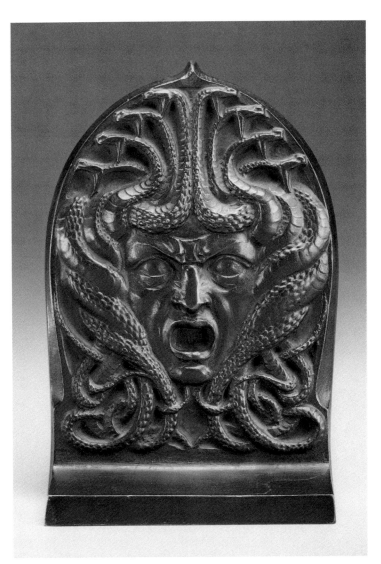

THE image on this vase is strikingly similar in design to a color woodcut by Peter Behrens entitled *The Kiss*, designed for the influential Berlin art journal *Pan* and published in its November 1899 issue. While the flowing tresses in the woodcut have been replaced by leaves and vines which become the vessel's handles, the two works epitomize Jugendstil design.

THE dangerous, seductive woman was a popular theme for Symbolist painters and from them, Lalique may have drawn this image of Medusa, a Gorgon whose hair was made of writhing snakes and who could turn men to stone with a glance. This object, often refered to as a paperweight, is one of only two known; the other is in the collection of the Virginia Museum of Fine Arts, Richmond.

84

99

René Lalique

René Lalique et Cie., manufacturer

Chalice · ca. 1902

. . . .

Silver and glass
19 x 10.9 cm diam. (7½ x 4⅜ in.)
Impressed on rim of foot «LALIQUE 2»

Collection of Laurie and Joel Shapiro

100

René Lalique

René Lalique et Cie., manufacturer

Vase «Grand Boule Lierre» · ca. 1919

. . . .

Glass with patinated enamel
36.3 x 34.9 cm diam. (14¼ x 13¾ in.)
Engraved on underside of base «R. LALIQUE»

Collection of Laurie and Joel Shapiro

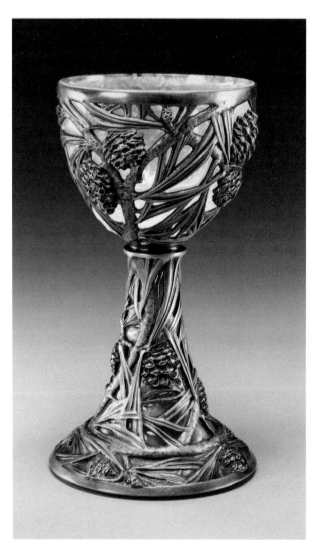

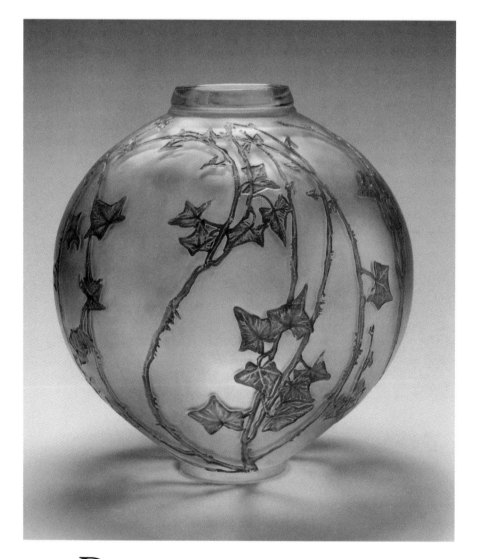

THIS chalice, one of a series, was made before Lalique had begun to blow glass into molds, and is evidence of Lalique's early interest in mass production. It is decorated with pine cones and branches, inspired by English Arts and Crafts design and was probably meant for decorative use in the home.

DELICATE trailing ivy vines decorate the sides of this vase in a naturalistic, irregular pattern, a dramatic contrast to the large areas of undecorated, frosted glass. This design was in production from 1919 until about 1932, attesting to its continuing popularity as an essential component of a stylishly designed interior.

101

René Lalique

Cougar · 1919

. . . .

Glass with patinated enamel
15.3 x 10.4 x 13.5 cm (6⅛ x 4 x 5¼ in.)
Incised on base «25-19» and wheel-cut
«R. LALIQUE»

Collection of Laurie and Joel Shapiro

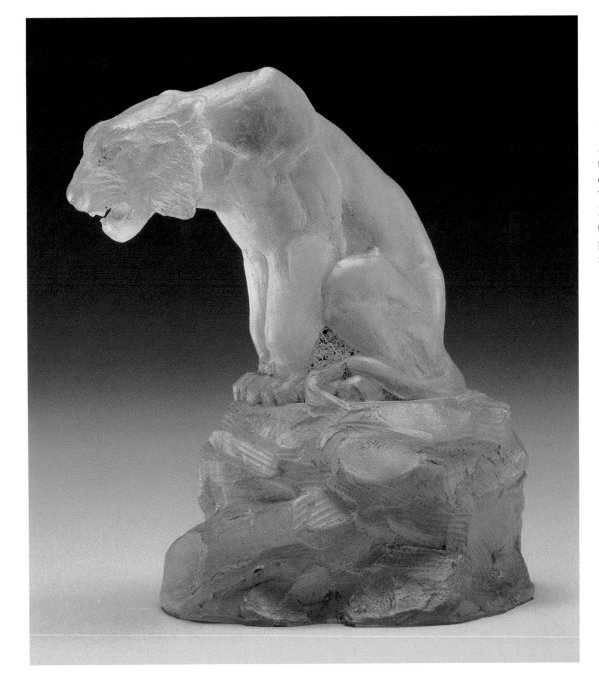

LALIQUE used the lost-wax process to create a few unique glass sculptures of naturalistic, highly detailed subjects. This cougar was made for Edward John Moreton Prax Plunkett, Lord Dunsany (1878–1975), an art connoisseur and popular playwright, who was a personal friend of Lalique.

Adolf Loos
Austrian, 1870–1933

Tea Cart · ca. 1900

· · · ·

Mahogany, glass, and metal
80 x 99.1 x 58.4 cm (31½ x 39 x 23 in.)
Anonymous loan

T HE tea cart comes from Gustav Turnowsky's apartment in
Vienna, designed in 1900 by Adolf Loos. Loos and Hoffmann were
often at odds over design and intellectual issues. The elegant,
curving, and scrolling lines of the tea cart show Loos to be far
from the rigid geometry that characterizes the work of Hoffmann
and Moser around 1900. While Loos was a leading modernist, he
was prepared to accept elements of Biedermeier and other earlier
styles depending on the client's wishes. The upper section of the
cart is a removable tray.

Louis Majorelle
French, 1859–1926

Pair of Side Chairs · 1900–10

· · · ·

Oak, leather upholstery,
and brass
98.4 x 43.2 x 47 cm each
(38¾ x 17 x 18½ in.)
**Collection of
James and Rose Ryan**

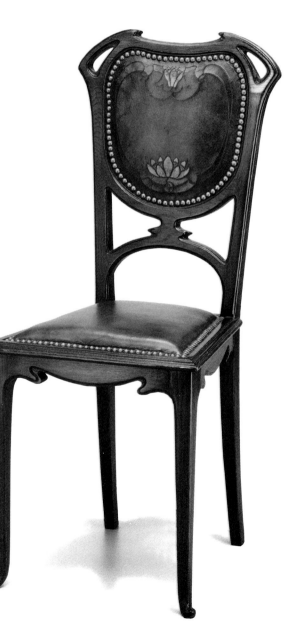

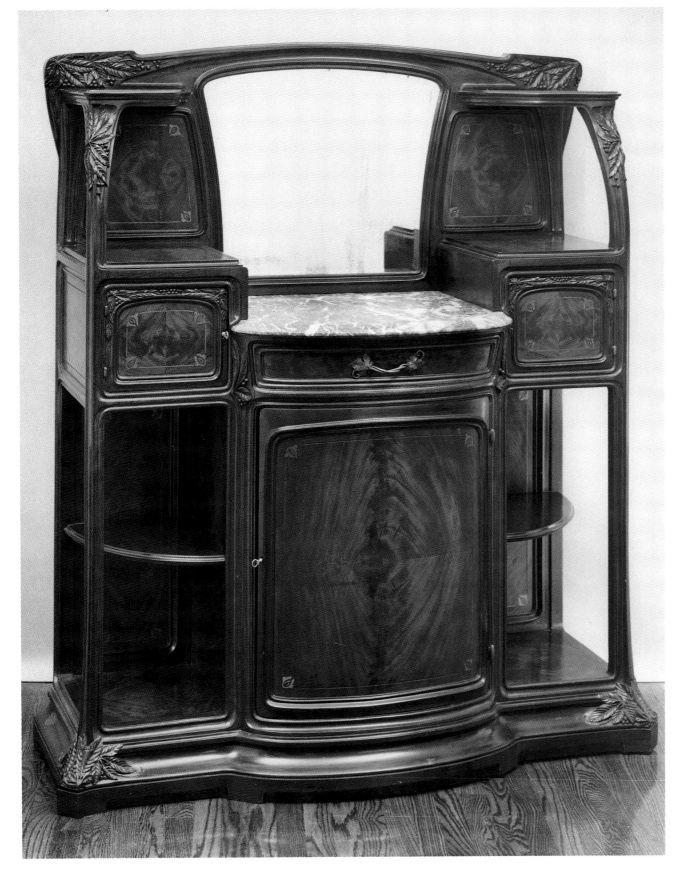

104

Louis Majorelle

Sideboard · 1900–10

. . . .

Mahogany, glass, and
marble with brass inlay
and bronze pulls
160 x 137.8 x 55.9 cm
(63 x 54¼ x 22 in.)

**Collection of
James and Rose Ryan**

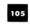

105

Louis Majorelle

Cabinet «*La Mer***»** · ca. 1910

· · · ·

Mahogany case, oak interior, various exotic wood
veneers, mother-of-pearl, and iron
200.3 x 119.7 x 39.4 cm (78⅞ x 47⅛ x 15½ in.)
Signed in marquetry at lower right of backboard
«L Majorelle»

Manoogian Collection

Louis Majorelle was probably the
most successful Art Nouveau furniture
designer in Europe. His workshops
in Nancy produced many pieces of a
consistently high quality, such as the
richly decorated furniture seen here.
The mahogany sideboard (cat. no. 104)
has pulls and carving with decoration
of leaves and berries, while the combined
storage cabinet and étagère (cat no. 105)
features strongly figured wood on
doors with vinelike decorative hinges,
leafy carving on the case, and lyrical
underwater imagery in the marquetry.
The choice of patinated iron for the
hinges and the escutcheons on the
cabinet, rather than the more usual
bronze (often gilded), harmonizes well
with the dark wood of the doors. The
cabinetry, hardware, and even the
embossed leather upholstery on the
chairs (cat. no. 103) were produced by
Majorelle's own workshop.

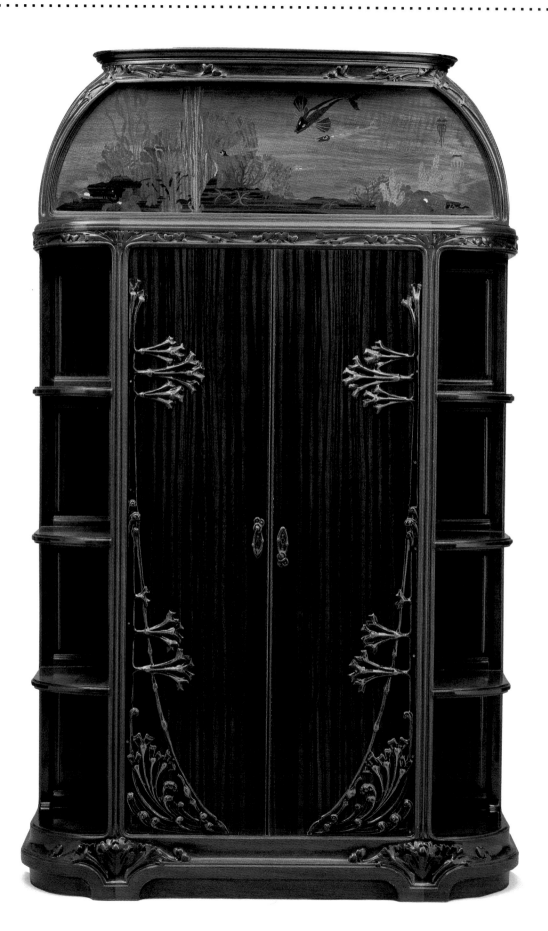

106

Louis Majorelle

Keller et Guérin, manufacturer

Ewer · ca. 1900

· · · ·

Glazed earthenware with luster
28.6 x 17.8 cm diam. (11¼ x 7 in.)
Initials «LM» in relief incorporated into design of vines

Collection of Jerome and Patricia Shaw

Koloman Moser

Austrian, 1868–1918

Table · ca. 1901

· · · ·

Various stained woods, brass, and glass
71.8 x 89.5 cm diam. (28¼ x 35¼ in.)

Donald Morris Gallery, Inc.

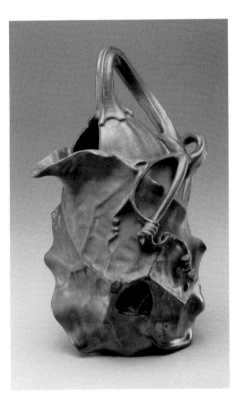

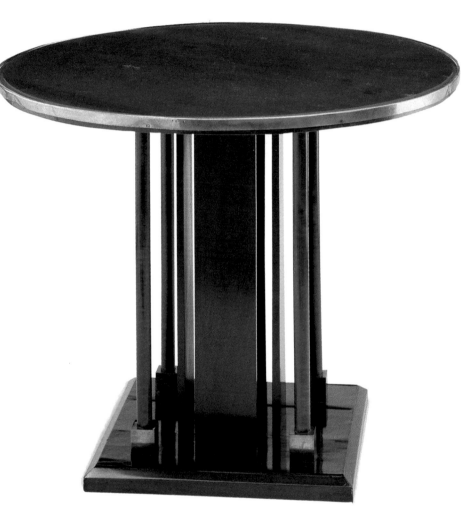

Majorelle's facility for adapting natural forms to manufactured objects is nowhere more evident than in this ewer. Its gourd-shaped body is nearly obscured by the high relief of the surface, enlivened with areas of subtle luster. The handle is in the form of a delicate ribbed vine curling over the top, from which a few tendrils escape. Majorelle designed only a few ceramics, and this perfectly preserved pitcher is one of only two examples of this design known.

The table is an example of the rigid application of geometry to design that characterized the first years of the Wiener Werkstätte. Comprised of circle, square, cube, and cylinder, Moser's pattern demonstrates the elegant simplicity that can result from this approach.

90

Koloman Moser

Jacob & Josef Kohn, manufacturer

Washstand · 1902

· · · ·

Marble, painted wood, aluminum, and brass
99.1 x 119.4 x 53.5 cm (39 x 47 x 21 in.)

Anonymous loan

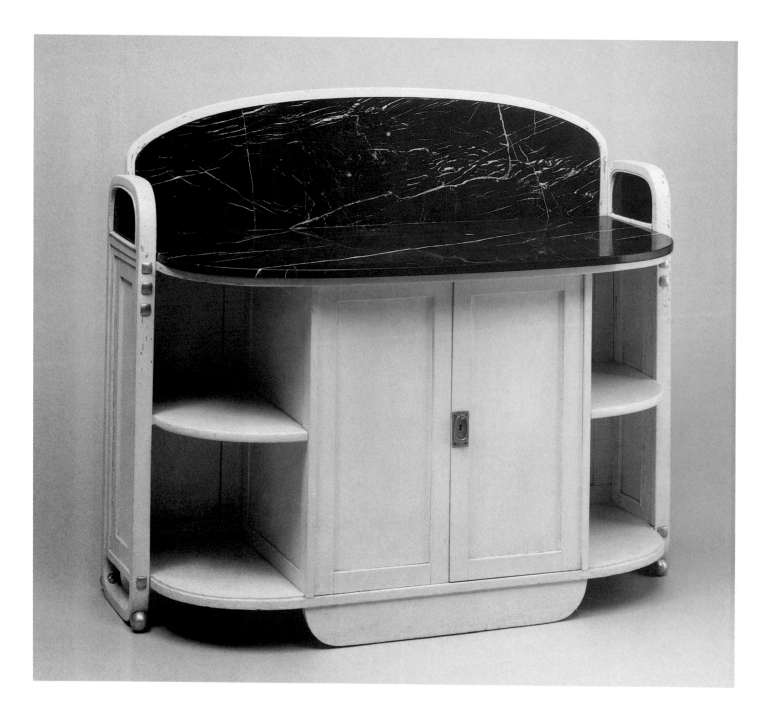

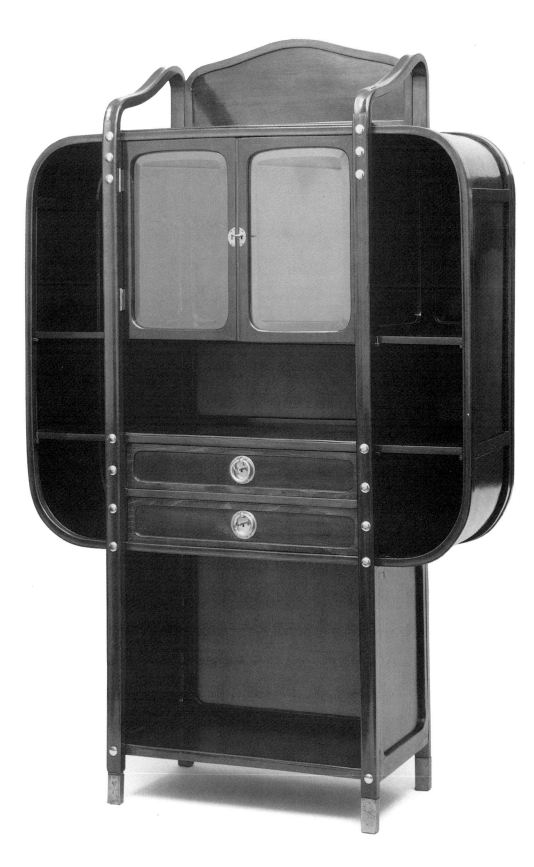

109

Koloman Moser (attributed)

Jacob & Josef Kohn, manufacturer

Vitrine · ca. 1905

. . . .

Stained beechwood, glass, and brass
183.5 x 116.8 x 41.3 cm (72¼ x 46 x 16¼ in.)
Anonymous loan

Moser's white washstand (cat. no. 108) is consistent with the bright Viennese interiors of the first years of the twentieth century. Embellishment is restricted to the functional use of marble for the top and backsplash and the aluminum hardware. The sideboard and the vitrine (cat. no. 109) successfully unite the rectilinear forms of much Wiener Werkstätte design with the curvilinear shapes offered by bentwood technology. The use of bentwood for furniture was perfected by Michael Thonet in Germany in the 1840s and brought to Vienna before 1850. After Thonet's patent expired in 1869, the Kohn firm was able to begin producing bentwood furniture and by 1907 was making several thousand pieces a day.

92

110

Richard Mutz
German, 1872–1931

Ernst Barlach
German, 1870–1938

Vase · ca. 1904

· · · ·

Glazed stoneware
44.5 x 26.7 cm diam. (17½ x 10½ in.)
Impressed circular mark on bottom
«RICHARD MUTZ BERLIN W15»

Collection of Jerome and Patricia Shaw

111

Joseph Maria Olbrich
Austrian, 1867–1908

Armchair · 1898

· · · ·

Walnut
88.9 x 57.2 x 52.1 cm
(35 x 22½ x 20½ in.)

Anonymous loan

THE Mutz workshop produced many low-relief plaques and small sculptures designed by the German Expressionist sculptor Ernst Barlach. The international taste for the exotic impressed Mutz, who began to formulate «oriental»-style dense glazes after seeing examples of Chinese pottery. Barlach designed the carved masks, possibly inspired by medieval grotesques, placed below the handles.

THIS chair was designed for the children's room of the Villa Friedmann in the suburbs of Vienna, Olbrich's first important private commission. The form of the chair and its ornament predate the rigid geometry of the Wiener Werkstätte, founded in 1903. Olbrich's predilection for curving lines can be seen as Jugendstil, although the details of this chair are somewhat idiosyncratic. The upright supports of the chair's arm under tension are particularly distinctive.

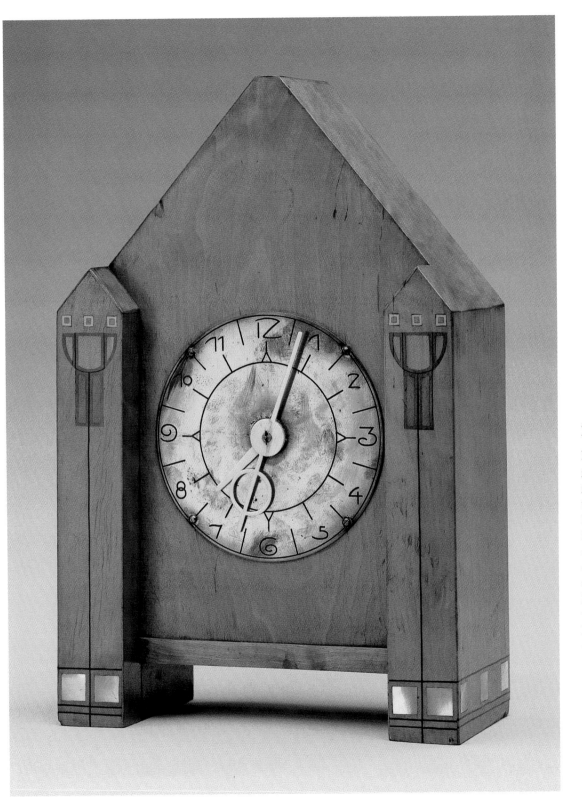

Joseph Maria Olbrich

Clock · ca. 1902

. . . .

Maple veneer with copper dial, ivory,
mother-of-pearl, and various woods
26.7 x 17.8 x 8.9 cm (10½ x 7 x 3½ in.)

Anonymous loan

OLBRICH designed the clock only
a few years after the chair for the
Villa Friedmann, but the vocabulary
has changed markedly here. The
geometric form, with its pointed
gable and heavy piers at either side of
the metal clock face, is architectonic.
Furthermore, the highly stylized floral
inlay and the use of mother-of-pearl
are consistent with other Viennese
design of the period, particularly that
of Koloman Moser. It should be noted,
however, that by this time Olbrich
was already in Germany where he
helped to found the Darmstadt Artists'
Colony in 1899.

94

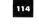

113

Joseph Maria Olbrich

Zinngiesserei Eduard Hueck, manufacturer

Candelabrum · 1901–02

. . . .

Pewter
36.2 x 19.7 x 11.4 cm diam. (14¼ x 7¾ w x 4½ in.)
Raised circular mark under base «EDELZINN/1819/E.
HUECK» and «JO» monogram in a square

Donald Morris Gallery, Inc.

114

Joseph Maria Olbrich

Zinngiesserei Gerhardi & Cie., manufacturer

Coffee and Tea Service · ca. 1906

. . . .

Pewter
Coffee pot 32.4 x 24.1 x 10.8 cm (12¾ x 9½ x 4¼ in.)
Tea pot 22.9 x 24.5 x 10.5 cm (9 x 9⅝ x 4⅛ in.)
Creamer 12.4 x 12.4 x 7.3 cm (4⅞ x 4⅞ x 2⅞ in.)
Sugar 15.9 x 14 x 10.2 cm (6¼ x 5½ x 4 in.)

Anonymous loan

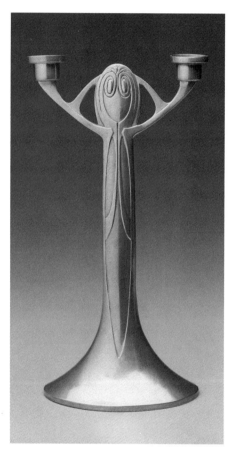

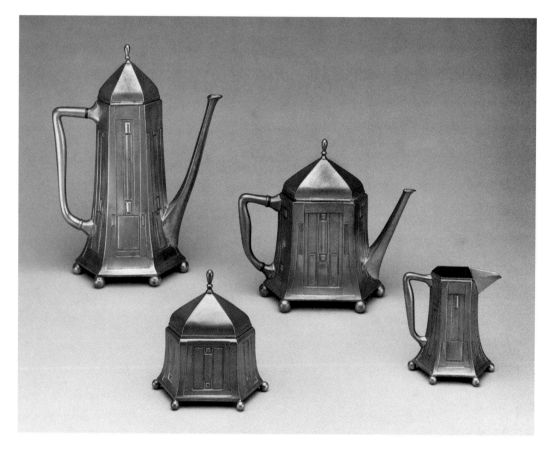

THE candelabrum was first shown in St. Louis at the Louisiana Purchase
Exhibition of 1904 and also in the same year at an exhibition in Darmstadt.
Pewter was popular as an alternative to silver from the Middle Ages through
the eighteenth century. The use of pewter declined in the nineteenth century
with the advent of modern silver-plating techniques. It was revived around 1900,
particularly in England and Germany, perhaps because of pewter's warm
surface and its association with objects of the preindustrial period.

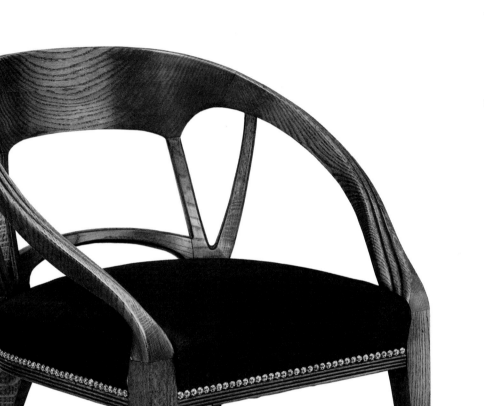

115

Bruno Paul
German, 1874–1968

Vereinigte Werkstätten für Kunst im Handwerk,
manufacturer

Desk Chair · 1901–02

· · · ·

Oak
78.1 x 65.4 x 59.1 cm diam. (30¾ x 25¾ x 23¼ in.)
Stamped «2545», also inscribed in chalk inside seat rail
«2545»

Donald Morris Gallery, Inc.

PAUL advocated simple furniture for
mass production. Due to the unity of
the back, arms, and the front legs of
this chair, it functions well as a desk
chair, allowing ease of movement. It
was first shown at the Esposizione
delle Arti Decorative in Turin in 1902
and again in 1904 in the President's
Office (Arbeitszimmer des Präsidenten
für das Regierungsgebaude) in Bayreuth
and at the Louisiana Purchase
Exhibition in St. Louis.

96

Dagobert Peche
Austrian, 1887–1923

Wiener Werkstätte, manufacturer

Table Lamp · 1921

· · · ·

Silver-plated metal with original silk shade
83.8 x 50.8 cm diam. (shade), 19.7 cm diam. (base)
(33 x 20 x 7¾ in.)
Impressed on base Wiener Werkstätte mark and
Peche monogram; the same marks and «made in
Austria» appear on the petals of finial

Anonymous loan

Younger than Hoffmann and Moser, Peche was associated with the Wiener Werkstätte during and after World War I, joining the workshop in 1915. By this time Viennese design was less committed to the geometric purity of the years just after 1900. Peche excelled in the design of silver objects. The ribbed decoration of the lamp base and the elegant leafy finial echoed by the painted decoration on the silk shade are typical of his fluid designs.

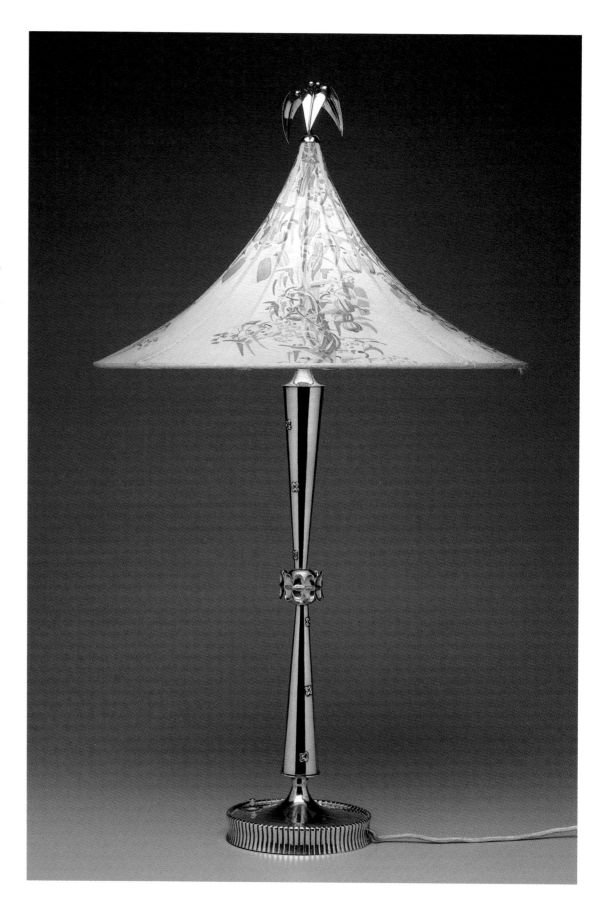

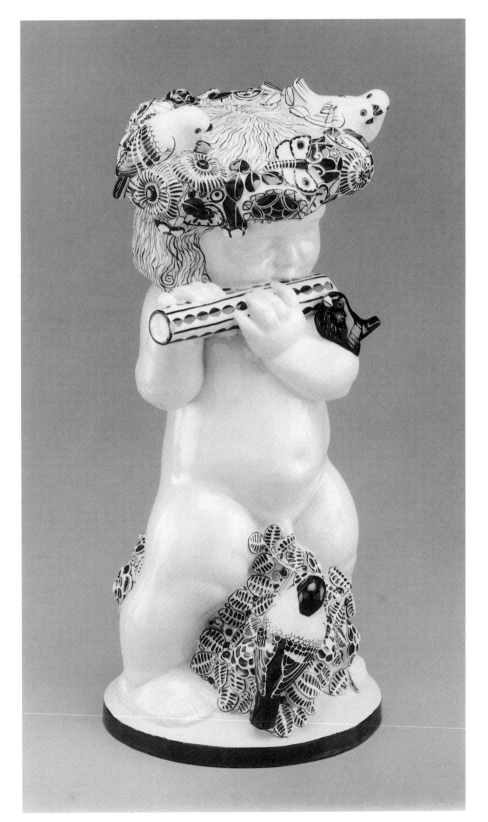

Michael Powolny
Austrian, 1871–1954

Wiener Keramik, manufacturer

Cherub Playing a Flute · ca. 1910

. . . .

Tin-glazed earthenware
45.1 x 21.6 cm diam. (17¾ in. x 8½ in.)
Incised outside on base «MP», impressed mark «Wiener
Keramik», inscribed in black inside base «W286»

Collection of Jerome and Patricia Shaw

THE sweetly rounded forms of this putto
are belied by the linear geometric ornament
in black and white influenced by the graphic
designs of the Wiener Werkstätte. This figure
is also found in unglazed and pure white
versions. While most of Powolny's putti carry
attributes that make them part of his «Four
Seasons» or «Twelve Months» series, few single
figures exist, particularly on this large scale.

118

Otto Prutscher
Austrian, 1880–1949

Meyr's Neffe, manufacturer

***Decanter, Seven Stemmed Glasses,
and Tray*** • ca. 1905–12
. . . .

Glass with gilding
Decanter 27.9 x 7.3 cm diam. (11 x 2⅞ in.)
Glasses 14 x 5.4 cm diam. each (5½ x 2⅛ in.)
Tray 5.4 x 21.6 cm diam. (2⅛ x 8½ in.)

Anonymous loan

Gₗₐₛₛwₐᵣₑ was not produced at the
Wiener Werkstätte, but designs were
created for production by established
manufacturers of commercial glassware.
Some examples were hand painted by
Wiener Werkstätte artists and the gilded
floral elements on this set may have been
applied by hand. Prutscher also designed
metalwork, combining rigid geometric
ornament with dramatic fluting.

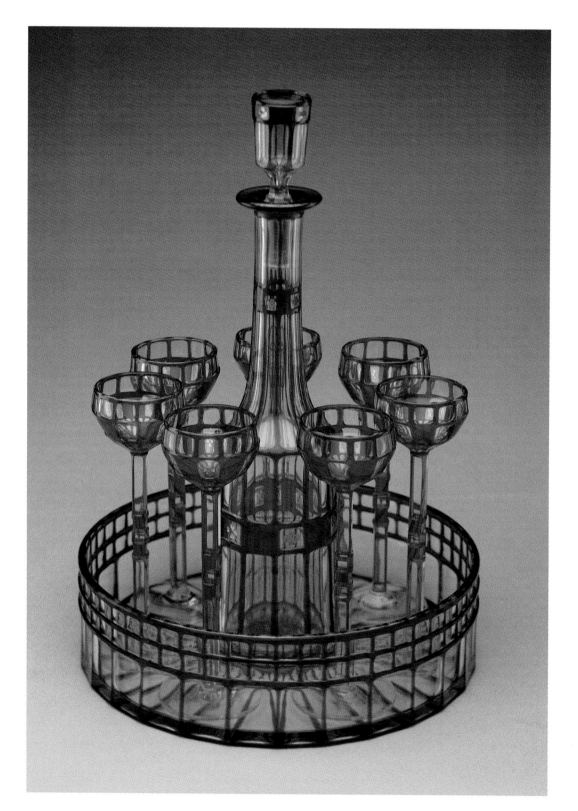

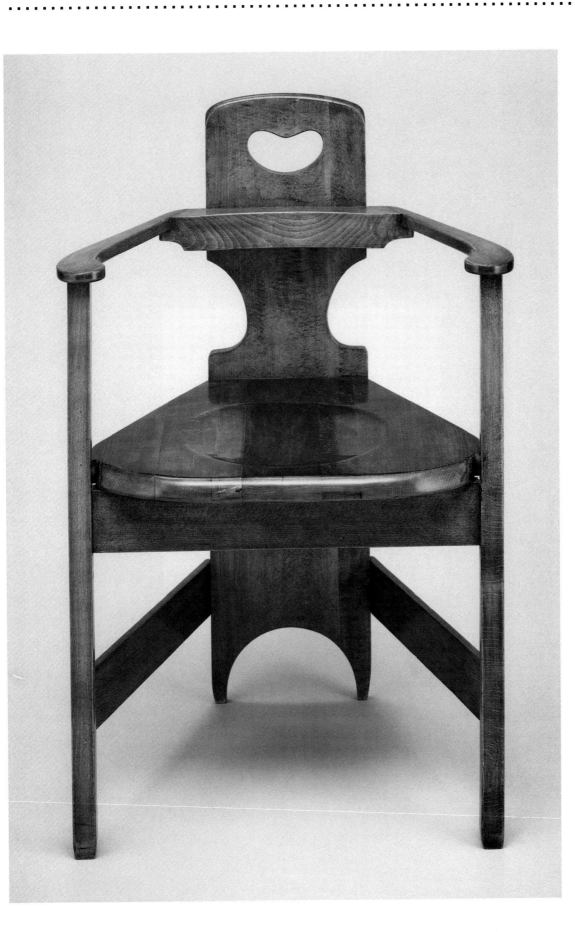

119

Richard Riemerschmid
German, 1868–1957

Armchair · 1900

· · · ·

Stained beech
84.5 x 59.1 x 49.5 cm (33¼ x 23¼ x 19½ in.)

Donald Morris Gallery, Inc.

LIKE Bruno Paul, his colleague
at the Vereinigte Werkstätten für
Kunst und Handwerk in Munich,
Riemerschmid was concerned with
the production of well-designed,
easily manufactured furniture. The
corner chair is constructed of simply
but attractively shaped boards and
planks in a manner consistent with
the ideals of the Arts and Crafts
movement and perhaps inspired by
German furniture of the sixteenth
century.

❖ •••

100

Eliel Saarinen
Finnish, 1873–1950

Coffee Service · 1905–10

. . . .

Brass and wood
Coffee pot on stand 27.9 x 21 cm diam.
(11 x 8¼ in.)
Tray 1.25 x 22.2 cm diam. (½ x 8¾ in.)
Creamer 10.2 x 9.5 cm diam. (4 x 3¾ in.)
Sugar bowl with cover 8.3 x 14.6 cm diam.
(3¼ x 5¾ in.)
Collection of Ronald S. and Nina H. Swanson

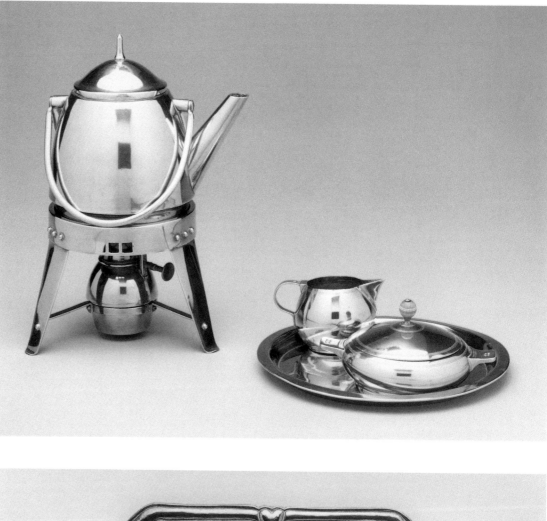

T HE coffee service shows the
work of the young Saarinen in an
international idiom, greatly influenced
by the geometric designs of the Wiener
Werkstätte. The wall sconce is one of
a pair made for Hvitträsk, Saarinen's
lakeside country house in Finland, built
between 1901 and 1903. A photograph
of the dining room at Hvitträsk taken
after 1918 shows the pair of sconces
mounted on the wall over the dining
table. While much of the house and
its furnishings is consistent with the
Viennese influence seen in the coffee
service, the sconces reveal an interest
in what might be termed an idiomatic
«Finnish» style.

Eliel Saarinen

Wall Sconce · before 1918

. . . .

Brass and enamel
37.2 x 60.3 x 15.2 cm (14⅝ x 23¾ x 6 in.)
Collection of Ronald S. and Nina H. Swanson

122

Emilie Schleiss-Simandl
Austrian, 1880–1962

Standing Angel · 1905–12

· · · ·

Glazed earthenware
80 x 21 cm square (31½ x 8¼ in.)
Anonymous loan

Wᴴɪʟᴇ a student of Moser at the Kunstgewerbeschule, Vienna, Simandl joined Hoffmann and other members of the Wiener Werkstätte in the 1904 commission for the Palais Stoclet, a mansion built in Brussels for Adolphe Stoclet and his family. Simandl designed figurative sculpture for the interior and a model for the stone carving on the facade. The striking resemblance of this angel to the central figure over the entrance of the exhibition pavilion designed by Hoffmann for the Vienna Kunstschau (1908) suggests that she may have had a hand in designing the decoration for that building as well.

123

Gustave Serrurier-Bovy
Belgian, 1858–1910

Coat Rack · 1906

· · · ·

Iron and brass
203.9 x 63.5 cm diam. (80¼ x 25 in.)
Anonymous loan

Sᴇʀʀᴜʀɪᴇʀ-ʙᴏᴠʏ designed a wide range of objects in the Art Nouveau style. Among his most important contributions are experiments in metal furniture and furnishings, such as this coat rack designed in 1906 for the Marchal pastry shop in Brussels. These achievements can be viewed in the context of nineteenth-century architectural monuments such as the Crystal Palace of 1851 and the Eiffel Tower of 1889. Except for cast-iron architectural elements, metal furniture was rare until the introduction of tubular steel used by the Bauhaus designers in the 1920s. The clock, too, demonstrates Serrurier-Bovy's interest in metal, here used in a purely decorative manner.

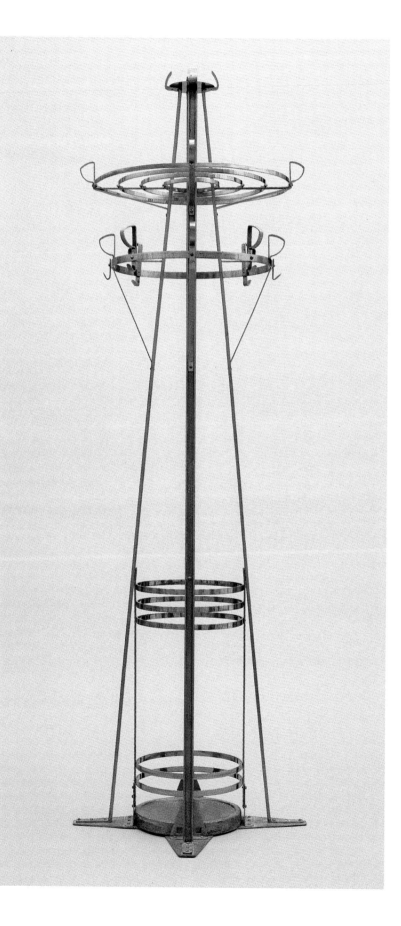

124

Gustave Serrurier-Bovy

Clock · 1900–10

. . . .

Oak, brass, iron, and miscellaneous materials
73 x 39.4 x 20.3 cm (28¾ x 15½ x 8 in.)

Anonymous loan

125

Josef Urban
Austrian, 1872–1933

Armchair • ca. 1900

· · · ·

Walnut and metal
84.8 x 61.6 x 60 cm (33⅜ x 24¼ x 23⅝ in.)
Collection of Gayle and Andrew Camden

Urban's armchair design is bold and distinctive. The broad back sweeps forward to form the front legs of the chair, minimizing the necessity of joinery in the structure. This is a rare example of Urban's furniture, because by 1906 design for the stage became the focus of his successful career.

Tʜɪs screen was shown in the study designed by Van de Velde for the Munich Secession in 1899. The period saw renewed demand for folding screens and Van de Velde went on to design other examples in different styles. The trapezoidal glass panels and the powerful, openwork line carved above the end panels of the screen show the characteristic energy in the work of this pioneering designer. Van de Velde's facility with graphic design provided additional dynamism to his furniture designs.

126

Henry van de Velde
Belgian, 1863–1957

Folding Screen • 1898–99
. . . .

Oak and glass with brass hinges
161.9 x each panel 50.2 cm w.
(63¾ x 19¾ in.)
Anonymous loan

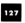

127

Henry van de Velde

Reinhold Hanke, manufacturer

Vase · 1903

· · · ·

Glazed stoneware
22.7 x 17.8 cm diam. (9 x 7 in.)
Impressed on bottom Van de Velde monogram,
«2043B», and «WESTERWALD/ART
POTTERY» in rectangle

Collection of Jerome and Patricia Shaw

V AN DE VELDE was asked to
collaborate on revitalizing the outdated
Westerwald ceramic works at Höhr-
Grenzhausen in Germany; his designs
for this pottery were his first venture
into ceramics. This vase is a rare
decorated example of a standard shape.
The dynamic, doubled-back line that
defines the shoulder of this vase is
seen throughout Van de Velde's work;
the shape of the body is emphasized
by firm and repetitive lines.

128

Henry van de Velde

Insel-Verlag, Berlin

Friedrich Nietzsche, *Also Sprach Zarathustra, ein Buch für Alle und Keinen* · 1908

. . . .

Title page with ornament, added decorated
double title page, four full-page designs,
vignettes, and ornaments by Henry van de Velde
Set in type designed in 1900 by George Lemmen
and printed under the direction of Van de Velde
on the press of W. Drugulin on handmade
Van Gelder paper with Z watermark
Publisher's binding of vellum with gilt lettering
37.2 x 24.8 cm (14⅝ x 9¾ in.)
Copy no. 456 from an edition of 530

Collection of Sheila and Jan van der Marck

Richly ornamented throughout in a rhythmic, dynamic pattern, the intricate design of this book is a testament to Van de Velde's virtuosity as a graphic designer. His well-known interest in the writings of Nietzsche was no doubt an added inspiration; while Van de Velde orchestrated the printing and binding of many works by Nietzsche, no other is so lavish. The large edition is unusual for what was probably a very expensive volume.

129

Otto Wagner
Austrian, 1841–1918

Shelving Unit · 1904

· · · ·

Beech, oak, and aluminum
136.8 x 120.7 x 36.2 cm (53⅞ x 47½ x 14¼ in.)
Anonymous loan

Wagner's Österreichische Postsparkasse (Austrian Postal Savings Bank), built in Vienna between 1904 and 1906, is one of the key monuments of early modern architecture in Europe. The bentwood furnishings which Wagner designed for the building are no less important for the history of design than is the architecture. Even the executive offices and the board room were furnished with bentwood pieces trimmed with aluminum hardware. The best known of these pieces are the armchair designed for the board room and the variations on that design made for other offices throughout the building. The shelving unit, however, is perhaps the most striking of Wagner's early furniture designs. The shelves are supported by bentwood rings held in place by prominent aluminum bolts through the bentwood uprights. Unlike the chairs and Wagner's other designs, the shelving unit was not mass produced for the general retail market.

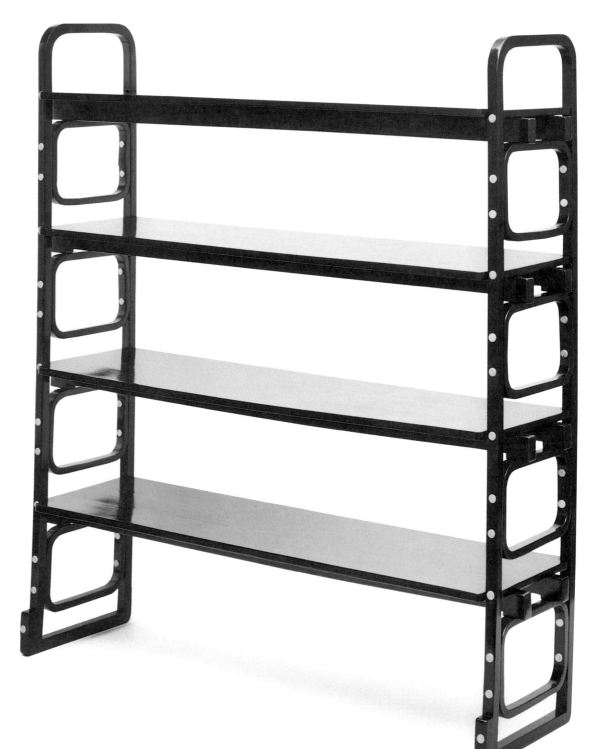

130

Zsolnay
Hungarian, 1862–present

Ewer · ca. 1900

. . . .

Earthenware with luster decoration
22.9 x 12.7 cm diam. including handle (9 x 5 in.)
Raised Zsolnay mark on bottom; impressed «6029»,
and «M»; inscribed in black «C528»

Collection of Donald and Marilyn Ross

THIS Hungarian ceramic works became known at the turn of the century for dramatic and intensely colored luster patterning, often in Art Nouveau designs. Their trademark glaze was the rich, red iridescent one seen here, marketed as «Eosin». Little is known about individual designers in this family-run business. The shape of this ewer is intended to suggest the body of a bird, and both this detail and the exotic bird which decorates the side of the vessel may have been inspired by Isnik pottery.

Biographies

✣

Bibliography

✣

Index

Mary Beth Kreiner

Biographies

L'Art Nouveau · French (1895–1905)

In 1895 **Siegfried Bing** (French, 1838–1905) opened L'Art Nouveau, a showcase and gallery in Paris. **Henry van de Velde** and **Maurice Denis** designed rooms in the gallery. Impressed with **Louis Comfort Tiffany**'s workshops, Bing opened similar workshops at the gallery in 1898 to produce textiles, furniture, metalwork, jewelry, and stained glass. In some cases works by designers commissioned by Bing were made by outside manufacturers. For example, the ceramics designed by **Georges de Feure** and **Edward Colonna** for L'Art Nouveau were manfactured by **G.D.A.**, one of the oldest of the Limoges ceramic houses. Colonna and de Feure designed a variety of decorative objects for Bing, and were responsible, along with Eugène Gaillard, for the design of the six rooms in the L'Art Nouveau Pavilion at the 1900 Paris Exposition Universelle. L'Art Nouveau was not a commercial success. Bing probably went bankrupt in 1903 but kept the gallery going on a smaller scale until his death in 1905.

Ashbee, Charles Robert · English (1863–1942)

Ashbee graduated from King's College, Cambridge, with a degree in history and worked briefly for the architect G. F. Bodley in 1886. Influenced by the writings of John Ruskin, Ashbee founded the School and **Guild of Handicraft** in London in 1888. Workshops at the Guild included metalwork and jewelry making, leatherwork, cabinetry, and decorative painting. The **Essex House Press** was added to these in 1898. The guild moved from London to Chipping Camden in the Cotswolds in 1902. The School and Guild disbanded in 1908, and Ashbee returned to his architectural career.

Barlach, Ernst · German (1870–1938)

A German Expressionist primarily known for his prints and sculptures, Barlach also designed works in ceramic throughout his career. He and **Richard Mutz** first collaborated on a ceramic plaque to commemorate the twenty-fifth anniversary of the Altonaer Museum in Hamburg in 1902, and Barlach continued to design work for Mutz's workshop.

Behrens, Peter · German (1868–1940)

Behrens studied painting in Düsseldorf and Munich. In 1892 he was one of the founding members of the Munich Secession and of the Vereinigte Werkstätten für Kunst im Handwerk in 1898. He designed, among other things, furniture, wallpaper, carpets, and glassware. He was invited to join the Darmstadt artists colony in 1899, where he designed, furnished, and decorated his own home, his first attempt

at architecture. Between 1907 and 1914, Behrens's work as artistic director for the Allgemeine Elektricitäts-Gesellschaft (AEG) in Berlin made him a leading figure in industrial design.

Bugatti, Carlo · Italian (1856–1940)

Bugatti studied at the Accademia di Brera in Milan and the Ecole des Beaux-Arts in Paris. He was trained as an architect, but around 1880 he decided to devote his talents to furniture design. His combinations of varied materials, such as leather, silk, lacquer, copper, and inlays of ivory, metal, and mother-of-pearl, contribute to the unusual quality of his furniture. In 1904, he moved from Milan to Paris, where he concentrated on designs for metalwork.

Chini, Galileo · Italian (1873–1956)

Around 1896, Galileo Chini and Vittorio Giunti set up a ceramics factory in Florence which they named **L'Arte della Ceramica**. Galileo's cousins Guido and Chino also worked at the factory. The pottery designed by Galileo exhibits a number of influences, including oriental pottery and early tin-glazed wares, as well as contemporary works by English and Viennese designers. Galileo and Chino left L'Arte della Ceramica in 1904 and opened a ceramics factory in the Mugello region.

Cobden-Sanderson, Thomas James · English (1840–1922)

Cobden-Sanderson, a lawyer by profession, was encouraged by **William Morris**'s wife, Jane, to pursue his interest in bookbinding. He set up the **Doves Bindery** in 1893 near the Morrises' home, Kelmscott, in Hammersmith. Desiring to produce entire books, he and Morris's former associate Emery Walker established the **Doves Press**, which published its first book in 1901 and closed in 1916.

Colonna, Edward · French/American (1862–1948)

Colonna was born in Germany and emigrated to the United States in 1882. In New York, he worked briefly for several design firms, including **Louis Comfort Tiffany** and Associated Artists. He moved to Dayton, Ohio, in 1885 to work for the Barney and Smith Manufacturing Company, a firm that built railroad cars. By 1897, he had returned to Europe, and was one of the primary designers employed by Siegfried Bing at **L'Art Nouveau**. Colonna designed a myriad of decorative objects for Bing, including jewelry, textiles, ceramics, and furniture. From 1905 until his death, he worked in America.

Dalpayrat, Pierre-Adrien · French (1844–1910)

Born in Limoges, Dalpayrat worked in several regions in France before setting up in 1889 a workshop in Bourg-la-Reine near Paris. Here he developed a coppery-red stoneware glaze, *rouge Dalpayrat*, which he often combined with blues, reds, and yellows to achieve a marbled effect. His work won a gold medal at the World's Columbian Exposition in Chicago in 1893. Dalpayrat worked increasingly with porcelain and earthenware after 1902. Around 1910, he produced stoneware from the designs of Marcel Dufrêne for La Maison Moderne in Paris.

Deck, Joseph-Théodore · French (1823–1891)

Deck was superintendent of a ceramic stove factory in Paris when he began producing his own ceramic pieces in 1856. He drew his primary inspirations from Chinese, Japanese, and Middle Eastern ceramics.

Deck is credited with producing the first flambé glaze (a glaze streaked with coppery reds and purples) of the period. He became director of the Manufacture Nationale de Sèvres in 1887.

De Morgan, William Frend · English (1839–1917)

William De Morgan attended the Royal Academy in London from 1859 to 1861. He began designing stained glass and tiles for Morris, Marshall, Faulkner, and Company in 1862. He established a pottery factory in Sand's End, Fulham, in 1888 with architect Halsey Ricardo as his partner. At Fulham, De Morgan continued the experiments with luster glazes he began at **Morris and Company**, achieving double and triple luster effects, and a range of pure color glazes similar to those found in Middle Eastern ceramics. His most lucrative tile commissions came from the P & O steamship line, for which he supplied decorative schemes for twelve liners.

Denis, Maurice · French (1870–1943)

Primarily known as a Symbolist painter, art theoretician, and member of the Nabis, Denis worked also as a graphic artist. He attended both the Académie Julian and the Ecole des Beaux-Arts in Paris. He made his first lithograph around 1889, and his prints illustrate several books, including Verlaine's *Sagesse* (1889, published 1911) and André Gide's *Le voyage d'Urien* (1893).

Doat, Taxile · French (1851–ca. 1938)

Doat supported himself as a telegrapher while studying sculpture at the Ecole des Beaux-Arts in Paris. He began working at the Manufacture Nationale de Sèvres in 1877. The works he exhibited at the 1900 Exposition Universelle in Paris gave him a worldwide reputation as a ceramic artist. His writings on his ceramic experimentations, *Grand Feu Ceramics*, were published in 1905. He came to St. Louis in 1909 to serve as director of the pottery works in University City, the cultural institution established by businessman Edward Lewis Gardner. Doat returned to France in 1915.

Dresser, Christopher · English (1834–1904)

Dresser studied at the government School of Design in Somerset House, London, but later received a doctorate in botany. Dresser was one of the prominent industrial designers in England from the mid-1860s to the 1890s. He designed ceramics for **Minton and Company** and J. Wedgwood and Sons in the 1860s and 1870s and for **Ault Pottery** in the 1890s. Dresser established his own business, Linthorpe Pottery, in Derbyshire which was in operation from 1879 to 1882. He designed silverplated work for **Hukin and Heath** of Birmingham from 1877 to 1900, and glass for **James Couper and Sons** of Glasgow from 1880 to 1896. He also designed wallpaper, textiles, cast-iron furniture, and linoleum and published articles and books on industrial design.

Eckmann, Otto · German (1865–1902)

Eckmann gave up painting to pursue the applied arts. He studied Japanese methods of printmaking, and his woodcuts for the journals *Pan* and *Jugend* secured his reputation. His flowing interpretation of natural forms made him one of the foremost exponents of Jugendstil. He designed many different types of decorative objects, including furniture, tapestries, silver, and ceramics.

Feure, Georges de · French (1868-1943)

Born of Dutch parents, de Feure (whose real name was Georges Joseph van Sluijters) was a Symbolist painter and poster designer before he won acclaim for his interior designs for a woman's sitting room and boudoir in the Pavillon de L'Art Nouveau Bing at the 1900 Exposition Universelle in Paris. He continued to design furniture, pottery, rugs, jewelry, and other decorative objects for **L'Art Nouveau**.

Follot, Paul · French (1877–1941)

In the late 1890s, Follot studied under graphic designer Eugène Grasset at the Ecole Normale d'Enseignement du Dessin in Paris and later succeeded Grasset in that post. From 1901 to 1904, he designed metalwork, jewelry, and textiles for La Maison Moderne, art critic Julius Meier-Graefe's gallery in Paris. He became director of the interior design studio Pomone of the Paris department store Le Bon Marché in 1923, introducing the Art Deco style into many middle-class homes.

Gallé, Emile · French (1846–1904)

Gallé learned about glassmaking and ceramics from his father Charles, who made most of the wares he sold in his shop in Nancy. Gallé studied botany for several years at the Université de Nancy and began an apprenticeship at the glassworks Burgun, Schwerer, and Company in Meisenthal, Germany in 1866. In 1874, Gallé became artistic director of his father's prosperous business. Gallé showed over three hundred pieces of glass at the Union Centrale des Arts Décoratifs in Paris in 1884. He took up cabinetmaking and first exhibited his furniture at the 1889 Exposition Universelle in Paris. In an effort to unite the decorative artists of Nancy, which included **Louis Majorelle** and Auguste Daum, Gallé founded the Alliance Provinciale des Industries d'Art in 1901.

Gates Potteries · American (1890–1930)

Located in Terra Cotta, Illinois, Gates Potteries was a division of the **American Terra Cotta and Ceramic Company** and the parent company to **Teco Pottery**. Teco, the name formulated from the first syllables of "terra cotta" by the company's founder, William Day Gates (1852-1935), was first offered to the public at the Louisiana Purchase Exhibition in St. Louis in 1904. The pottery produced by Teco was molded rather than hand thrown, utilizing the stylized approach to natural forms created by such designers as the sculptor **Fritz Albert** (1865-1940) and the architect **Frank Lloyd Wright**.

Gimson, Ernest William · English (1864–1919)

Gimson met the brothers Ernest and Sidney Barnsley while working for London architect J. D. Sedding. In 1890, they established Kenton and Company, a furniture design firm which disbanded in 1892. In 1902, Gimson opened his own workshop at Daneway House, Sapperton, where he hired experienced craftsmen to carry out his designs. Although best known as a furniture designer, Gimson's preferred area of expertise was decorative plasterwork.

Godwin, Edward William · English (1833–1886)

Godwin was trained as an architect, and his early work is mostly in the Neo-Gothic style. In 1862, influenced by Japanese art, he was one of the first to work in the Anglo-Japanese style. He designed a home for the painter James McNeil Whistler on Tite Street in Chelsea in 1877-78 and redecorated Oscar Wilde's house on the same street in 1884. Godwin began designing furniture in 1867. He was

not concerned with the revival of craftsmanship, as were his colleagues in the Arts and Crafts movement. His furniture designs usually featured simple forms easily manufactured by machines.

Gorham Manufacturing Company · American (1831–present)

Established by Englishman Jabez Gorham in Providence, Rhode Island, in 1831, the Gorham Manufacturing Company became one of the foremost manufacturers of silver in the world. At the 1900 Paris Exposition Universelle, the company introduced a line of silver «Martelé» (the French for «hammered») which was entirely made by hand in the Arts and Crafts tradition but was Art Nouveau in style. The company ceased producing the line in 1912.

Grueby Faience Company · American (1894–ca. 1920)

Established in Boston by William H. Grueby in 1894, the Grueby Faience Company was one of the major producers of American art pottery. The demand for wares made by Grueby became so great that, in 1908, the company was split into the Grueby Pottery Company (closed 1910) and Grueby Faience and Tile Company. Grueby was the first American art pottery to perfect an opaque matte glaze and was particularly well known for its green matte glaze.

Gruel, Léon · French (1841–1923)

In 1891, Gruel took over the bookbindery his father had established in 1825 in Paris. In 1887, Gruel published a two-volume work entitled *Manuel historique et bibliographique de l'amateur de reliure* in which he asserted his belief that modern bookbindings should be decorated in a modern fashion. His bindings often featured panels of repoussé and incised leather, inlaid ivory pieces, and bright colors.

Hoffmann, Josef · Austrian (1870–1956)

Hoffmann was born in Moravia and studied architecture at the Akademie der bildenden Künste in Vienna under **Otto Wagner** from 1892–94. He was a co-founder of the Vienna Secession in 1897, co-founder, with **Koloman Moser**, of the **Wiener Werkstätte** in 1903, and co-founder of the Werkbund in Vienna in 1910. Highlights of Hoffmann's long career as an architect and designer include the Purkersdorf Sanatorium near Vienna in 1904 and the Palais Stoclet in Brussels in 1905–11.

Iribe, Paul · French (1883–1935)

Iribe published a satiric journal, *Le Témoin*, from 1906 to 1910. In 1908, his album of illustrations of haute couture designs by Paul Poiret made his work very popular among the fashion-conscious women of the day. He set up an interior decorating studio in Paris in 1910 and designed furniture, textiles, wallpaper, and decorative objects. In 1914, he moved to the United States where he was employed by Cecil B. DeMille and other producers as an artistic director. He returned to Paris in 1931, designed jewelry for Chanel, and contributed illustrations to various books and publications.

Jarvie, Robert Riddle · American (1865–1941)

Jarvie was a clerk for the city of Chicago and began metalsmithing as an amateur. In 1905, the popularity of his work, particularly the simple and elegant lines of his cast bronze and copper candlesticks, allowed him to open his own shop. There he offered an expanded line of metalwork, and later, rugs

and furniture of his own design. His unusual presentation pieces and trophies were also in demand. During and after World War I, sales dwindled, and he closed the shop in 1920.

Jacob and Josef Kohn · Austrian (1867–1914)

Jacob Kohn and his son Josef established a partnership in 1867 and built their first furniture-making factory in 1869. By 1890, they had seven factories in Eastern Europe. When the Thonet brothers' patent on bentwood furniture expired in 1869, the Kohns became their strongest competitors. Between 1899 and 1914, Gustav Siegel, a former student of **Josef Hoffmann**'s at the Kunstgewerbeschule in Vienna, was head of the firm's design department. Siegel supervised the production of furniture designed by Hoffmann, **Otto Wagner,** and **Koloman Moser.** In 1914, the firm of Jacob and Josef Kohn merged with the Mundus company of Vienna.

Königliche Porzellan-Manufaktur (K.P.M.) · German (1763–present)

The Königliche Porzellan-Manufaktur was established by Frederick the Great in Berlin in 1763. The first porcelain produced by the factory was neo-classical in style, but in the early 1800s porcelain with elaborate decoration was introduced. K.P.M. began making less expensive porcelain for the middle-class market in the 1840s. **Hermann August Seger** became the company's research director in 1878.

Lalique, René · French (1860–1945)

In 1876, Lalique studied at the Ecole des Arts Décoratifs in Paris and was an apprentice for goldsmith Louis Aucoc. He studied sculpture at the Ecole Bernard Palissy in 1880. He worked on a freelance basis for several jewelers, including Cartier and Boucheron, from 1881 until 1886, when he opened his own workshop in Paris. Lalique began experimenting with glass in the 1890s, and made his first piece, a perfume bottle and stopper, in the lost-wax method in 1893. In 1905, Lalique established a retail shop next to Coty and designed bottles for Coty and other perfumers.

Liberty and Company · English (1875–present)

Arthur Lasenby Liberty (1843-1917) entered the retail trade as a young man, worked for Farmer and Rogers' Great Shawl and Cloak Emporium on Regent Street in London, and developed an eye for the exotic and unusual. Liberty was very perceptive as to up-coming fads and fashions, and was associated with the Aesthetic movement, the Arts and Crafts movement, and Art Nouveau. He established Liberty and Company in 1875. The designers and companies he contracted to design for the firm were not allowed to use their own marks, so the public would keep only the name «Liberty» in mind. **Archibald Knox** (1864–1933) began working for Liberty's in 1898 and was responsible for the best examples of the firm's popular Celtic-inspired pewter and silver lines, «Tudric» and «Cymric». **Christopher Dresser** also designed textiles for the company in the early 1880s as well as the «Clutha» glass line. **E. W. Godwin** was director of Liberty's costume department, which opened in 1884.

Charles P. Limbert · American (1854–1923)

Limbert moved from Chicago to Grand Rapids, Michigan, in 1889. He and his partner Philip Klingman rented a building for a furniture showroom and began making chairs in 1890. The business became known as **C. P. Limbert Company** and began manufacturing «Holland Dutch Arts and Crafts» Furniture in 1902. The factory moved to Holland, Michigan, in 1906 and closed in 1944.

Loos, Adolf · Austrian (1870–1933)

Loos studied architecture at the Technische Hochschule in Dresden from 1890–93. He then spent three years traveling in the United States, visiting New York, Philadelphia, and Chicago. Loos's designs both for architecture and decorative arts were simple and functional. He was opposed to what he saw as meaningless ornamentation in the designs of **Josef Hoffmann** and the **Wiener Werkstätte**, which he denounced in a 1908 article entitled «Ornament and Crime».

Mackintosh, Charles Rennie · Scottish (1868–1928)

In 1889, Mackintosh became a junior draftsman in the Glasgow architectural firm of Honeyman and Keppie and was made a partner in 1901. There he became acquainted with James Herbert MacNair. At evening classes of the Glasgow School of Art, he met Margaret and Frances MacDonald. Mackintosh, MacNair, and the MacDonald sisters became known as «The Four», and their designs for furniture, graphics, and decorative arts were exhibited in Glasgow and London. Mackintosh's architectural works include the Glasgow School of Art (1896), and the Buchanan Street (1896), Argyle Street (1897), and Ingram Street (1900) Tea Rooms he designed for Catherine Cranston. While not widely acclaimed in England, artists and designers on the continent, especially those from Vienna such as **Koloman Moser** and **Josef Hoffmann,** greatly admired Mackintosh's architecture and interiors.

Majorelle, Louis · French (1859–1926)

Majorelle was studying painting and architecture at the Ecole des Beaux-Arts in Paris when his father died in Nancy and he assumed the directorship of his father's cabinetmaking and ceramic business there. Majorelle's first furniture designs were in the neo-classical mode, but in the 1890s he embraced the Art Nouveau style. The furniture he exhibited at the Paris Exposition Universelle in 1900 won him worldwide acclaim. In 1901, he, **Emile Gallé**, and other designers in Nancy became known as the «Ecole de Nancy», which thrived until around 1910, when interest in the Art Nouveau movement was waning.

Martin Brothers · English (1873–1915)

Robert Wallace Martin (1843–1924) opened a pottery in 1873 in Fulham with three of his younger brothers, Walter (1857–1912), Edwin (1860–1915), and Charles (1846–1910). Wallace was the designer, Walter the thrower, Edwin the decorator, and Charles oversaw the financial end of the business and supervised their shop in London. In 1903, a fire in the London store virtually destroyed their recent output and some of their best work. After the fire, Charles, Walter, and Edwin died within a few years of each other, and Wallace produced very little work after Edwin died in 1915.

Moore, Bernard · English (1850–1935)

Bernard and his brother Samuel Vincent inherited their father Samuel's pottery works in St. Mary's Work, Longton, in 1867. The Moore Brothers produced high-quality tableware and decorative items until the firm was sold in 1905. Bernard set up his own workshop in Stoke-on-Kent, where his continuing attempts to recreate Middle Eastern glazes and effects proved successful.

Morris, William · English (1834–1896)

Morris attended Oxford University, where he was influenced by the writings of John Ruskin. Along with Pre-Raphaelite artists Edward Burne-Jones, Dante Gabriel Rossetti, Ford Maddox Brown, and the architect Philip Webb, Morris founded Morris, Marshall, Faulkner, and Company in 1861, renamed **Morris and Company** in 1875. The firm produced stained glass, furniture, tiles, textiles, wallpaper, and metalwork. An avowed socialist, Morris spent most of the 1880s promoting political causes. In 1890, he founded the Kelmscott Press, located near his home, Kelmscott House, in Hammersmith.

Moser, Koloman · Austrian (1868–1918)

Moser studied painting at the Akademie der bildenden Künste and the applied arts at the Kunstgewerbeschule, both in Vienna. He was a founding member of the Vienna Secession in 1897 and often contributed artwork to its journal, *Ver Sacrum*. A designer of everything from postage stamps to furniture to glassware, Moser began teaching at the Kunstgewerbeschule in 1899. In 1903, Moser was co-founder with **Josef Hoffmann** of the **Wiener Werkstätte.**

Mutz, Richard · German (1872–1931)

Mutz became a full partner in his father Hermann's pottery in Altona, near Hamburg, Germany, in 1896. He and **Ernst Barlach** began collaborating on various works in 1902. This collaboration continued after Richard set up his own workshop in Berlin in 1904. In 1906, he established Keramische Werkstätten Mutz und Rother in the small German town of Liegnitz to produce architectural ceramics and later manufactured wall tiles and ceramic stoves.

Newcomb Pottery · American (1895–1940)

Newcomb Pottery sprang from the academic programs offered at H. Sophie Newcomb Memorial College, the women's branch of Tulane University in New Orleans. In 1894, **Mary Given Sheerer**, a china painter and pottery designer from Cincinnati, was hired and the pottery was in full operation by 1895. The women designed and decorated the pottery and men were hired to throw, glaze, and fire the pottery. One of these men was **Joseph Meyer** (1848–1931), who started working at Newcomb in 1896 and stayed for thirty years. **Harriet Joor** (d. 1965) was among the first students in the Newcomb program. By the early 1900s, Newcomb was the largest American producer of individually decorated art pottery, second only to the **Rookwood Pottery**. Production was strong through the 1920s, but in the 1930s sales declined. Around 1940, pottery making became a strictly academic program at Tulane.

Olbrich, Joseph Maria · Austrian (1867–1908)

Olbrich attended the Akademie der bildenden Künste in Vienna from 1891 to 1893. In 1894, he worked in **Otto Wagner's** architectural studio as did his former classmate, **Josef Hoffmann**. Olbrich was one of the co-founders of the Vienna Secession in 1897 and was the architect of the Secession's exhibition building in Vienna in 1897–89. He became a member of the Darmstadt artists colony in 1899. Olbrich was the architect of many buildings and homes there, including the «Wedding Tower», which was built in honor of the marriage of Darmstadt's patron Grand Duke Ernst Ludwig in 1905.

Paul, Bruno · German (1874–1968)

Paul started attending the Kunstgewerbeschule in Munich at age twelve and later studied painting at the Kunstakademie, also in Munich. Along with **Peter Behrens, Richard Riemerschmid**, and others, he was one of the founding members of the Vereinigte Werkstätten für Kunst im Handwerk in Munich in 1897 as well as one of the co-founders of the Deutscher Werkbund in 1907. In the early 1900s, Paul began experimenting with an unornamented style of furniture that would result in 1908 in «Typenmöbel», a standardized system of units of furniture for smaller dwellings that could be added to when desired and was manufactured by the Vereinigte Werkstätten. He served as director of the Vereinigte Staatsschulen für Freie und Angewandte Kunst in Berlin from 1907 to 1933 and after the early 1920s devoted most of his energy to his architectural practice.

Peche, Dagobert · Austrian (1887–1923)

Peche studied architecture at the Akademie der bildenden Künste in Vienna from 1908 to 1911. In 1915, he joined the **Wiener Werkstätte**, and supervised its branch in Zurich from 1917 to 1919. His design style, known as *Spitzbarock* («spiky baroque»), had a great deal of influence on the work produced at the Werkstätte after 1915, enlivening the more severe and geometric style favored by most members of the group. He designed a wide variety of decorative objects.

Pewabic Pottery · American (1900–present)

Detroit's Pewabic Pottery was named for a copper mine near the birthplace of its founder, **Mary Chase Perry Stratton** (1867-1961), at Hancock in Michigan's Upper Penninsula. Stratton and her partner Horace Caulkins, a Detroit dentist and inventor of the «Revelation» portable porcelain kiln, began pottery production in 1900. Her pottery is renown for its dense matte glazes and, in particular, iridescent glazes. Challenged by Charles Lang Freer in 1904 to produce a finish similar to one found on a shard of ancient Babylonian pottery in his collection, Stratton experimented for five years before devising reliable formulas for six different iridescent glazes. Pewabic began producing handmade architectural tile as well as vessels around 1905; these tiles grace such buildings as the Detroit Institute of Arts, the Detroit Public Library, and several of **Eliel Saarinen**'s buildings at Cranbrook.

Pissarro, Lucien · English (1863–1944)

Lucien Pissarro, the son of French Impressionist painter Camille Pissarro, is known primarily for his graphic work. After emigrating to England in 1890, his woodcuts appeared often in **Charles Ricketts**'s periodical *The Dial*. In 1894, he and his wife Esther, who was also an accomplished wood engraver, founded the Eragny Press, which flourished until 1914. Pissarro became an English citizen in 1916.

Powolny, Michael · Austrian (1871–1954)

Powolny attended the Fachschule für Tonindustrie in what is now Znojmo, the Czech Republic, from 1891 to 1894, and the Kunstgewerbeschule in Vienna from 1894 to 1901. He was one of the co-founders of the Vienna Secession in 1897. He and Bertold Löffler established **Wiener Keramik** in 1905 and marketed their products through the **Wiener Werkstätte**. In 1913, Wiener Keramik merged with Gmundner Keramik (founded by Franz and **Emilie Schleiss-Simandl**) to form Vereinigte Wiener und Gmundner Keramik. Powolny taught at the Kunstgewerbeschule from 1912 until his retirement in 1936.

Prutscher, Otto · Austrian (1880–1949)

Prutscher attended the Kunstgewerbeschule in Vienna under **Josef Hoffmann** in 1897 and later taught there. He was a member of the **Wiener Werkstätte** and designed glass and a wide variety of objects. He was also an architect and designed interiors of shops and cafés.

Rhead, Frederick Hurten · American (1880–1942)

A descendant on both sides from several generations of English potters, Rhead emigrated to the United States at the age of twenty-two. After working at both Vance/Avon Faience and S. A. Weller Pottery, Rhead was appointed art director at **Roseville Pottery Company** (1892–1954) in Zanesville, Ohio, in 1904. Rhead left Roseville in 1908 and spent several years at the University City Pottery in Missouri. He was then appointed manager at **Arequipa Pottery** (1911–18) which was established at the Arequipa Sanatorium in Fairfax, California, to serve as both a therapeutic activity and a source of revenue for the female tubercular patients convalescing there. The pottery was made by male potters hired from outside the sanatorium and was decorated by the patients. Rhead left Arequipa in 1913 and briefly set up his own pottery in Santa Barbara; he worked for American Encaustic Tile Company in Zanesville, Ohio, from 1917 until 1927, serving as both the manager of the design and decorating facilities and the Director of Research. In 1927, he became Art Director of the Homer Laughlin China Company in East Liverpool, Ohio, where he developed the still-popular «Fiesta» dinnerware line.

Ricketts, Charles · English (1866–1931)

A man of diverse talents, Ricketts was a painter and sculptor, but it is his book illustrations that link him to Art Nouveau. They show the influence of **William Morris**, Aubrey Beardsley, and the Pre-Raphaelites. From 1889 to 1897, he and Charles Shannon published the journal *The Dial*, with Ricketts serving as co-editor and primary illustrator. In 1896, Ricketts established the **Vale Press** so he could have full control over every aspect of the books produced; it closed in 1904. He began working as a set designer for theater in 1906, and this became his primary focus for the rest of his life.

Riemerschmid, Richard · German (1868–1957)

Riemerschmid trained as a painter at the Kunstakademie in Munich from 1888 to 1890. Soon after, he began experimenting with furniture design and his first pieces were exhibited in 1895. He also designed textiles and porcelain. In 1897, he, **Peter Behrens, Bruno Paul**, and others began the Vereinigte Werkstätten für Kunst im Handwerk in Munich. For the Dresdener Werkstätte, he designed «Maschinenmöbel», reasonably priced suites of machine-made furniture. He was one of the founders of the Deutscher Werkbund in Munich in 1907 and served as its chairman from 1921 to 1926.

Rohlfs, Charles · American (1853–1936)

Rohlfs studied at the Cooper Union in New York. Initially a designer of cast-iron stoves, he worked briefly as an actor before he became interested in woodworking in the late 1880s. By 1898, he was able to open a workshop with a small staff in Buffalo, New York. His furniture was exhibited at Chicago's Marshall Field and Company, as well as the Pan-American Exposition in 1901 in Buffalo, the Esposizione delle Arti Decorative in Turin in 1902, and the Louisiana Purchase Exhibition in St. Louis in 1904.

Rookwood Pottery · American (1880–1960)

Maria Longworth Nichols Storer (1848-1932) had studied china painting for several years before her wealthy father suggested she establish her own pottery at his expense. Rookwood Pottery soon gained an international reputation for the beauty and rich variety of its glazes and decoration. Rookwood was one of the few foreign potteries handled by **L'Art Nouveau** in Paris, thereby making its way into the decorative arts collections of museums throughout Europe. **Artus Van Briggle, Kataro Shirayamadani, John Delaney ("Dee") Wareham,** and **William Purcell McDonald** are several of the many outstanding decorators and designers that were employed by Rookwood.

The Roycrofters · American (1893–1938)

Former soap salesman and Harvard drop-out **Elbert Hubbard** (1856–1915) was on a walking tour of England in 1894 when a visit to Hammersmith and a brief chat with **William Morris** gave direction to his life. Inspired by Morris, Hubbard established the Roycroft Press in East Aurora, New York, to publish his own writings and the works of other authors. The success of this venture allowed him to open a bindery, and not long after, a leathercraft workshop. The construction of the Roycroft Inn in 1901 and the need to furnish it saw the opening of furniture and metalsmithing workshops. **Karl Kipp** headed the Copper Shop from 1908 to 1911. The Roycroft Community, as it was known, thrived until Hubbard and his wife perished during the sinking of the *Lusitania* in 1915. Elbert Hubbard II took over his father's role, and the community closed in 1938.

Saarinen, Eliel · Finnish (1873–1950)

In 1893, Eliel Saarinen studied architecture in Helsinki and went into partnership with two of his fellow students in 1896. In 1922, Saarinen's entry won second prize in the Chicago Tribune Tower competition. In 1925, *Detroit News* publisher George G. Booth commissioned Saarinen as the chief architect for Cranbrook, the educational community Booth was developing in Bloomfield Hills, Michigan. Saarinen's work for Booth included the Cranbook School for Boys, the Kingswood School for Girls, and the Cranbrook Academy of Art, of which Saarinen served as president from 1932 to 1943.

Schleiss-Simandl, Emilie · Austrian (1880–1962)

Simandl attended the Kunstgewerbeschule in Vienna from 1904 to 1908. **Koloman Moser** was one of her professors. She participated with other members of the **Wiener Werkstätte** in the decoration of **Josef Hoffmann**'s Palais Stoclet in Brussels from 1905 to 1911. Her husband, Franz Schleiss, also was a ceramicist. In 1909, they established the Gmundner Keramik in Vienna, which merged with **Michael Powolny**'s Wiener Keramik in 1913 to form Vereinigte Wiener und Gmundner Keramik.

Seger, Hermann August · German (1839–1893)

Seger was appointed technical director of the Königliche Porzellan-Manufaktur in Berlin in 1878. His research lead to the invention of «Seger porcelain», a high-fired soft paste porcelain which was compatible with a wide range of colored glazes. In 1884, he successfully reproduced the Chinese *sang-de-boeuf* glaze and crackle glazes. In 1886, he marketed «Seger Cones», small cones of clay which are placed in kilns and melt at pre-determined temperatures, allowing precise control of firing temperatures. Seger cones are still in use today.

Serrurier-Bovy, Gustave · Belgian (1858–1910)

In the mid-1870s, Serrurier-Bovy studied architecture at the Académie at Liège. He traveled to England in 1884 where he became interested in the English Arts and Crafts movement. On his return to Liège, he opened a shop where he sold objects from Japan and **Liberty and Company** as well as furniture of his own design. In 1899, he established a large furniture manufactory in Liège and opened a shop in Paris named L'Art dans l'Habitation in which to sell his furniture. He exhibited his work at the 1900 Paris Exposition Universelle and the Louisiana Purchase Exhibition in St. Louis in 1904.

Stickley, Gustav · American (1857–1942)

Stickley was introduced to furniture making as a teenager when he worked in his uncle's chair factory in Brandt, Pennsylvania. He began making simple furniture on his own in the late 1880s. In 1899, he opened United Crafts, a workshop modeled on that of **Morris and Company**, near Syracuse, New York. Gustav's brothers Albert and John George set up the Stickley Brothers Company in Grand Rapids, Michigan (1891-present). John George later joined forces with another brother, Leopold, to establish L. and J. G. Stickley in Fayetteville, New York (1902-54). In 1901, the name of Gustav's firm was changed from United Crafts to Craftsman Workshops, and Stickley began publishing *The Craftsman*, a monthly journal concentrating on Arts and Crafts philosophy. Around 1903, Stickley hired the architect **Harvey Ellis** (1852-1904). Influenced by Art Nouveau and **Charles Rennie Mackintosh** in particular, Ellis's designs significantly changed the style of furniture produced by the Craftsman Workshops. He introduced lighter construction, curved aprons and seat rails, and intricate inlays. In 1905, Stickley started a metalwork shop to produce furniture hardware which later added lamps and candlesticks and other household objects to its line. A textile workshop was opened in 1910. In 1913, Stickley bought a twelve-story building in New York which included a restaurant, several floors of Craftsman products for sale, and the headquarters for *The Craftsman*. He filed for bankruptcy in 1915.

Sullivan, Louis · American (1856–1924)

Born in Boston, Massachusetts, Sullivan studied architecture at the Massachusetts Institute of Technology for a year before joining the office of Frank Furness in Philadelphia in 1873. He worked briefly in the Chicago office of William LeBaron Jenney but resigned to continue his education at the Ecole des Beaux-Arts in Paris. Back in Chicago, he worked for several architectural firms before joining Dankmar Adler's office in 1879. Adler and Sullivan became one of the most sought-after architectural firms in Chicago. **Frank Lloyd Wright** was an apprentice and draftsman for Adler and Sullivan from 1887 to 1893. Adler and Sullivan was dissolved in 1895. Sullivan had only twenty commissions in the last twenty-nine years of his life, but these included the Carson-Pirie-Scott Store in Chicago (1899–1904) and several banks, often refered to as «jewel-boxes», scattered in small towns across the Midwest.

Tiffany and Company · American (1837–present)

The firm that was to become Tiffany and Company began as a stationery and fancy goods store named Tiffany and Young in New York in 1837. Charles Louis Tiffany (1812-1902) changed the name to Tiffany and Company when he gained full control of the firm in 1853. The company soon became synonymous with quality due to their finely wrought silverware, as well as vases, presentation pieces, trophies, and jewelry. Although **Louis Comfort Tiffany**, Charles's son, was vice-president and artistic

director of Tiffany and Company after his father's death in 1902 until 1918, his actual role in the design of objects produced during his tenure remains unclear.

Tiffany, Louis Comfort · American (1848–1933)

Tiffany was a painter before he became interested in the decorative arts. In 1879, he and fellow artists Samuel Coleman, Candice Wheeler, and Lockwood De Forest formed L. C. Tiffany and Associated Artists, an interior design firm which proved to be very successful in New York. The firm disbanded in 1883. In 1885, he formed the Tiffany Glass Company which became the largest company of its kind in the United States and was one of the few American companies handled by **L' Art Nouveau** in Paris. In 1892, Tiffany changed the title of his company to the Tiffany Glass and Decorating Company. In 1893, Tiffany opened glass furnaces in Corona, New York, and introduced «Favrile» glass. The name of the glass was derived from *fabrilis*, a Latin word indicating craftsmanship, to signify that the glass produced in the Corona furnaces was individually hand-blown rather than blown into a mold. The name of the firm was changed again in 1900 to Tiffany Studios. The firm produced an amazing variety of work, including stained-glass windows, mosaics, table and decorative glassware, enamelware, metalware, ceramics, jewelry, lamps, and lampshades. Tiffany went into semi-retirement in 1919; the Tiffany glass furnaces were closed in 1924; and Tiffany Studios went bankrupt in 1932.

Urban, Josef · Austrian (1872–1933)

Urban practiced as an architect and designer in Europe and was president of the Hagenbund in Vienna from 1906 to 1908. He emigrated to New York in 1911, where he set up his own interior and scenic design firm. He served as scenic designer for the Boston Opera (1911–14) and the Metropolitan Opera (1917–33). He also worked for Florenz Ziegfeld, designing sets for twelve presentations of the Ziegfeld Follies and, in 1927, he was the architect of the Ziegfeld Theatre. He was instrumental in the establishment and design of the **Wiener Werkstätte** shop which opened in New York in 1922.

Van Briggle Pottery Company · American (1901–present)

In 1899, **Artus Van Briggle** (1869–1904) was forced by an advancing case of tuberculosis to leave his position as a senior designer at the **Rookwood Pottery** in Cincinnati, Ohio, for the healthier climate of Colorado. Van Briggle had studied in Europe during his years at Rookwood and became intrigued by the matte glazes on Chinese Ming Dynasty vases exhibited in decorative arts museums in France. Van Briggle carried out experiments at Rookwood, but it was at his own pottery, established at Colorado Springs in 1901, where a version of this matte glaze was perfected. After his death in 1904, his wife Anne Gregory, also a potter, took over the company which is still producing pottery.

Van de Velde, Henry · Belgian (1863–1957)

Van de Velde was born in Antwerp and studied painting at the Ecole des Beaux-Arts in Paris in 1881–82 and in the atelier of painter Carolus Duran from 1884–85. Influenced by the philosophy of **William Morris**, he began working as an architect and designer of applied arts in the early 1890s. In 1895 he designed interiors and furnishings for both **L' Art Nouveau** and Julius Meier-Graef's La Maison Moderne in Paris. That same year, he built his own house, «Bloemenwerf», near Brussels and designed all its furnishings. He moved to Weimar in 1907 where he was appointed artistic adviser to the Duchy of Weimar and was cofounder of the Deutsche Werkbund.

Van Erp, Dirk · American (1860–1933)

Van Erp was trained in metalsmithing by his father in the Netherlands and emigrated to the United States in 1886. He traveled to California, and went to the Klondike to pan for gold several times before opening the «Copper Shop» in Oakland in 1908. Everything in his shop, from vases to firescreens, was constructed and hand hammered. The shop moved to San Francisco in 1910.

Wagner, Otto · Austrian (1841–1918)

Wagner studied architecture at the Königliche Bauakademie in Berlin and the Akademie der bildenden Künste in Vienna, from which he graduated in 1863. He received numerous commisions in Vienna for homes and apartment and commercial buildings and also designed furniture, ceramics, silverware, and textiles. In 1894, Wagner was appointed a professor at the Akademie in Vienna. Among his students were **Josef Hoffmann** and **Joseph Maria Olbrich**. He joined the Vienna Secession in 1899.

Wiener Werkstätte · Austrian (1903–1932)

Josef Hoffmann, **Koloman Moser**, and Fritz Wärndorfer founded the Wiener Werkstätte in Vienna in 1903. The primary aim of the organization was to unite art and craftsmanship in the production of useful yet decorative furnishings for the home. The artisans affiliated with the Werkstätte designed many different types of decorative objects. Some crafts, such as leatherwork and bookbinding, were executed in workshops on the premises of the Werkstätte, while other objects, such as ceramics and glass, were commissioned from outside manufacturers.

Wright, Frank Lloyd · American (1867–1959)

Wright was born in Wisconsin, and, after working briefly for the Chicago architect Joseph Lyman Silsbee, joined the firm of Dankmar Adler and **Louis Sullivan** in 1887. Wright was fired from the firm in 1893 for accepting outside commissions on his own and went on to become the foremost American architect of the twentieth century. Wright's Prairie-style homes featured furnishings specifically designed by the architect for that dwelling to achieve the overall effect sought by Wright.

Zsolnay · Hungarian (1862–present)

The Zsolnay ceramics manufactory was established in 1862 at Pécs, Hungary. Ignaz Zsolnay, founder of the pottery works, passed the directorship on to his brother Vilmos in 1865. The factory began by producing tableware; decorative ware inspired by Middle and Far Eastern porcelains was eventually added. Around 1899, a chemist at the factory, Vinsce Wartha, developed an iridescent, deep red glaze named «Eosin» for which Zsolnay became famous.

Bibliography

This selected bibliography emphasizes the most recent literature which contains references to earlier source materials.

General References

Alcouffe, Daniel, Marc Bascou, Anne Dion-Tenenbaum, and Philippe Thiébaut. *1851–1900: Le arti decorative alle grandi esposizioni universali.* Milan: Idealibri, 1988.

Anscombe, Isabelle and Charlotte Gere. *Arts and Crafts in Britain and America.* New York: Van Nostrand Reinhold Company, 1983.

Bayley, Stephen, Philippe Garner, and Deyan Sudjic. *Twentieth-Century Style and Design.* New York: Van Nostrand Reinhold Company, 1986.

Brandt, Frederick R. *Late 19th and Early 20th Century Decorative Arts: The Sydney and Frances Lewis Collection in the Virginia Museum of Fine Arts.* Seattle: University of Washington Press, 1985.

Chicago, David and Alfred Smart Museum, University of Chicago. *Imagining an Irish Past: The Celtic Revival, 1840–1940.* T. J. Edelstein, ed. Exh. cat., 1992.

Cumming, Elizabeth, and Wendy Kaplan. *The Arts and Crafts Movement.* New York: Thames and Hudson, 1991.

Duncan, Alastair. *Art Nouveau Furniture.* New York: Clarkson N. Potter, Inc., 1982.

Fidler, Patricia J. *Art with a Mission: Objects of the Arts and Crafts Movement.* Exh. cat., Spencer Museum of Art, University of Kansas, Lawrence, 1991.

Haslam, Malcolm. *In the Art Nouveau Style.* Boston: Little Brown and Company, 1990.

Naylor, Gillian. *The Arts and Crafts Movement: A Study of Its Sources, Ideals, and Influence on Design Theory.* Cambridge, Mass.: MIT Press, 1980.

Naylor, Gillian, et al. *The Encyclopedia of Arts and Crafts: The International Arts Movement, 1850–1920.* New York: E. P. Dutton, 1989.

Préaud, Tamara, and Serge Gauthier. *Ceramics of the 20th Century.* New York: Rizzoli, 1982.

Rotterdam, Museum Boymans-van Beunungen. *Silver of a New Era: International Highlights of Precious Metalware from 1880–1940.* Exh. cat., 1992.

Rudoe, Judy. *Decorative Arts 1850–1950: A Catalogue of the British Museum Collection.* London: British Museum Press, 1991.

Russell, Frank, ed. *A Century of Chair Design.* New York: Rizzoli, 1980.

Schmutzler, Robert. *Art Nouveau.* New York: Harry N. Abrams, Inc., 1962.

Sembach, Klaus Jürgen. *Art Nouveau. Utopia: Reconciling the Irreconcilable.* Cologne: Benedikt Taschen, 1991.

Victoria and Albert Museum. *Art and Design in Europe and America 1800–1900.* New York: E. P. Dutton, 1987.

Wichmann, Siefried. *Jugendstil Art Nouveau: Floral and Functional Forms.* Boston: New York Graphic Society, 1985.

British Bibliography

Aslin, Elizabeth. *E.W. Godwin: Furniture and Interior Design.* Exh. cat., London: The Fine Art Society, 1986.

BILLCLIFFE, Roger. *Charles Rennie Mackintosh: The Complete Furniture, Furniture Drawings, and Interior Designs.* New York: E. P. Dutton, 1986.

Mackintosh Furniture. New York: E. P. Dutton, 1984.

CALLOWAY, Stephen, ed. *Liberty of London: Masters of Style and Decoration.* Boston: Bullfinch Press, 1992.

CRAWFORD, Alan. *C.R. Ashbee: Architect, Designer, and Romantic Socialist.* New Haven, Conn.: Yale University Press, 1985.

DURANT, Stuart. *Christopher Dresser.* London: Academy Editions, 1993.

GREENWOOD, Martin. *The Designs of William DeMorgan.* Shepton Beauchamp, Ilminster, Somerset, England: Richard Dennis and William E. Wiltshire III, 1989.

HALÉN, Widar. *Christopher Dresser.* London: Phaidon/Christie's, 1990.

HASLAM, Malcolm. *Arts and Crafts Carpets.* New York: Rizzoli, 1991.

The Martin Brothers Potters. London: Richard Dennis, 1978.

LEVY, Mervyn. *Liberty Style: The Classic Years, 1898–1910.* New York: Rizzoli, 1986.

SPARLING, Henry Halliday. *The Kelmscott Press and William Morris, Master Craftsman.* London: Macmillan and Company, Ltd., 1924.

STANSKY, Peter. *Redesigning the World: William Morris, the 1880s, and the Arts and Crafts.* Princeton, N.J.: Princeton University Press, 1985.

TAYLOR, John Russell. *The Art Nouveau Book in Britain.* London: Methuen and Company, 1966.

TIDCOMBE, Marianne. *The Doves Bindery.* London and New Castle, Del.: The British Library and Oak Knoll Books, 1991.

TORONTO, Art Gallery of Ontario. *The Earthly Paradise: Arts and Crafts by William Morris and His Circle from Canadian Collections.* Exh. cat., Toronto: Key Porter Books Limited, 1993.

American Bibliography

BARTINIQUE, A. Patricia. *Gustav Stickley. His Craft: A Daily Vision and A Dream.* Exh. cat., Parsippany, New Jersey: The Craftsman Farms Foundation, 1992.

BROOKS, H. Allen. *Frank Lloyd Wright and the Prairie School.* New York: George Braziller, Inc., 1984.

The Prairie School: Frank Lloyd Wright and His Midwest Contemporaries. New York: W. W. Norton and Company, 1972.

BRUNK, Thomas W. "Painting with Fire." *American Craft* 48, no. 6 (Dec. 1988-Jan. 1989): 56-60, 69.

Pewabic Pottery: Marks and Labels. Detroit: Historic Indian Village Press, 1978.

CARPENTER, Charles H., Jr. *Gorham Silver, 1831–1981.* New York: Dodd, Mead and Company, 1982.

CARPENTER, Charles H., Jr. and Mary Grace Carpenter. *Tiffany Silver.* New York: Dodd, Mead and Company, 1978.

CATHERS, David M. *Furniture of the American Arts and Crafts Movement: Stickley and Roycroft Mission Oak.* New York: New American Library, 1981.

CHICAGO, The Art Institute of Chicago. *Fragments of Chicago's Past: The Collection of Architectural Fragments at the Art Institute of Chicago.* Exh. cat., 1990.

CINCINNATI Art Galleries. *The Glover Collection: The David W. and Katherine M. Glover Collection of Rookwood Pottery.* Sales cat., 1991.

CLARK, Robert Judson, ed. *The Arts and Crafts Movement in America, 1876–1916.* Exh. cat., Princeton, N. J.: Princeton University Press, 1972. Reprint, 1992.

COLORADO Springs, Colorado Springs Fine Arts Center. *Van Briggle Pottery: The Early Years.* Exh. cat., 1975.

DALE, Sharon. *Frederick Hurten Rhead: An English Potter in America.* Exh. cat., Erie, Penn.: Erie Art Museum, 1986.

DARLING, Sharon S. *Chicago Metalsmiths.* Chicago: Chicago Historical Society, 1977.

Teco: Art Pottery of the Prairie School. Exh. cat., Erie, Penn.: Erie Art Museum, 1989.

DETROIT, The Detroit Institute of Arts. *Arts and Crafts in Detroit, 1906–1976: The Movement, The Society, The School.* Exh. cat., 1976.

The Quest for Unity: American Art between World's Fairs 1876–1893. Exh. cat., 1983.

DOROS, Paul E. *The Tiffany Collection of the Chrysler Museum of Norfolk*. Norfolk, Va.: The Chrysler Museum, 1978.

Louis Comfort Tiffany. New York: Harry N. Abrams, Inc., 1992.

DUNCAN, Alastair, Martin Eidelberg, and Neil Harris. *Masterworks of Louis Comfort Tiffany*. New York: Harry N. Abrams, Inc., 1989.

EIDELBERG, Martin. "The Ceramic Art of William H. Grueby." *Connoisseur* 184 (Sept. 1973): 47-54.

"Tiffany's Early Glass Vessels." *The Magazine Antiques* 137 (Feb. 1990): 502-15.

From Our Native Clay: Art Pottery from the Collection of the American Ceramic Arts Society. New York: American Ceramic Arts Society, 1987.

ELLIS, Anita J. *Rookwood Pottery: The Glorious Gamble*. Exh. cat., Cincinnati Art Museum. New York: Rizzoli, 1992.

FELDSTEIN, William Jr., and Alastair Duncan. *The Lamps of Tiffany Studios*. New York: Harry N. Abrams, 1983.

GRAY, Stephen, ed. *A Catalog of the Roycrofters Featuring Metalwork and Lighting Fixtures*. New York: Turn of the Century Editions, 1988.

Charles P. Limbert Company, Cabinet Makers, Grand Rapids, Michigan. Reprint. New York: Turn of the Century Editions, 1981; revised, 1990.

The Early Works of Gustav Stickley. New York: Turn of the Century Editions, 1987.

Gustav Stickley after 1909: Including a complete Facsimile Reproduction of the 120-page, 1909 "Craftsman Furniture" Catalogue. New York: Turn of the Century Editions, 1990.

GRAY, Stephen and Robert Edwards, eds. *Collected Works of Gustav Stickley*. New York: Turn of the Century Editions, 1981.

GREEN, Leslie Bowman. *American Arts and Crafts: Virtue in Design*. Exh. cat., Los Angles County Museum of Art, 1990.

HANKS, David A. *The Decorative Designs of Frank Lloyd Wright*. New York: E. P. Dutton, 1979.

HIRSCHL and Adler Galleries. *From Architecture to Object: Masterworks of the American Arts and Crafts Movement*. Exh. cat., New York, 1989.

HOSLEY, William. *The Japan Idea: Art and Life in Victorian America*. Exh. cat., Hartford, Conn.: Wadsworth Atheneum, 1990.

KAPLAN, Wendy. *"The Art that is Life": The Arts and Crafts Movement in America*. Exh. cat., Boston: Museum of Fine Arts, 1987.

MANSON, Grant Carpenter. *Frank Lloyd Wright to 1910: The First Golden Age*. New York: Reinhold, 1958.

MAREK, Don. *Arts and Crafts Furniture Design: The Grand Rapids Contribution, 1895–1915*. Exh. cat., Grand Rapids, Mich.: Grand Rapids Art Museum, 1987.

NEW York, Cooper-Hewitt Museum. *American Art Pottery*. Exh. cat., Seattle: University of Washington Press, 1987.

NEW York, The Metropolitan Museum of Art. *In Pursuit of Beauty: America and the Aesthetic Moment*. Exh. cat., 1986.

POESCH, Jesse. *Newcomb Pottery: An Enterprise for Southern Women, 1895–1940*. Exh. cat., Newcomb College, Tulane University. Exton, Penn.: Schiffer Publishing Company, 1984.

Roycroft Hand-Made Furniture. East Aurora, New York: House of Hubbard, 1973.

SAN Francisco, San Francisco Craft and Folk Art Museum. *The Arts and Crafts Studio of Dirk Van Erp*. Exh. cat., 1989.

SMITH, Mary Ann. *Gustav Stickley: The Craftsman*. New York: Dover Publications, 1983.

STICKLEY, Gustav. *The 1912 and 1915 Gustav Stickley Craftsman Furniture Catalogs*. Reprint. New York: Dover Publications, 1991.

What is Wrought in the Craftsman Workshops. Syracuse, N.Y.: 1904. Reprint. New York: Turn of the Century Editions, 1982.

STORRER, William Allin. *The Architecture of Frank Lloyd Wright: A Complete Catalog*. Cambridge, Mass.: MIT Press, 1983.

STOVER, Donald L. *The Art of Louis Comfort Tiffany*. Exh. cat., San Francisco, M. H. de Young Museum, 1981.

SYRACUSE, New York, Everson Museum of Art. *Grueby*. Exh. cat., 1981.

Fragile Blossoms, Enduring Earth: The Japanese Influence on American Ceramics. Exh. cat., 1989.

TRAPP, Kenneth R., et al. *The Arts and Crafts Movement in California: Living the Good Life*. Exh. cat., Oakland, Ca., Oakland Museum. New York: Abbeville Press, 1993.

128

VINCI, John. *The Trading Room: Louis Sullivan and the Chicago Stock Exchange.* Chicago, The Art Institute of Chicago, 1989.

VOLPE, Tod M., and Beth Cathers. *Treasures of the American Arts and Crafts Movement, 1890–1920.* New York: Harry N. Abrams, Inc., 1988.

Continental Bibliography

BARONI, Daniele, and Antonio D'Auria. *Kolo Moser: Graphic Artist and Designer.* New York: Rizzoli, 1984.

BAYER, Patricia, and Mark Waller. *The Art of René Lalique.* Secaucus, New Jersey: The Wellfleet Press, 1988.

BRUNHAMMER, Yvonne, et al. *Art Nouveau: Belgium/France.* Exh. cat. Houston, Texas: Institute for the Arts, Rice University, 1976.

BRUSSELS, Palais des Beaux-Arts. *Jugendstil.* Exh. cat., 1977.

CAMBRIDGE, Mass., Harvard University, Houghton Library, Department of Printing and Graphic Arts. *Turn of the Century, 1885–1910: Art Nouveau-Jugendstil Books.* 1970.

CLAIR, Jean, et al. *Vienne 1880–1938: L'Apocalypse Joyeuse.* Exh. cat., Paris: Editions du Centre Pompidou, 1986.

DARMSTADT, Museum Künstlerkolonie. *Katalog.* n.d. [1992].

DAWES, Nicholas H. *Lalique Glass.* New York: Crown Publishers, Inc., 1986.

DEJEAN, Philippe. *Carlo-Rembrandt-Ettore-Jean Bugatti.* New York: Rizzoli, 1982.

DUNCAN, Alastair. *Louis Majorelle: Master of Art Nouveau Design.* New York: Harry N. Abrams, Inc., 1991.

EIDELBERG, Martin. *E. Colonna.* Exh. cat., Dayton, Ohio: Dayton Art Museum, 1983.

EISLER, Max. *Dagobert Peche.* Vienna: Gerlach and Wiedling, 1925. Reprint. Stuttgart: Arnoldsche Verlagsanstalt GMBK, 1992.

FENZ, Werner. *Koloman Moser.* Salzburg: Residenz Verlag, 1984.

FRANZKE, Irmela. *Jugendstil: Glas, Graphik, Keramik, Metall, Möbel, Skulpturen und Textilien von 1880 bis 1915.* Karlsruhe: Badisches Landesmuseum, 1987.

FROTTIER, Elisabeth. *Michael Powolny.* Vienna: Bohlau Verlag, 1990.

GARNER, Philippe. *Emile Gallé.* New York: Rizzoli, 1990.

GEBHARD, David. *Josef Hoffmann: Design Classics.* Exh. cat., Fort Worth, Texas: Modern Art Museum of Fort Worth, 1983.

GRAVAGNUOLO, Benedetto. *Adolf Loos: Theory and Works.* New York: Rizzoli, 1982.

GÜNTHER, Sonja. *Bruno Paul: 1874–1968.* Berlin: Gebr. Mann Verlag, 1992.

HAMBURG, Ernst Barlach Haus. *Mutz-Keramik: Werke von Ernst Barlach und andere ausgewählte Arbeiten aus den Altonaer und Berliner Werkstätten.* Exh. cat., 1966.

HASLAM, Malcolm, Philippe Garner, Mary Harvey, and Hugh Conway. *The Amazing Bugattis.* Woodbury, New York: Barron's Educational Series, Inc., 1979.

HAUSEN, Marika, Kirmo Mikkola, Anna-Lisa Amberg, and Tytti Valto. *Eliel Saarinen: Projects 1896–1923.* Helsinki: Otava Publishing Company, Ltd., 1990.

KALLIR, Jane. *Viennese Design and The Wiener Werkstätte.* Exh. cat., New York: Galerie St. Etienne/George Braziller, 1986.

LOZE, Pierre and François. *Belgium Art Nouveau: From Victor Horta to Antoine Pompe.* Ghent: Snoeck-Ducaju and Zoon, 1991.

MARCILHAC, Félix. *René Lalique 1860–1945 Maitre Verrier.* Paris, Les éditions de l'amateur, 1989.

MILLMAN, Ian. "Georges de Feure: A Turn of the Century Universal Artist." *Apollo* 128 (Nov. 1988): 314-19.

MONTI, Raffaele. *La Manifattura Chini.* Rome: DeLuca Edizioni d'Arte-Leonardo, 1989.

NERDINGER, Winfried, ed. *Richard Riemerschmid vom Jugenstil zum Werkbund: Werke und Dokumente.* Exh. cat., Munich: Prestel Verlag, 1982.

NEUWIRTH, Waltraud. *Österreichische Keramik des Jugendstils: Sammlung des Österreichischen Museums für angewandte Kunst, Wien.* Munich: Prestel-Verlag, 1974.

Wiener Keramik: Historismus, Jugendstil, Art Deco. Braunschweig: Klinkhardt und Biermann, 1974.

Wiener Werkstätte: Avantgarde, Art Deco, Industrial Design. Vienna: Dr. Waltraud Neuwirth, 1984.

Glas 1905–1925: Vom Jugendstil zum Art Déco. Coll. cat., Vienna, 1985.

NOEVER, Peter, ed. *Josef Hoffmann Designs.* Exh. cat., Austrian Museum of Applied Arts, Vienna. Munich: Prestel-Verlag, 1992.

OLBRICH, Joseph Maria. *Architecture/Joseph Maria Olbrich.* Essays by
 Peter Haiko and Bernd Krimmel. New York: Rizzoli, 1988.

OTTOMEYER, Hans. *Jugendstil Möbel: Katalog der Möbelsammlung des
 Münchner Städtmuseums.* Munich: Prestel-Verlag, 1988.

PARIS, Bibliothèque Forney. *Paul Iribe: Précurseur de l'art deco.* 1983.

PARIS, Grand Palais. *Le Japonisme.* Exh. cat., Réunion des musées nationaux,
 1988.

PELICHET, Edgar, and Michèle Duperrex. *Jugendstil Keramik.* Lausanne:
 Kossodo Verlag, 1976.

PFEIFER, Hans-Georg, et. al. *Peter Behrens: "Wer aber will sagen, was
 Schönheit sei?"* Düsseldorf, 1990.

PHILADELPHIA, Philadelphia Museum of Art. *Art Nouveau in Munich: Masters
 of Jugendstil.* Exh. cat., 1988.

RAY, Gordon N. *The Art of the French Illustrated Book 1700 to 1914.*
 Vol II. Ithaca: Cornell University Press, 1982.

RUTHERFORD, Jessica. "Paul Follot." *The Connoisseur* 204, no. 820 (June
 1980): 86-91.

SCHWEIGER, Werner J. *Wiener Werkstätte: Design in Vienna, 1903–1932.*
 New York: Abbeville Press, 1984.

SEMBACH, Klaus Jürgen. *Art Nouveau. Utopia: Reconciling the Irreconcilable.*
 Cologne: Benedikt Taschen, 1991.

 Henry Van de Velde. New York: Rizzoli, 1989.

SEMBACH, Klaus Jürgen, and Brigit Schulte, eds. *Henry Van de Velde: Ein
 Europäischer Künstler seiner Zeit.* Exh. cat., Cologne:
 Wienand Verlag, 1992.

TROY, Nancy J. *Modernism and the Decorative Arts in France: Art Nouveau
 to Le Corbusier.* New Haven, Conn.: Yale University Press,
 1991.

VARNEDOE, Kirk. *Vienna 1900: Art, Architecture and Design.* Exh. cat.
 New York: The Museum of Modern Art, 1986.

VAUGHAN, Gerard. "André Gide and Maurice Denis *Le Voyage d'Urien.*"
 Print Quarterly 1 (Sept. 1984): 173-187.

VERGO, Peter. *Vienna 1900: Vienna, Scotland and the European Avant-Garde.*
 Exh. cat., Edinburgh: National Museum of Antiquities of
 Scotland, 1983.

VIENNA, Österreichisches Museum für Angewandte Kunst. *Die Wiener
 Werkstätte Modernes Kunst und Werk von 1903–1932.*
 Exh. cat., 1967.

 *Koloman Moser, 1868–1918: Zusammenstellung und
 Gestaltung der Ausstellung Oswald Oberhuber Julius
 Hummel.* Exh. cat., 1979.

WEISBERG, Gabriel P. *Art Nouveau Bing: Paris Style 1900.* Exh. cat.,
 Smithsonian Exhibition Traveling Exhibition Service. New
 York: Harry N. Abrams, Inc., 1986.

WINDSOR, Alan. *Peter Behrens: Architect and Designer.* New York: Watson-
 Guptill Publications, 1981.

ZIFFER, Alfred, ed. *Bruno Paul: Deutsche Raumkunst und Architektur
 zwischen Jugendstil und Moderne.* Exh. cat., Müncher
 Stadtmuseum. Munich: Klinkhardt und Biermann, 1992.

Index